LETTERING &
CALLIGRAPHY
Workbook

LETTERING &

Calligraphy

Workbook

The Diagram Group

Sterling Publishing Co., Inc.
New York

Acknowledgements
We would like to thank the following calligraphers for permission to produce their work.

Section 1
William Cartner (p47, *bottom*), Lindsay Castell (p43, quotation from *The Idiot* by Fedor M Dostoyevsky 1868/9); Barbara Feld (p65, *top left*), Michael Herring (p64) Margaret Kennedy (p65, *top right*); David Mekelburg (p74, quoting from *Life in the Snake pit* by Bette Howland); John Smith (p75, *top*); Peter Thornton (p57, p63); Wendy Westover (p75), John Weber (p54); John Woodcock (p55, Quotations from *The Family Reunion* by T. 5. Eliot 1953, Victoria & Albert Museum MS Circ 169–1953 by permission of Faber & Faber Publishers Ltd), the late Pamela Wrightson (p71).

Section 2
Maura Cooper (p98, St Columba quotation).

Section 4
Alianza Editorial SA of Madrid, Spain, for permission to use several images from Enric Satué's *El diseño gráfico desde los orígines hasta nuestros días* (1988).

In the world of ephemeral printing many designs appear without full credit either to the designer, the company responsible for the design, the date, or the current owners of the copyright.

We have made every effort to locate and clear permission for the use of the illustrations in this book. But should we have unwittingly infringed copyright in any illustration reproduced we will gladly pay an appropriate fee on being satisfied as to the owner's title.

Library of Congress Cataloging-in-Publication Data Available

10 9 8 7 6 5 4

Published by Sterling Publishing Company, Inc.
387 Park Avenue South, New York, N.Y. 10016
© 1997 by Diagram Visual Information Ltd
195 Kentish Town Road, London, NW5 2JU, England
Distributed in Canada by Sterling Publishing
c/o Canadian Manda Group, One Atlantic Avenue, Suite 105
Toronto, Ontario, Canada M6K 3E7
Distributed in Great Britain and Europe by Cassell PLC
Wellington House, 125 Strand, London WC2R 0BB, England
Distributed in Australia by Capricorn Link (Australia) Pty Ltd.
P.O. Box 6651, Baulkham Hills, Business Centre, NSW 2153, Australia
Manufactured in the United States of America
All rights reserved

Sterling ISBN 0-8069-4273-8

FOREWORD

THIS BOOK IS WRITTEN TO BE USED. It is not meant to be simply read and enjoyed. Like a course in physical exercises, or any area of study, you must carry out the tasks to gain benefit from the instruction.

1 Read the sections through once.
2 Begin again, reading two pages at a time and carry out the tasks set before you go on to the next two pages.
3 Review each chapter by re-examining your previous results and carrying out the review tasks.
4 Collect all your work and store it in a safe place, having written in pencil the date when you did the work.

LEARNING HOW TO DO THE TASKS IS NOT THE OBJECT OF THE BOOK. It is to learn lettering and calligraphy by practicing the tasks. Do not rush them.

THE LETTERING AND CALLIGRAPHY WORKBOOK IS:
1 A program of clear instruction.
2 A practical account of various techniques and procedures.

Like a language course, the success of your efforts depends upon you. YOU DO THE WORK!

CONTENTS

SECTION 1
BASIC SKILLS

Calligraphy is an art which comes through practice and patience, so in this book, practice is fun and informative, rather than dreary and monotonous. Confidence which gives lettering a rhythm and a sense of freedom cannot come without understanding the basic structure of letters. Your calligraphy will develop as you learn the basic structure, the various techniques and experiment with different lettering styles.

Calligraphy is not a matter of copying but rather a question of developing a skill and using it appropriately to express the meaning of a text. As you work your way slowly through this book you will learn to achieve small successes step-by-step.

It is important to familiarize yourself with the pens and drawing instruments. This process involves playing with them. Just as children learn naturally through play, so will you! Mastering your tools will give you a basic confidence which will gradually develop as your skills improve.

It is important to allow plenty of time to enjoy your work. Go slowly and you will gain the maximum benefit from what you are learning. Instant results are not really satisfying, so if time is short, you simply have to expect less of yourself to begin with. There are no short cuts to practicing a craft.

" *The art of calligraphy is a form of recreation in which one unburdens one's heart and soul, dissipates care and gets rid of melancholy.* **"**
T'SAI YUNG

Chapter 1

 The lyf so short, the craft so long to lerne.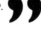
CHAUCER

Workstation

Consider creating a calligraphy workstation in your home. You will need:

A A source of natural light and a desk lamp.

B A steady, strong, flat table on which to put the drawing board.

C A drawing board (preferably adjustable).

D A comfortable adjustable chair.

E Space to keep tools and equipment within easy reach.

F Jars or cutlery tray to store pens and brushes without damaging them.

G Space to store work. (You may like to keep work in a portfolio or put it under the bed between sheets of card.)

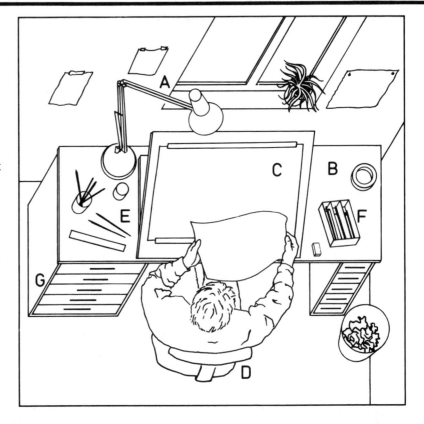

BASIC TOOLS

Calligraphy is the craft of writing beautifully. It will take much time and patience before you acquire the range of skills which are the hallmark of a good calligrapher.

To begin with, you will need a collection of tools. These should be kept clean and ready to use, so that whenever you find that you have some time available, you can start practicing your letters straight away. Cleaning pens and brushes immediately after use is also a good habit.

In this chapter you are introduced to various tools and writing instruments, which, as a beginner, you are recommended to use. You will be advised on how to care for them, and the illustrations of the various pen marks show you the effects which can be obtained from each nib or pen.

Your hand and your eye are two other important tools! With practice, they will learn to work together and you should be able to achieve better results than you might now think possible.

This book aims to show you how much fun practicing calligraphy can be. The tasks in this chapter are designed to help you establish some good habits related to your calligraphy equipment. You should keep your tools safely, and not allow others to use them. Soon your calligraphy tools will be a source of new enjoyment and must not become an excuse for bad workmanship!

Task
Prepare a drawing board

1 If you do not have a drawing board, you can make one. Find a strong, flat board with straight edges. Prop it up at an angle of 45° using bricks or books. Make sure it is firm.

2 Tape three sheets of good thick paper securely to the board to create a firm but "sympathetic" writing surface.

3 Use a sheet of ruled lines as a guide underneath the sheet of paper you're writing on.

4 Write onto a sheet of layout paper which is not taped down. This paper needs to be free to move upward as you write down the page so that your hand stays at the same level on the board at all times.

5 Use a sheet of layout paper to protect your work from grease and splatters etc.

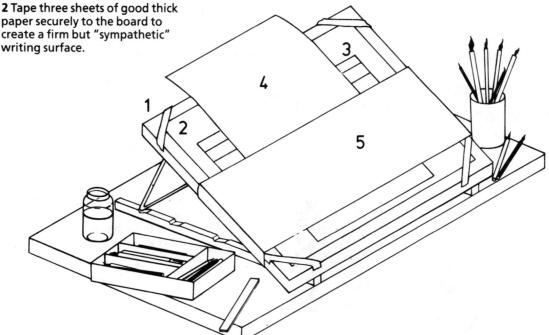

Pens and writing tools

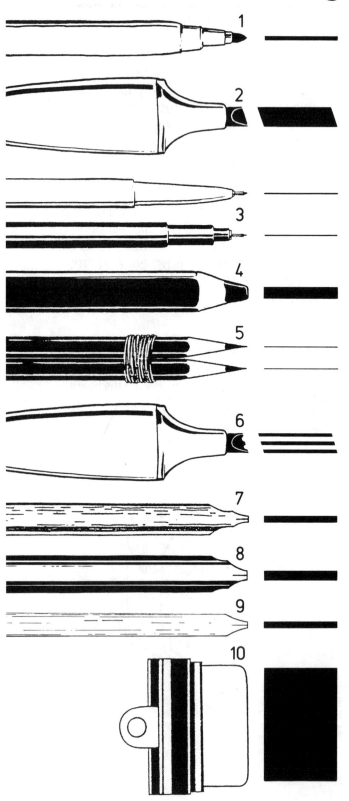

These two pages illustrate the variety of writing implements available. The ones marked with an asterisk (*) are the ones you need to start with. Left handed readers should refer to page 15 and to the end of the chapter before attempting tasks.

1 Instant marker pen.
2 Chisel-ended felt tip pen *
1 and 2 are ideal for practicing and planning layouts. They are available in a variety of widths and colors.
3 A fine tip pen is useful for ruling-up templates (see page 40).
4 A carpenter's pencil for practice and experimenting with different layouts.
5 The double pencil is the most useful dry pen of all. Simply bind two pencils together at the top and bottom with tape or rubber bands to produce an outline pen which shows clearly the letter construction. To make a broader pen, place an eraser between the two pencils and then bind them together. If you want a narrower pen, shave off some of the wood from the pencils along their length before binding *.
6 Chisel-ended felt tip pen which has had small wedges cut out of the tip with a scalpel, producing a decorative mark.
7 Reed pen. These can be made from bamboo, honeysuckle and other tubular stems. The reed pen is the original broad-nibbed pen and is ideal for large letters.
8 Synthetic "reed pen". Nylon tubing from hardware stores can be made into one. The nib can be cut into to make a pen which produces a double line.
9 A quill. This is made from a cured flight feather of a goose or swan which has been shaped at the end with a sharp knife.
Pens 7, 8, and 9 can be used with added reservoirs (see page 15).
10 Homemade poster pen. Made by covering a piece of balsa wood with felt and gripping them together in a bulldog clip. This produces an inexpensive pen with a broad nib, which is useful for display work, experimenting or for children to practice with.

Task
Collecting pens
Start collecting and making pens. Store the pens with the nib pointing upwards, not flat in a box. A jar is ideal for this. Having several pen holders will avoid the need to change nibs too often – this can damage them.

11 William Mitchell Roundhand nib with a slip-on reservoir (top, bottom and side views).
12 Brause nib with its reservoir on top of the nib. Both 11 and 12 are available in a range of widths (see page 15).
* You will need either 11 or 12.
13 Poster pens also have their reservoirs on top of the nib and a right oblique writing edge. This pen is ideal for decorated letters and display work.
14 The Witch pen has a writing edge which copes with textured papers very well.
15 Boxall Automatic pen. This range includes a variety of nib widths.
16 Boxall Automatic pen with a decorative nib.
17 Scroll nibs are available in sets consisting of a variety of widths, all giving a double line.
18 The Decro Script pen is useful for practicing skeleton letters in various sizes.
19 Coit pens are expensive but have a variety of writing edges which produce decorative marks, and are ideal for display work.
20 Fountain pen. Using a fountain pen with an italic nib for your everyday writing will help to improve it*
21 A shadow fountain pen nib gives two lines. This is ideal for analysing your strokes as well as being decorative.

Task
Preparing nibs
New nibs need to be cleaned before use, otherwise the ink will not flow freely. Remove the manufacturer's lacquer from both nibs and reservoirs, either by boiling them in water or by putting them into the flame of a lighted match and then wiping clean.

Task
Making mountains
Rule writing lines 1¼in (30mm) apart on 11 × 14in (A3) paper. With the double pencil pen (no.5) make mountains with a 45° angle. Keep the angle constant. This simple practice exercise is helpful to the beginner even before you start writing.

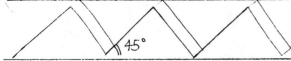

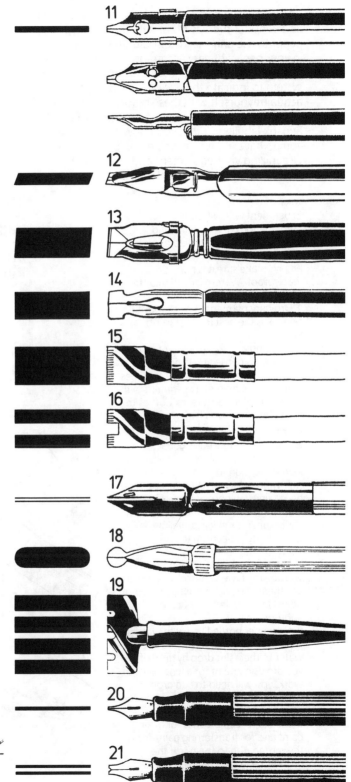

Additional materials

As well as selecting a writing implement you must also consider the size of the nib, the right type of paper to use and the ink or paint that you will put in your pen. Nibs vary according to manufacturer and each manufacturer uses a different numbering system to indicate the size of the nib. Try to acquaint yourself with these before choosing a nib.

It is a good idea to keep pens and pots of paint and ink labelled so that you know exactly what you do have. Paper can be kept in piles or folders. Organizing your equipment and materials in this way saves time and prevents mistakes.

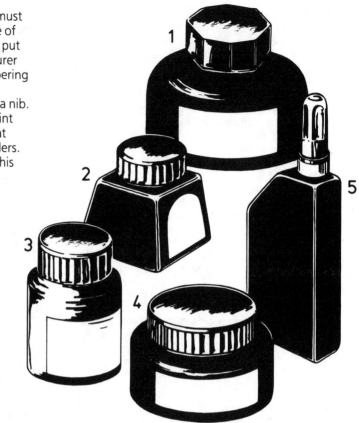

Inks
Experiment with different combinations of ink, paper and writing board angle to find out what suits you best. When choosing ink always make sure it is non-waterproof. Waterproof inks contain gum which will clog your pen.
1 Ordinary permanent black fountain pen ink is the best ink to start off with.
2 Black Indian ink is good for finished work as it is dense and very black.
3, 4 and **5** There are many other types of ink on the market. Experiment with different colors. Secure ink bottles to the table to avoid spillage.

Paint
6 Gouache. A few basic gouache paints (designer colors) will give a new dimension to your work. The following colors would be useful to have: zinc (Chinese) white, cobalt blue, lemon yellow, emerald oxide of chromium (mix in lemon yellow to give it body), spectrum red or vermilion hue.
7 A mixing dish for preparing paint. If you already have watercolors you can use them and add zinc white to give opacity to your letters when it is appropriate.
8 A dropper bottle filled with water is ideal for mixing paint. Always add the water to the paint drop by drop. If you are using paint for a long piece of work, you will need to add drops of water occasionally to compensate for evaporation.
9 Use old, cheap brushes for mixing paint and for transferring paint from the mixing dish to the nib. If the brushes have long handles, shorten them to prevent accidents.

Task
Paper storage
If you don't already have a plan chest or set of shallow drawers you can make a paper storage system without glue or nails. You need some large flat sheets of wood and some thin strips of wood 1-2in (2.5-5cm) thick. Place one of the flat sheets on a stable surface, put a strip of wood down either edge and place another flat sheet on top. This creates a compartment which paper can be slid into. Continue building upwards until you have enough space for all your paper.

Task
Tool storage
Protect your rulers, pencils, set squares and cutting knives by storing them in a cutlery tray or shallow box. Larger tools (T-squares, etc) can be hung from nails or hooks in the wall. Check your equipment with the list on page 16.

Nib widths

Nibs are available in an enormous range of widths. The wider the nib, the greater the contrast between the thick and thin strokes produced. Two manufacturers nib sizes are shown here.

Left handed calligraphers

If you are left-handed you may find left oblique nibs (**A**) easier to use than square cut ones (**B**). You have to decide what is best for you. Several first class calligraphers are left handed so it is no excuse for not succeeding!

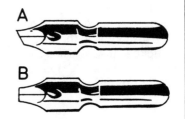

William Mitchell roundhand nibs

▪	0
▬	1
▬	1½
▬	2
▬	2½
▬	3
▬	3½
▬	4
▬	5
▬	6

Brause nibs

▰	5
▰	4
▰	3
▬	2½
▬	2
▬	1½
▬	1
▬	¾
▬	½

Reservoirs

Reservoirs hold ink on the nib and help to control the ink flow. There are five basic types:

a This reservoir slips underneath the nib and forms a shallow cup shape which just touches the slit. It should not force the slit open. This type is easily removed for cleaning.

b Similar to (**a**) but sits on top of the nib and can also be removed for cleaning.

c The shape of this nib creates its own reservoir. Work with the hairlines on the writing edge facing upwards as these help control ink flow. Clean the nib by passing a soft cloth between the two "blades".

d Coit pen reservoir. These occasionally need to be taken apart to be cleaned.

e (Cross section) This reservoir is made from a piece of aluminum from a soft drink can. Cut the metal into small strips, bend into an S shape and tuck into the barrel of your reed or nylon pen (such as pens 7 and 8 on page 12).

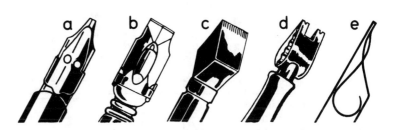

Paper

You will probably use a great deal of paper so you will need to locate a good art shop or a specialist paper supplier so that you can stock up from time to time. Good paper is worth paying extra for, but only buy small quantities until you find which ones you like. You need to consider three main factors when choosing paper: weight (thickness), surface texture ("tooth"), and finish (absorbency). If you buy some new papers, write the name and other details in a corner so that you can easily reorder it if you find you like using it. Experiment with different paper, ink and pen combinations. To begin with, buy an A3 layout pad. This is an inexpensive, translucent, lightweight paper which you can use for practice and pasting up. Guidelines placed underneath will show through. Some good quality drawing paper is very useful so try a few different weights, then stock up with ones you like. Parch marque is a substitute for parchment and is ideal for making a finished piece look interesting. Fabriano paper, made from cotton, comes in several weights and is very good to use.

Size	DIMENSIONS		NEAREST US EQUIVALENTS
	METRIC	IMPERIAL	
A5	148 × 210 mm	5¾ × 8¼in	5½ × 8½in
A4	210 × 297mm	8¼ × 11¾in	8½ × 11in; 9 × 12in
A3	297 × 420mm	11¾ × 16½in	11 × 14in; 14 × 17in; 11 × 17in; 12 × 18in
A2	420 × 594mm	16½ × 23½in	18 × 24in; 19 × 24in

Review

This first chapter has shown you the essential tools for calligraphy. You now know how to store, prepare and clean them, so once you have completed the tasks and the checklist, you should be quite ready for Chapter 2 where you learn the letterforms.

Posture

Body weight should go through the spine. Legs and both feet should rest squarely on the floor. Avoid weight going forward into the arms.
This position should give you:
- Steady ink flow
- Good view of your work
- Relaxed working posture which will not tire you

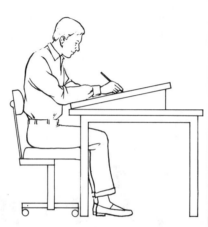

Hints for left handed calligraphers

- Left oblique nibs can be purchased. If required, the angle of the nib can be increased by rubbing with FINE silicon carbide paper.
- Tilt the paper or steepen the angle of the drawing board to make yourself more comfortable.
- Keep work to the left hand side of your board. Turn your head a little to the left and don't write across your body – only as far as your chin. Keep your elbow tucked into your waist.

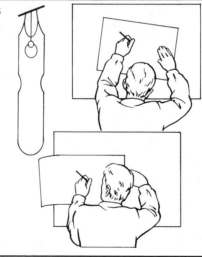

Task
Sketch book
Buy a small sketch book and keep it on your person, along with a felt pen or fountain pen. Using this you can doodle and design whenever an idea occurs.

Task
Quotations notebook
Buy a small notebook in which you can jot down quotations and poems which you may one day like to write out.

Basic equipment checklist
Some of these may be things you already have. Items marked with an asterisk (*) are not essential right at the beginning, but would be very useful as you progress through the book.

1 Chisel edged felt tip pens in various sizes, ¼-⅕ in (3-5mm)*
2 Two 2B pencils bound together top and bottom
3 Several round pen holders
4 Set of nibs for the pen holders – either Brause or William Mitchell
5 Several slip-on reservoirs if you use William Mitchell Roundhand nibs
6 No. 3 or 3A Automatic pen*
7 No. 7 Automatic pen*
8 Fountain pen with italic nib. Usually packed with three nibs and some ink cartridges
9 11 × 14in (A3) layout paper pad
10 Two 18 × 24in (A2) sheets of paper
11 Hot-pressed (smooth) paper from art shop to experiment with
12 Bottle of fountain pen ink
13 Bottle of black Indian ink (non-waterproof)
14 4 Designer's Gouache colors*
15 4 cheap brushes for mixing paint*
16 Dropper bottle containing distilled water
17 Blu Tak, plasticine or similar for securing bottles to the table
18 Palette or screw-top jars and water jar
19 Soft cloth
20 Masking tape
21 Typewriter correction fluid*
22 Eraser
23 Ruler
24 Craft (X-Acto) knife
25 Triangles (set squares) 30°/60°, 45°
26 Pencils – HB and softer for writing; 3H (or harder) for ruling lines
27 Pencil sharpener or old craft knife
28 Compass for circles and arcs*
29 Dividers for accurate measuring*
30 T-square for ruling parallel lines quickly and accurately*
31 A drawing board, of a minimum 16×20 in (400×500mm)
32 Comfortable chair/stool and table
33 Well-lit work area
34 Spotlamp
35 Storage facilities

1 *Italia*

2 Sommières

3 Wïen

4 Roma

5 Auxerre Boulogne Calais

6 Napoli · Bologna

7 Ludwigsburg

Pen marks

Here are several examples of pen marks, they vary enormously.

1 Nylon tubing cut in just the same way as a reed pen
2 Monoline pen
3 Coit pen
4 Bamboo pen cut in just the same way as a reed pen
5 Scroll nib
6 Italic fountain pen with shadow nib
7 Automatic pen

Task

Equipment check
Check the equipment list and finish collecting your tools and materials.

©DIAGRAM

17

Chapter 2

The greatest thing in the world is the Alphabet as all wisdom is contained therein – except the understanding of putting it together.
GERMAN BOOKPLATE

The letterform is the "hand" or style in which you write. The skeleton letterform is the most basic form of the upper and lower case alphabets (majuscules and minuscules). The skeleton letters can be made with any implement as they do not rely on the "thick and thin" effect of a broad-nibbed pen. For this reason no pen angle or ladder (see *opposite*) is needed. You can make the letters as large or as small, thick or thin as you wish. The other two letterforms in this chapter, Foundational and Italic, require you to use a broad-nibbed pen. Familiarizing yourself with the points shown here will help you start using the pen.

Terms used in lettering

A	Serif	**F**	Bowl	**K**	Writing line
B	Stem	**G**	Counter	**L**	x-height (height of minuscules)
C	Ascender	**H**	Foot serif	**M**	Majuscule (capital) height
D	Arch	**I**	Descender	**N**	Height of ascenders
E	Hairline	**J**	Cross-bar	**O**	Depth of descenders

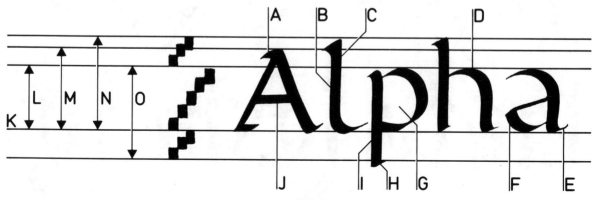

LETTERFORMS

In this chapter you are shown a skeleton alphabet to teach you the proportions of the letters. This will give you a knowledge of the basic Roman alphabet.

The next step is to take up the broad-nibbed pen and, after some initial pen exercises, learn the shapes and stroke order of Edward Johnston's Foundational hand. The minuscule hand is based on an old manuscript called the Ramsay Psalter which Johnston studied in the British Library in London.

Roman-based majuscules are shown next. These, together with Foundational minuscules, form the best-known version of the letters of the alphabet.

Formal Italic and the less formal Italic handwriting are shown at the end of the chapter. Instructions are also given for flourishing Italic and some alternative forms are included.

Once you are familiar with these three basic styles you will be ready to begin a few simple writing projects.

Ladders

The height of each style of letterform is set at a specific number of nib widths. Therefore the nib you use acts as a measuring unit to find the height of the letters. The nib widths are made with a pen angle of 90° and are piled up in a formation known as a ladder. You must make a new ladder each time you use a different size of nib or change lettering style. In this way, whichever size nib you use, your letters will always be in the correct proportions. For example, Foundational majuscules (**A**) are 6 nib widths high and the minuscules are 4½ nib widths. Italic majuscules (**B**) use 7 nib widths and the Italic minuscules are 5.

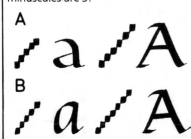

Guidelines

Guidelines are lines which act as a guide for the proportions of the letterforms. These proportions are found by making a ladder and then ruling pencil lines from it. They can either be fine pencil lines ruled on the writing sheet itself or templates placed under the writing sheet so that the lines show through.

Pen angles

The pen angle is the angle between the flat edge of the nib and the horizontal writing line. This varies depending on which letterform you are writing.

90° for ladders

30° for Foundational hand

45° for Italic

19

Skeleton letters

The alphabet we know today has two basic forms — capitals or upper case letters (majuscules) and lower case letters (minuscules). The terms upper and lower case originated in the typesetting industry. The majuscule type was kept in a separate flat wooden tray (case) above the minuscule tray. The skeleton alphabet (shown *right*) is the first lettering style to learn. It is the most basic form of the alphabet and has no thick or thin strokes. For this reason it can be made with any monoline pen (any pen with a Round nib) and needs no ladder or pen angle. The x-height of the minuscules should be half the height of the upper case, while the ascenders of the minuscules should equal the height of the upper case letters. When learning the majuscules it is useful to divide them into four groups based on their proportional spaces. Familiarizing yourself with this alphabet and memorizing the stroke order will give you a firm grounding in the art of lettering.

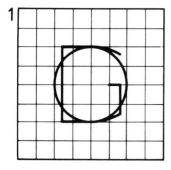

Proportional groups
1 C D G O Q are based on a circle. D and G use the edge of the rectangle.
2 A H N T U V X Y Z all fit into a rectangle. Note that the crossbars on A and H are at different heights.
3 B E F J K L P R S use half a square. Curves in the lower section need to be a fraction larger to stop letters looking top-heavy.
4 M fits into a square and W (double V, not double U!) is the widest letter. I is the narrowest.

Task
Letter groups
Familiarize yourself with the letter groups. Rule guidelines ½in (13mm) apart on some layout paper and, using a 2B pencil, work through the majuscule alphabet.

Task
Decro Script pen
Using a script pen (No 18 on page 13) or a round-tipped felt pen, go through the groups of majuscules again with lines ¾in (20mm) apart.

Task
Proportion
Write out the whole alphabet using whichever tool you prefer. See if you can keep the proportion for each letter correct even though you are now mixing up the letter groups.

Letter spacing
The skeleton alphabet is ideal for practising letter spacing as its simplicity allows faults to become obvious.

The most important thing to remember is to take the shape of the adjoining letters into account. Hints for well-balanced lettering:
● Leave a large gap between the two verticals (**1**).
● Put one vertical and one round letter closer together (**2**).
● Put two round letters even closer together (**3**).
To put it simply, regular spacing, that is, leaving the same size gap between each letter, is INCORRECT (**4**). Follow the above three hints and make your spacing irregular (**5**). Balance the AREAS, not the distance, between letters.

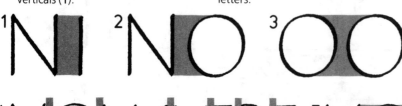

ABCDEFGHIJJK

ABCDEFGHIJJK

LMNOPQRSTU

LMNOPQRSTU

VWXY&Z abcde

VWXY&Z abcde

fghijklmnopqrstu

fghijklmnopqrstu

vwxyz 1234567890

vwxyz 1234567890

The Foundational hand

The Foundational hand is the name given by the calligrapher and typographer Edward Johnston to the style he developed in the early years of this century. It is based on his study of the Ramsay Psalter, a 10th century Carolingian manuscript in the British Museum (see detail on page 36.) This minuscule alphabet is used with majuscules based on the classic Roman capitals. They keep the same proportions and quality of balance that the stonecut letters have.

Task
Pencil mountains
Using two 2B pencils secured together at the top and the bottom, practice holding the pen at a 30° writing angle and make several rows of mountains. Check the angle as you finish each line. Then speed up a little and enjoy the rhythm.

Foundational
The hand has an x-height of 4½ nib widths, with an ascender height of 7 nib widths, and a capital height of 6 nib widths. The basic shape is the round O and the letters stand vertically without a slope. The hand is written with the pen at 30° to the writing line, except in the case of some of the capital letters when several changes in pen angle must be made (see following pages).

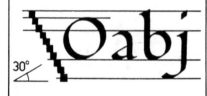

Task
Ladder
Make a ladder upwards from your writing line to find out how high 4½ nib widths is using double pencils. When you have that height draw another line so that you have two lines to guide you. Practice the O shape using two pulling strokes all the time, first anticlockwise, then clockwise. You start at 11 o'clock and travel round to 5 o' clock each time.

Task
Foundational minuscules
Work through the minuscule alphabet taking care to keep your letters 4½ nib widths high. Maintain the height, but steepen the angle when you get to the letters v, w and z. Date these practice sheets.

Minuscule letter groups
Don't write out the alphabet. Look first at the groups of letters. They are grouped according to their shape and it is easier to stick to one basic shape at a time.

Group 1 The O shape
Work around from 11 o'clock to 5 o'clock, first anticlockwise, then clockwise. Follow the stroke order from the alphabet diagram.

Group 2 The arch shape
Note how it relates to the O and is not angular at all.

Group 3 The inverted arch, the u shape
I and t both have stable bases to sit on.

Group 4 Diagonals
The angle is steepened for these strokes, otherwise they would spread too wide.

Group 5 The remaining letters
The shapes of these letters have little in common, but all need individual attention during construction.

The construction of the serif is illustrated for you on page 24 .

Task
Letter groups
Still using the double pencil pen work your way through the five groups of letters. Write each group three times before you move on to the next.

abcdefghijk

abcdefghijk

lmnopqrstu

lmnopqrstu

vwxyz gxyy

vwxyz gxyy

1234567890

1234567890

Foundational majuscules

The Foundational hand majuscule alphabet is a modern version of the classic Roman capitals alphabet which has been adapted for use by the broad-nibbed pen. The original Roman capitals, for example those seen on Trajan's Column in Rome (see page 36), have inspired lettercutters, typographers and signwriters for two thousand years. They were originally drawn with a brush before being cut with a chisel.

They aimed to convey the power of the Roman Empire. The elegance of these letters has been captured in the modern pen version which, when used with the minuscules, makes one of the most popular hands used by calligraphers.

Task
Stroke order
Before going through the alphabet turn back to page 20 and, using these letter groups, begin learning the stroke order using the double pencil pen. Write each group of letters three times before going on to the next.

Task
Capitals stroke by stroke
When you feel ready, start to work your way through the alphabet using a double-pencil pen, making two copies of each letter. Use the stroke order diagrams and make each letter 7 nib widths high. Date these sheets when you have finished. Remember to steepen stroke angles on diagonals.

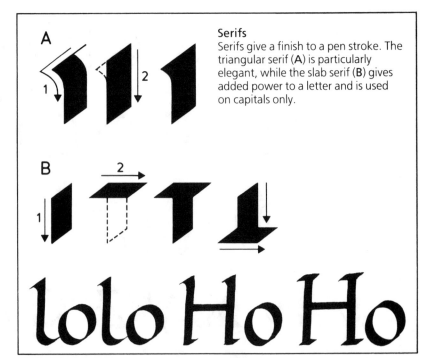

Serifs
Serifs give a finish to a pen stroke. The triangular serif (**A**) is particularly elegant, while the slab serif (**B**) gives added power to a letter and is used on capitals only.

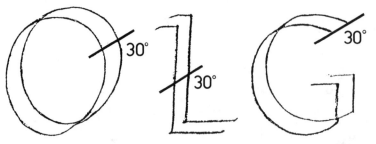

Changing pen angle
The pen angle used is 30°, but there are a few exceptions to this. The diagonal strokes are steepened to 45° and occasionally the pen is flattened to a mere 5° in order to maintain a harmonious look.

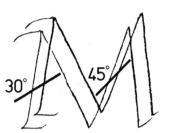

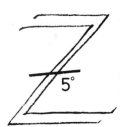

A B C D E F G

A B C D E F G

H I J K L M N

H I J K L M N

O P Q R S T U

O P Q R S T U

V W X Y & Z

V W X Y & Z

Practicing Foundational

The nature of practice is that while it is very necessary, it can be boring! Here are some ideas for you to work on and develop while you practice the Foundational hand and Roman capitals. Do not be tempted to rush on and try the Italic at this stage. There are several differences between these two hands that may confuse you. Before you leave the Foundational hand why not write out a small quotation.

For advice on layout turn to pages 46-47.

ABLE · BAT · CAT · DOG ·
I suggest experimenting with
EGG · FISH · GET · HIGH ·
capitals, serifs & lower case using
ICE · JOE · KATE · LION ·
different nib sizes, remembering
MAN · NUT · ORBIT ·
that nib widths are the measur-
PIP · QUILL · RAT · STY ·
ing unit for letter height & you
TOP · UNITY · VIEWS ·
aim for roundness and check for
WOW · X-RAY · YOUNG ·
even spacing by reversing the page
& ZEST · EXERCISES!

Doodling
Above, doodling does not need concentration and can be very relaxing. Try to keep your pen at the correct angle.

Task
Words
Go through the alphabet using a short word for each letter (*left*). Continue even if some words look very bad. The aim is to keep writing and fill a sheet or two with words.

Task
Naming names
Repeat the previous task using people's names instead of words. Work right through the alphabet. Date it and keep for reference.

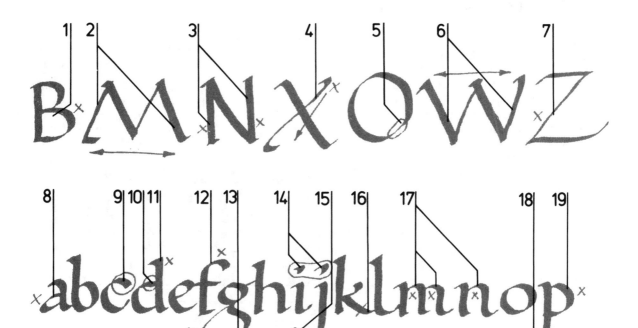

Problems

A student's early attempts at the alphabet are shown here to demonstrate some of the problems you might be experiencing. With capitals or majuscules keep the lines straight or circular. Don't invent swoops and curves. Don't go too low before you arrive at the halfway mark on the letters P R F E K B. Check the proportions by turning the page upside down, constructional mistakes are easily revealed with this simple procedure. Try not to be over critical.

1 Bottom bowl too wide.
2 Feet are splayed out too wide, so alter angle to 45°; remember the square.
3 Side strokes too thick, need to change pen to 45° angle.
4 Lost control! 45° angle needed.
5 This lacks confidence, a good attempt.
6 Too wide, 45° angle needed. Blots and smudges are a beginner's hazard. Stroke 4 pushed up instead of pulled down.

7 A weak middle stroke, flatten the pen angle here.
8 Wrong proportions.
9 Too curved.
10 Bad join between two strokes.
11 Clumsy serifs.
12 Too hooked.
13 Control lost.
14 Dot too comma-like.
15 Hook far too big.
16 Leg stroke too long.
17 Wobbly arches.
18 Too heavy.
19 Poor curve.

Pen play

It's essential to feel at ease when you are learning calligraphy. As well as practicing the stroke order, try some drawing with the pen. Some simple patterns based on letterforms are shown here.

©DIAGRAM

The Italic hand

The Italic hand was developed in Italy during the Renaissance. There were famous writing masters then as well as many artists and craftsmen, and we still refer to their teaching examples today. There are several different versions of Italic: formal, informal, pointed, cursive and chancery.

Additionally, it can be compressed, extended, flourished and decorated. It is the most flexible of all the calligraphic hands.

All Italic hands share two basic characteristics, the branching arches and the elliptical stress, which make it faster to write than round hand. Don't try to speed up when you write, think instead of the shapes and the rhythm; speed will come later.

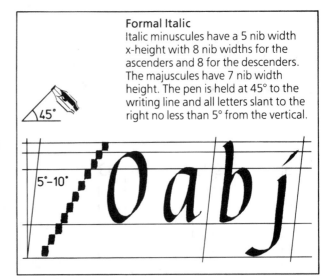

Formal Italic
Italic minuscules have a 5 nib width x-height with 8 nib widths for the ascenders and 8 for the descenders. The majuscules have 7 nib width height. The pen is held at 45° to the writing line and all letters slant to the right no less than 5° from the vertical.

Pen play
The simple pen exercises (*left*) will give you a "feel" for the Italic hand.

Changing proportions
The Italic hand lends itself to decoration. Descenders and ascenders can be extended and flourished. When you are more confident you can try this by changing the proportions when ruling up and allowing extra space above and below the x-height.

If you are writing out a poem, or anything with more than three or four lines, keep your ascenders and descenders controlled as they can interrupt the flow of the whole piece if they are too long. On the other hand, elegance and charm can be added to Italic by increasing the ascenders and descenders. You will soon learn when that would be appropriate.

Task
Italic minuscules
Practice the pen play exercises first before working through the minuscule alphabet. Use your double pencil pen the first time and concentrate on the 45° pen angle. Try to maintain it happily throughout an 11 × 14in (A3) sheet of mark-making exercises.

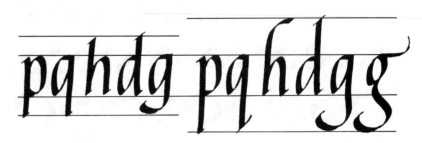

abcdefghijklmnop

abcdefghijklmnop

qrstuvwxy&z gk

qrstuvwxy&z gk

fbABCDEFGHIJKL

fbABCDEFGHIJKL

MNOPQRSTUVW

MNOPQRSTUVW

XY&Z 1234567890

XY&Z 1234567890

Flourishing Italic

Flourishes are extensions to ascenders, descenders and capital letters, and on the last letter of a line or a word. They are either alive, ribbon-like and effective, or tight, too condensed and distracting, so it is important to experiment and feel confident about making them. Over ornate flourishes are attention seeking and fussy, whereas successful ones delight the eye. Start with simple ribbons and aim to use them sparingly. Think of it as flicking a ribbon or cracking a whip, not as an ornate pattern.

Four ways to flourish
1 On an initial letter
2 On the ascenders
3 On the descenders
4 As the finishing stroke of a word

Single strokes
Some flourishes can be made in one stroke:
A A simple ribbon-like flourish
B A whipcrack flourish

A part of the word
These flourishes (*below*) are from the ends of words, and look like natural extensions of the letters. Beware of making flourishes look too "busy."

Task
Enhancing names
Analyse the flourishes on the names Suzy and Ailsa and, using various different nib sizes, learn them. Turn your work upside down to enhance ascenders too. Smaller nibs will be easier to use than large ones.

Task
Finishing strokes
Using a ¼in (6mm) line template under your layout sheets, write out an alphabetical list of girl's names and add finishing strokes that extend the word.

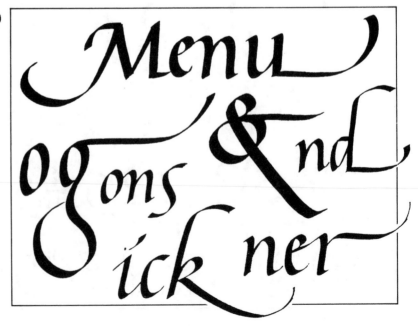

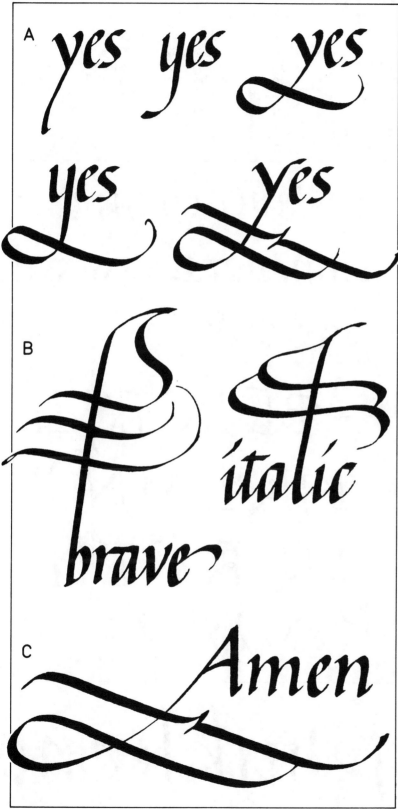

Variations

Some examples of flourishes on descenders and ascenders:

A They should be free flowing and rhythmic, but also depend on where the word appears in your work and the emphasis you want to put on it.

B Over ornate flourishes can look contrived and do not flow freely. They distract from the word and appear to seek attention. In these examples the flourishes, although ornate, are balanced by the exaggerated height of the ascender.

C Parallel strokes and diagonal stress give emphasis to a word.

Task

Developing shapes

Using every third line on your line template, write out the girl's name list again adding flourishes on ascenders and descenders. Work on improving several names to develop an interesting shape. Allow more space between writing lines for flourishes.

Task

Labels

Make a list of family and friends and write the names on thin card, using flourishes. Trim the card, leaving plenty of space, after you have completed the design to make labels. You might like to use designer colors or diluted inks.

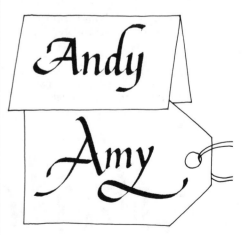

Variations of Italic

Italic is a generic term which covers all the variations of the style. The letterforms are formed in just the same way as formal Italic on page 29, but by changing the proportions, condensing or opening out the letters, or by making them more angular or rounded, endless variations on the theme are possible.

You can see this for yourself by taking one text and writing with swashes and a free-flowing hand. Then write it again with the angular spiky Italic that you see at the bottom of the page. The overall moods of the two pieces of writing will be surprisingly different.

Decorated Italic
This Italic alphabet uses swashes – elegant, free-flowing extensions of the letters. The capitals can be used to give vitality and charm to a piece of writing. The light and spacious quality is made by extending the ascender and the descender height of the minuscules, and opening out the capitals. The lettering should stand on its own without unnecessary additional decoration.

Task
Trial run
Write out "the quick brown fox jumps over the lazy dog" using the alphabet below. Check all your pen angles afterward using a protractor or a set square. Repeat if necessary.

Angular Italic
This lower case Italic (*below*) has an angular and spiky quality with hairlines on some ascenders and descenders.

abcdefghijk
lmnopqrstuvwx
yzß&&ft
ABCDEFGH
IJKLMNO
PQRSTU
VWXYZ

©DIAGRAM

abcdefghijklmno

Seguita lo essempio delle lre che pono
ligarsi con tutte le sue seguenti, in tal mo=
do cioe

aa ab ac ad ae af ag ah ai ak al am an

ao ap aq ar as af at au ax ay az

Il medesmo farai con d i k l m n u.

Le ligature poi de c f s ſ t sonno

le infra =

scritte

ct, fa ff fi fm fn fo fr fu fy,
st st

ſf ſſ ß ſt, ta te ti tm tn to tg tr tt tu
tx ty

Con le restanti littere de lo Alphabeto, che
sono, b c g h o p q r x y z z
non si deue ligar mai lra
alcuna seguente

p q r s t u v w x y z &

Arrighi's Italic

An extract from the work of Ludovico Arrighi, published in Venice in 1533. Arrighi's copy books using the cursive hand had a great influence on the development of the Italic hand.

Task

Alternative Italic

Find a 2 or 3 line piece of prose and write it out in a variation of Italic, condensing, extending or adding flourishes or hairlines as you wish. Don't worry if it doesn't work the first time, just put it aside and try again. Keep writing it out until you have a satisfactory result.

Task

Formal Italic

Find a poem or a nursery rhyme of about 12 lines and write it out. You can use flourishes on the top and bottom lines if you wish. Practice before you begin, leave space around the edge of the writing, and date and sign the piece.

Task

A gift

Choose a favorite piece of prose and write it out using either Italic or Foundational hand. Give it to a friend and keep the paste-up with all the details on it to enable you to make another copy.

Italic handwriting

As you begin to develop your calligraphic skills, you might like to take a closer look at your own handwriting. Do not confuse Italic handwriting with formal Italic script. If you feel this is beginning to happen, stop one and concentrate solely on the other one for a while. Italic handwriting is a rhythmic and legible way of writing beautifully all the time. Use it as often as possible, and write checks, notes, lists and memos beautifully! Your handwriting tells everyone something about you and is a form of self-expression. The alphabet shown here is to give you a framework to build upon. Italic is a system of rhythmic movements across the page, using letterforms. The exercises are to help you build up your mark-making experience. Don't rush at it. It is possible, with practice, to write fast and well in only a few weeks.

Points to remember
● Italic handwriting uses ligatures, strokes which join one letter to another to give a continuous, fluent script. The pen stays in contact with the paper most of the time.
● Hold the pen at 45° to the writing line so that the correct distribution of thick and thin is maintained.
● Left handed people need an oblique nib in their fountain pen. It is a good idea to keep the left elbow tucked well into the body and maybe adjust the paper sideways a little.
● Try not to press hard with the pen. Some letters require you to push the pen upwards and unnecessary pressure at this stage will slow you down and cause splatters.
● The x-height of the letters is 5 nib widths. The ascenders and descenders are both 9 nib widths, and the capitals are 7 nib widths high.

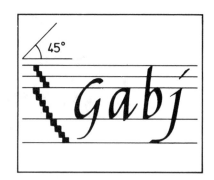

Handwriting exercises
A 45° mountains making thin and thick strokes
B Springing arches in the proportion 2:3
C Swinging-up pattern
D The pull-down stroke, the arch and the ligature (joining stroke)
E O can be made in one stroke, as can c and e
F Go through the alphabet with m as a middle letter, remembering to keep the 2:3 proportion
G Lift the pen after these letters: b, g, j, p, q, s, x, y, and before these: a, c, d, g, f, &, z
H Check the writing angle if your letters look wrong
i too steep
ii too flat
iii correct
Turn the page upside down to check your rhythm.

even seven ever even practice italic
München Köln Paris Amsterdam Roma

a b c d e f g h i j k l m

n o p q r s t u v w x y z

A B C D E F G H I J K L M

N O P Q R S T U V W X Y Z

Task
Italic handwriting
Using two sheets of paper, rule out a diary page for one week. Write down each day's events for one week in your best writing. You can use other styles for the month and the days of the week. Use your fountain pen for the Italic handwriting.

Task
Exercises
Use guidelines 2/5in (10mm) apart as writing lines under a sheet of layout paper and, with a fountain pen, play for a while with the exercises before going on to the alphabet itself.

Task
Fountain pen or felt-tip
If you're struggling a little, use a chisel-ended felt-tip pen first and do the exercises again. Then write out a "a quick brown fox jumps over the lazy dog." If you're happy with your efforts, write it out using a fountain pen and remember to put the date on.

a quick brown fox jumps
over the lazy dog

Review

These basic hands or styles are sufficient to be able to make finished pieces. You now need some technical skills which work together to give your writing a sense of organization and presentation. If ever you have a few moments to spare do some pen play. Go through your quotations notebook and write out a favorite quotation.

The Ramsay Psalter
This is the manuscript on which Edward Johnston based the Foundational hand (*below*). It is a Carolingian manuscript written in Winchester, England during the 10th century.

Trajan's Column
These majestic Roman capitals (*below*) were cut in Rome in the year AD114. They were first formed with a brush and then chiselled out of the stone.

Task
Optical illusion
If you measure the height of the letters on different lines of this example you will see that they decrease in size towards the bottom. This creates the optical illusion that all the letters are the same height when viewed from the ground. The Roman lettercutters used accurate measurement combined with subtleties like this. You too must be accurate and learn to trust your eye.

Practice line

Right, this student writes well but still needs to watch for some bad habits. Exercises like this are worth doing before you begin a proper piece of work because they help to get your hand and eye coordinated.

1 Angle too steep
2 Too rigid
3 Rigid
4 All too sharp
5 Narrow letter
6 Leaning back
7 A bit better
8 Short tail
9 Weak middle stroke

Task
Comparison

Write out a piece once in Foundational hand and once in Italic hand. Compare the two pieces.

Task
Your handwriting

Practice your handwriting for 20 minutes of each day for one week. Compare writing done on day one to writing done on day seven and see if a rhythm is developing.

Rhythm

Right, an extract from a letter to Michelangelo from his father. If you turn this upside down you will see that a few of the angles are not quite right.

Task
Review

Open your folder and take out all the signed and dated work you have done so far and pin it on the wall. Go round looking at this exhibition and examine the evidence of your learning. Be critical, and see how far you have progressed. Put away all the work except your best piece. Leave this on display until you know you can do better, then put it back in the folder.

an bn cn dn en fn gn hn in jn kn l n m

non pn qn rn sn t

nun vn wn xn yn z

Above all things,
take care of your head and
keep it moderately warm,
and see that you never wash:
have yourself rubbed down
but do not wash

keep it moderately

Chapter 3

Practice only teaches you to practise.
EDWARD JOHNSTON

The nature of any mark you make depends on the tool you use. Pens are most important; basically they need to be sharp and clean. A soft cloth is essential for periodically wiping your nib clean as you work. Ink and paint can build up between the nib and the reservoir very easily. Any build-up will interfere with ink flow and your letters become blobby and lose definition. New steel nibs may well be scratchy and need attention, but become smoother through use. Shown opposite is a useful technique for improving your nibs. (Left-handers may also find this a useful tip, adding a little to the oblique angle for ease of writing.) In completing one finished piece of calligraphy you will find yourself using several of your mark-making tools. Always make a note of your nib sizes that you've used.

Task
Make a pen
Pens can be simply made using lolly pop sticks, clothes pegs or pieces of balsa wood. Glue a piece of felt around a piece of balsa wood and grip them with a bulldog clip. This creates a wide pen which is very useful for display work. Patterns can be cut into the "nib" to make decorative marks.

TECHNIQUES

This chapter is concerned with the various technical skills you will need in order to do the projects in the last chapter of this section of the book. Designing a piece of work, developing the color scheme, pasting it up and possibly experimenting with changing the weight, style or size of the letters, are all familiar tasks to the graphic designer. Here they are all presented with clear instructions, presuming you know nothing about such technicalities! Read through the whole chapter first to familiarize yourself with the techniques. As you work through the tasks from this chapter, don't forget to continue practicing your calligraphy, that's important too!

Instructions for sharpening a steel nib

Use a fine oil stone, or if you don't have one, buy some very fine quality wet and dry abrasive paper from a hardware store. Tear off a strip of the paper and tape it down to a firm base such as a piece of wood or a corner of a work surface. Keep your nib in its holder, turn it upside down and pull the nib across the abrasive surface four or five times using firm pressure (**A**). This creates a burr on the tip which is easily removed by turning the nib back over, steepening the angle and, using a firm stroke, pulling the nib over the abrasive surface one more time (**B**). Test the result and repeat the process if necessary.

Task
Magnifying the problem
Use a small magnifying glass to check the writing tips of your steel nibs. Sometimes, too much pressure from a reservoir will force the slit open and this must be rectified by adjusting the reservoir.

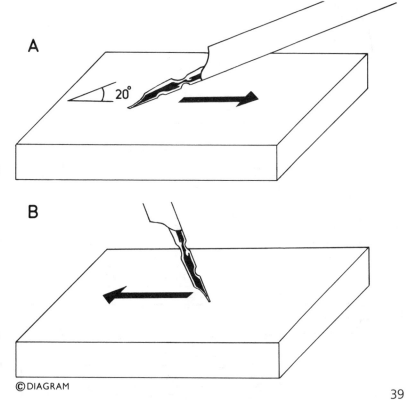

© DIAGRAM

Using templates

A template is a design aid. It is a basic pattern which helps you to make accurate repeats of the same shape. By using such devices you can save a great deal of time and reduce the risk of inaccuracy. Here you are shown four different types of templates, three of which you can make yourself. Once you have drawn them out make several copies by tracing them off or by using a photocopier. Some copiers have an enlarging and reducing facility which can be used to make copies at a variety of sizes. This way you can create a flexible range of templates which will be to hand whenever you need them. Practical aids such as these are not "cheating." Instead, they allow you to make more efficient use of your time and achieve better results, and as such they are invaluable.

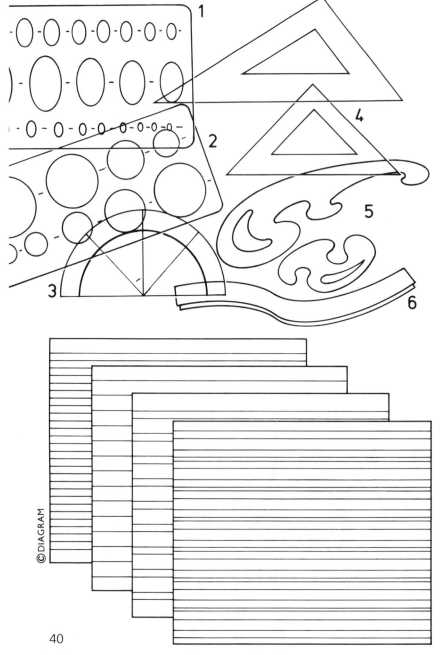

Plastic templates
These can help when drawing both regular and free flowing curves. They can be bought from art shops. They are useful, but beware, they are sometimes expensive, so only buy ones you know you will use!
1 Ellipses
2 Circles
3 Protractor for angles and arcs
4 Triangles (set squares)
5 French curves
6 A flexicurve, plastic coated wire which will bend to any shape you wish.

Writing lines
These can be very useful if you draw them to the correct sizes for your nibs. Don't forget that you can also use them to measure space between areas of writing. You can also make up one for page layouts, leaving margins and space for illustrations.

Task
Line templates
Make a complete set of writing lines, one for each of your nib sizes, using a photocopier to enlarge and reduce the pages at the end of the book.

Task
Layout templates
Using a shape template or a paper rule, practice your Foundational hand by writing out a rhyme or poem with several stanzas. Date this piece.

©DIAGRAM

40

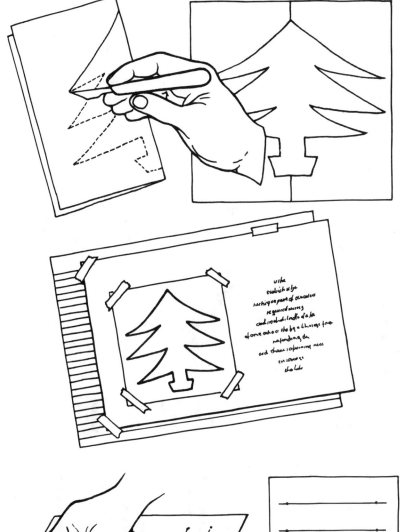

Cutting a silhouette

A silhouette template, cut from a piece of card, can be used to great effect. Using a line template along with a shape template can help a great deal when doing "production line" projects such as Christmas cards.

Task

Envelopes

Make a line template which fits inside your envelopes and practice your Italic handwriting using friends' addresses. Experiment with different layouts.

Pricking through and making a paper rule

Careful examination of old manuscripts will reveal that this method has been in use for centuries! It saved the scribes' time and ensured that all the pages of a book matched. When you have successfully completed one piece of work you can use it as a "master" by pricking through where each line starts so that the prick marks show on the pages underneath. The tiny holes can be hidden afterward by rubbing gently on the back of the paper with a fingernail. Alternatively, you can make a "ruler" from a piece of card and mark off the starting point of each line. This can then be transferred to copies and used as a guide when ruling up. Both of these methods help to eliminate inaccuracies.

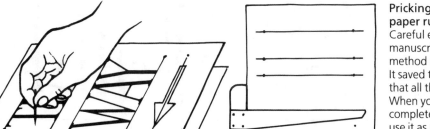

Spacing words and lines

When a typesetter finds that a line is too long he can adjust the letter spacing so that the words are more spread out or closer together. Calligraphers use other devices, including changing the letter size, overlapping letters, sharing stems, and placing letters within each other. These are all traditional options which add charm and individuality to a piece of work. You can follow in this tradition. What you have to remember is to reduce your nib size so that the smaller words have a pleasing proportion and match the rest of the text.

Letterfitting
In many ancient manuscripts, small letters were fitted inside or alongside larger ones. This was sometimes done to fill up the large counters (see page 18) of letters like L and C. Looping letters together was another way of squeezing them into a smaller space.

Task
Abbreviations
Find a piece of text and write it out in capitals. See how much you can shorten it by using abbreviations, stacking letters and writing with a smaller pen. Use the examples (*right*) to guide you.

Linespacing
Generally, a distance of twice the x-height between the lines of writing will guarantee that ascenders and descenders from one line will not touch the ascenders and descenders of the lines above and below it.
On regularly ruled paper or guidelines this will simply mean using every third line as your writing line, the one above acting as the guideline for the x-heights of the letters. Increase this standard linespacing when using flourishes, swashes, decorated letters or styles such as Carolingian, which has elongated ascenders and descenders.

Spacing capitals

Space between rows of capitals can be reduced. When using capitals to issue a short instruction or message it is the space around the letters which must be maintained.

1 A clear statement
2 Shouting at the reader!
3 Wrong, because the reader "reads" the space in the middle

Letter and word spacing

Letterspacing will depend on what style you are using. For example, Foundational and Italic minuscules, which are "open" and rich in curves, will need more space than a Gothic hand, in which nearly all the letters have straight sides.

In general, allow only enough space for the word to flow, and remember that the space between any two letters should be governed by their shape and not by strict rules of maintaining a set distance between them (see page 20). Large headings written in capitals can be very effective.

Between words you need only allow space equivalent to a letter n. Any more, and you may find that, on half closing your eyes, "rivers" of space run down between words.

This example (*right*) is as much about space as the letters. The layout draws your eye down the page to the conclusion of the quotation. It would not work so well if space were lost above the letters. Do not be tempted to crop work and deprive it of essential space. (Dostoyevsky quotation by Lindsay Castell.)

Task

Lettering practice
Write out a poem in Italic three times using a different nib size each time. Measure the dimensions and see how they vary.

Task

Within limits
Find a quotation, a prayer or a philosophical thought and, using capitals only, change the sizes of the letters. Work within a frame of 1½in x 6in (40mm x 150mm) as if it was to be used as a bookmark.

1 WE ARE CLOSED
2 WE ARE CLOSED
3 WE ARE CLOSED

thenquicknbrown foxnjumpsnover thenlazyndog

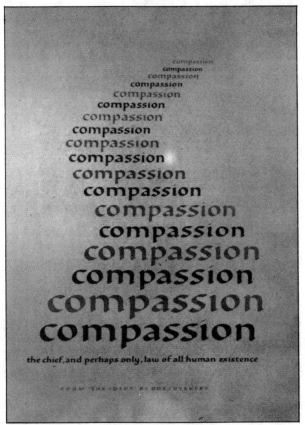

compassion
compassion
compassion
compassion
compassion
compassion
compassion
compassion
compassion
compassion
compassion
compassion
compassion
compassion
compassion
compassion
compassion

the chief, and perhaps only, law of all human existence

FROM 'THE IDIOT' BY DOSTOYEVSKY

Centering

Centering lines of lettering will immediately make a piece of work look much more professional. The effort you have to make is well worth it. With details of a menu or an invitation there is a strong tradition of centering, so for demonstration purposes we show a menu in Italic, although you could equally well use Foundational. Centering can be used for poems, posters, cards or page layout.

It is very flexible as it works well with plain letters or with flourishes and illustrations. You should aim for symmetry, both of content and space, so experiment by moving lines closer together or further apart. Write out some variations, maybe using capitals for emphasis, and play with different nib sizes before you make your final decision.

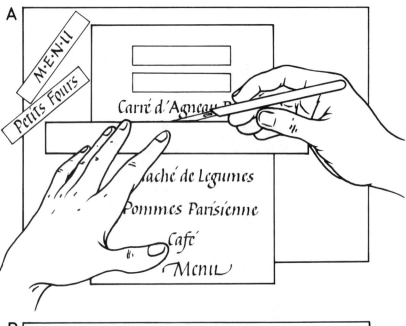

Procedure
1 Write out individual lines of writing with some variation in nib size.
2 Cut out the lines just above ascenders and just below descenders. You can cut close to your capitals (**A**).
3 Place a line template with a vertical line drawn through the center under a sheet of layout paper. Tape them at the corners.
4 Measure out each line of letters and mark the half-way point with a dot.
5 Lay the lines of writing out in the correct order with the center marks over the vertical line on your template (**B**).
6 Begin to experiment with the various options. Move lines closer together and further apart. Imagine that, instead of a series of labels, you are looking at one piece of work. Try to ignore the edges of the labels. Squinting through your eyelashes helps a little! It may be necessary to rewrite some words.

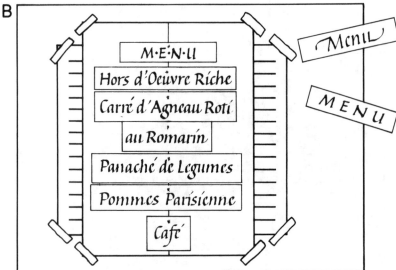

Task
Experiment 1: Text
Try this method by cutting up a nursery rhyme written in Italic or Foundational. Is there one line or a heading which will need more emphasis? Write in large letters on 11 × 14in (A3) layout paper and store this.

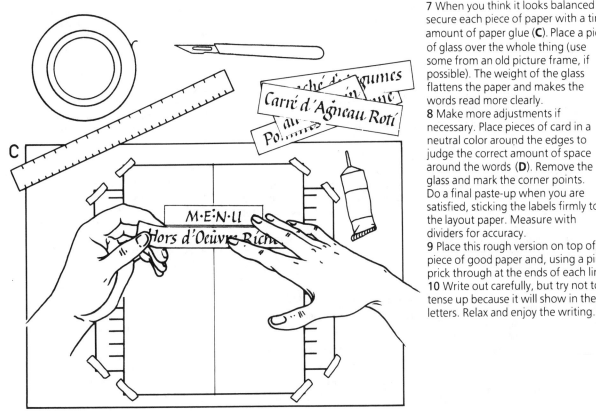

7 When you think it looks balanced secure each piece of paper with a tiny amount of paper glue (**C**). Place a piece of glass over the whole thing (use some from an old picture frame, if possible). The weight of the glass flattens the paper and makes the words read more clearly.

8 Make more adjustments if necessary. Place pieces of card in a neutral color around the edges to judge the correct amount of space around the words (**D**). Remove the glass and mark the corner points. Do a final paste-up when you are satisfied, sticking the labels firmly to the layout paper. Measure with dividers for accuracy.

9 Place this rough version on top of a piece of good paper and, using a pin, prick through at the ends of each line.

10 Write out carefully, but try not to tense up because it will show in the letters. Relax and enjoy the writing.

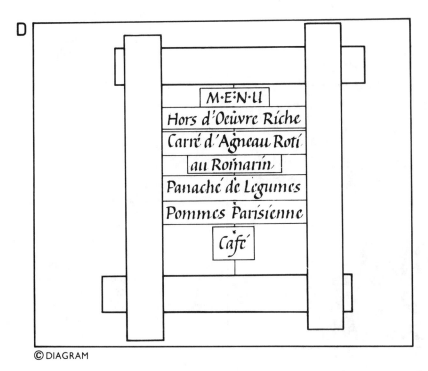

Task

Experiment 2: Poster

Imagine you have a poster to do. You will need an event, date, time, venue, prices etc. Use a variety of letters: all capitals; all minuscules; a mixture of the two; some heavyweight; some lightweight. Use an Automatic or Coit pen if possible. Center the words and juggle with space around them. Use 11 × 14in (A3) paper as this is a good size. Take it as far as the paste-up stage and store safely for reference.

Task

Experiment 3: Invitation

Imagine a family event such as a baptism, a wedding or a Bar Mitzvah. Using Italic, center the design and add flourishes to the top and bottom lines. Work to the paste up stage and store safely for reference.

Layout

Designing is decision making! Calligraphers, like actors, are interpreters of someone else's words. Therefore, it is important to read through anything before you write it out so that you can pick out the subtleties, humor, pathos, energy or any other human emotion which may lie within it. Remember, whatever is being expressed, it must be done so LEGIBLY. Your main objective is to render clearly your understanding of the author's words.

Where do you start designing?

1 Start with the words and decide which style to write in. Then look at line length. The meaning of the text should not be lost by breaking up lines in inappropriate places.
2 Consider the arrangement of the lines. Are they already in stanzas or paragraphs? Let the words speak for themselves; don't attempt a fancy arrangement for its own sake, even though it can be tempting. Consider overall size, taking into account where the work is to be positioned.
3 Consider whether color will add to the meaning of the words. Can it be used to convey your interpretation of the words? Are there any restrictions or obligations regarding color as far as the recipient is concerned (if the work is to be a present)? Using colored, textured or tinted paper should also be considered at this stage.
4 Will you need to divide up the text, use a translation or give any additional information? Would using more than one size of pen or using small capitals help with this?
5 Is there a logo, a heraldic shield, a flag or an illustration to go with the text? Sometimes a simple pen drawing, or a watercolor sketch, goes well with calligraphy. Don't try to be an artist though!
6 Don't be rushed into settling for the first ideas you have. Although they are often good you must explore other variations and possibly reject them, as part of the design process. Do several rough sketches of the layout at an early stage and discuss them with other people if that will help you. Criticism can be hard to take later on if you have written the whole thing out, but inviting constructive comment BEFORE writing means that you can incorporate other ideas if they're good ones. Alternatively, put your designs up on a door or a wall for a day or so and keep looking at them. As you become more objective your value judgements are less impaired and you can become your own best critic!

Alignment

There are five basic ways of aligning text:

A Justified; both the right and the left hand edges form a straight line
B Ranged left or flush left; the left hand side forms a straight line
C Ranged right or flush right; the right hand side forms a straight line
D Centered; the lines are uneven in length – but the layout is symmetrical
E Asymmetric; the lines are not aligned and are freely positioned

A

B

C

D

E

Interesting layouts

Refer to historical manuscripts and various cultural sources when considering layouts. Below, some of the many variations:

1 Use space to focus attention onto the letters. This device is frequently used in Eastern art.

2 If you have a large text, try splitting it into two columns. Bibles and some secular manuscripts were often done this way.

3 Embellish the opening of your text with large words. This was often done in Bibles and manuscript books.

4 Stagger the work quite freely. This would be appropriate for a humorous quotation or a lyrical rhyme.

5 and **6** Use geometric shapes to give structure and add to the image.

Alternative layouts

If you have just one large word, name or sentence to letter on a page, this can be your chance to do some really dramatic calligraphy *(left)*.

Task
Headings

These can be varied in weight and in so doing you will alter the whole balance of a piece. Write out a nursery rhyme in Foundational. Above it draw lines ½in (10-15mm) apart as your writing line and x-height. Write the title with three different nibs keeping the same height. Compare the results.

Task
Balance

Experiment with various nibs and pens by writing headings between a pair of lines and then fitting the different results to some 4 or 5 lines of writing. Can you achieve a balance between heading and text?

True
ease in
writing comes
from art, not chance,
As those move easiest
who have learn'd
to dance

Alexander Pope

Pasting up

As its name implies, a paste-up is a design rough, in which the different elements of the design are stuck down in their correct positions on one background sheet. It may be black and white or colored, and should include everything you want to appear on the final version, including text and illustrations, if there are any. The ability to produce a good paste-up is very useful, and takes a certain amount of practice, so do not worry if your early attempts are rather rough.

There are three basic reasons for doing a paste-up. First, as a reference for yourself during the production of a piece of work. Second, you might use one as a visual, that is, as a way of showing how the final piece of work will look to yourself or another person. Finally, a paste-up is also the last stage of a piece of work before going to press, if the work is to be printed.

Task
Experimentation
Cut up some spare pieces of writing you may have into lines and paste them down onto a clean sheet creating a variety of different layouts with the same words. Using paste-up in this way is a simple method of experimenting with layout.

Task
Reproducing work
Choose a favorite piece of prose, write it out in either Italic or Foundational hand, cut it up and make a paste-up of it creating an interesting layout. Transfer the measurements and sizes from the paste-up to a clean sheet and write out the new design. Repeat this last stage again and see how similar the two finished pieces appear. Store the paste-up and repeat the process again in a month's time.

Task
Trial run
Paste up a sample card using a motif and a simple message. Take it to a photocopying shop and have several copies made.

1 Paste-ups for reference
Producing a paste-up is a way of seeing whether your design will work before you actually settle down to do your best copy. By writing out all the text at the intended size and with the intended nib, and producing illustrations if necessary, you can judge whether you need to make any adjustments. When you have decided on your final design you can transfer the sizes and shapes to a good copy by a number of processes:
● Pricking through (1) involves laying the paste-up over a piece of paper and pricking the paper with a pin or other sharp point to mark where each line appears. By doing this you can make a number of copies identical.
● An alternative method is to use dividers (2) to transfer measurements from the paste up to the 'good' copy.
● You can also make a measuring ruler (3) to transfer the measurements. This consists of a piece of card which is held against the paste-up and on which the positions of the lines are ticked off. The "ruler" is then held against the new copy and these positions are transferred. Remember to keep a record of the nib sizes and colors used.

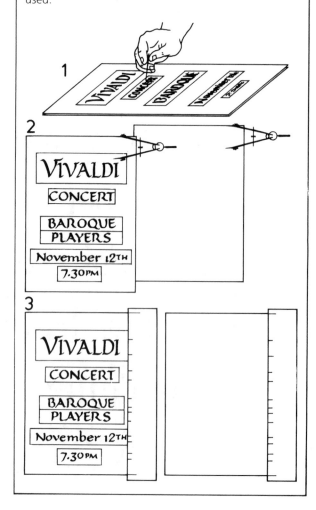

2 Paste-ups for consideration

A paste-up can be used as a "visual", that is, a representation of the way the finished piece of work will appear. If you have several possible designs and cannot decide which to use, or if you want to try the same design with a variety of color combinations, then make a paste-up of each. Put them all side by side and seek a friend's advice (or a client's opinion, if you have been asked to do the work for someone else) so that the designs which do not work are eliminated at this stage.

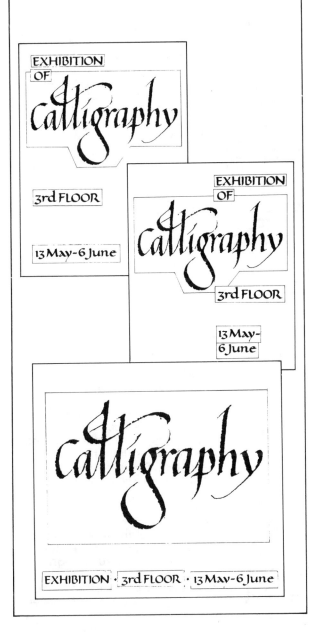

3 Paste-ups for printing

If you have a large print run, you may decide to use the services of a professional printer. If your print run is small, however, you may find that a photocopying shop can work out cheaper. Either way you will need to produce a neat, clean, accurate paste-up. Use thick paper or board as the base for the paste-up, and protect the paste-up with a piece of tracing paper fixed over the top with tape down one side (an overlay). Use typewriter correction fluid around the edges of your pasted down paper, otherwise you may get shadows. Test this by photocopying the paste-up.

Preparing work for printing in more than one color is a slightly more complex procedure. The most common way of doing this is by separating the paste-up onto overlays, each overlay printing a different color. A baseboard is used – usually thick card or board for the "majority" color – usually black – and the additional pieces to print in color are pasted onto transparent plastic film, hinged to one side with tape, and in register with each other (see illustration *below*).

Baseboard: 1st color
Overlay 1: 2nd color
Overlay 2: 3rd color

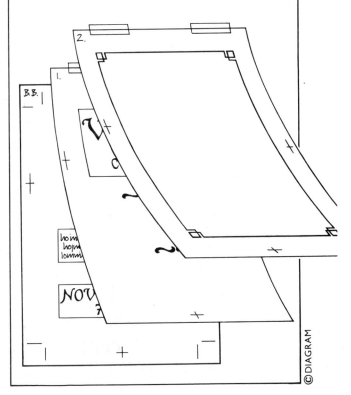

Using color

There is one simple rule which must always be followed when mixing paint – add the water to the paint, not vice versa. This rule applies regardless of whether you use tubes, jars or cakes of paint. You might find it useful to keep colors such as vermilion and white in screw top jars, just as ink is. This might encourage you to use them more. If you dilute some black fountain pen inks in the proportion of one part ink to three parts water you will get a gentle grey blue tint which is very subtle and effective. Reducing the length of the handle on your brushes can prevent accidents with paint and securing palettes and ink pots with Blu Tak also helps. Use the brush as a measure for the paint and dilute with drops of distilled water from a dropper bottle. A couple of smears of egg yolk in vermilion will make the color more vibrant and add permanency. When working on a long piece of work you must remember to add water to the paint as it will evaporate and will not flow through the nib well. Aim for a milky consistency when mixing paint whether you're writing with a pen or simply flooding in an area with a fine sable brush.

Traditional use of color
Headings and the initial letters of a stanza or verse are often red. Vermilion and spectrum red are strong colors which contrast dramatically when used along with traditional black ink. Red gives warmth to your work and claims attention, so use it on names, initials and anywhere that you want emphasis.
A These initials would look arresting in red with black text.
B The warmth of red contrasts well with the cool effect of blue and green. Alternating these three colors down a page in the traditional manner produces a balanced effect.

Task
Red and black
Write a poem or a piece of text in Italic using black ink and add a vermilion heading either in capitals alone or in majuscules and minuscules together.

Task
One, two, buckle my shoe
Find a piece of text which is like a list (for example, a counting rhyme). Write it out using alternating colors in the following sequence: red, blue, red, green and so on. Develop this into a finished piece and date it.

Task
A card for a friend
Write out a birthday or Christmas card to a friend with alternating green and blue words, and give it to that person on the date. You can also produce interesting effects if you use a textured paper.

Some newer ways of using color
Instructions

1 Choose a large nib and rule up a line template with gaps alternating from ⅖in (10mm) to 1/10in (2mm) as shown.

2 Put the template under a sheet of layout paper or a lightweight paper.

3 Using either green or blue ink, mix 3 bowls of tint: one watery (bowl 1), one stronger than this but still diluted (bowl 2), and one undiluted (bowl 3).

4 Choose a single word which has both an ascender and a descender and write it repeatedly in the ⅖in (10mm) space (this distance being the full x-height of the letters). Load your pen from the bowls in sequence 1,2,1,3,1,2,1,3,1 and so on to achieve a subtle effect.

5 Stagger the starting points of the lines and do not give the ascender its serif or the descender its final stroke.

6 Do not worry about the overlapping of letters, this is part of the effect of using watery tints.

Splattering
This can be a very effective way of decorating a humorous quotation. Use a diffuser containing waterproof ink or a watery mixture of paint. Fix the paper in a vertical position while you're working on it, but lay it flat to dry. Keep the angle of the diffuser at 90°. Don't overspray or the ink will run. Purse your lips tightly and blow long and hard. This technique can also be used to apply art fixative if you dislike using aerosols. Diffusers are readily available from art shops.

Task
Splattering
Write out a humorous quotation and splatter some bright color over it. Try several versions of this simple idea and display the most successful ones.

©DIAGRAM

Problems

There are numerous problems that can arise when learning calligraphy. These two pages show the possible solutions to the most likely ones.

The stroke not sharp on the paper
Your forefinger or thumb is pressing too hard and you're not placing the nib squarely to the paper. The nib may need attention. Try a few pulling strokes on very fine sandpaper. Finish off with a sideways stroke once each way.

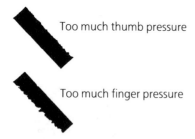

Too much thumb pressure

Too much finger pressure

Trouble with ink blobbing
Did you degrease the nib and the reservoir before writing? Either lick them or pass them through a flame to degrease. Your pen angle or the angle of the drawing board might need adjusting. Remember that the angle of the pen to the paper should be 90°.

The ink won't flow
This could be due to a number of causes: rusty nib and reservoir, dirty and blocked-up nib, stale ink that needs a few drops of distilled water, paint too thick, reservoir too tight and distorting nib, angle of pen to paper too low.

The ink 'bleeds' on the paper
Change ink or paper. Try protecting the surface with a brand solution bought from an art stockist.

The writing hand aches
You're trying too hard. RELAX. Take some refreshment, put on some soothing music and try some pen play.

The color smudges
Spray finished work with fixative (or even hairspray). Add a couple of drops of pure egg yolk (no white!) to the color – too much leads to cracking later.

Back, shoulders, and knees ache
Too tense – your writing will show this tension. Check height of table, chair and writing area.

The new nib scratches
A few pulling strokes on very fine sandpaper should help. Don't be tempted to press harder. After half an hour it should be eased for you.

The letters look careless
You are using the pen like a paintbrush! Instead, use it precisely, as you would a screwdriver or a chisel and try to be more precise about starting and finishing strokes.

The letters look childlike and stiff
You're trying too hard! Check your knowledge of stroke order before you start a letter. Don't read from the book stroke by stroke.

Double letters look clumsy
Remember to create them as a pair although this doesn't necessarily mean making them both identical. You could add a swash or flourish to one of the pair.

bubble

bubble

bubble

bubble

little

Certain letters always look wrong
Trace from the book the correct shape and try to *feel* what it is like to make that shape, then try again. Practice words with those problem letters with a dry pen, don't avoid them. Never do a long row of them, construct words instead, and check the stroke order with the book. Also, check your writing angle.

The letters look odd
Check with the skeleton alphabet. Are the proportions of your letters correct? Is your pen at the wrong angle? Thick and thin strokes show up this fault very clearly. Are you changing the angle?

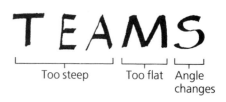

Too steep Too flat Angle changes

The letters change size
Rule a top line for a while, either an x-height or capital height, so that you get used to the size. Practice capital letters in a short quotation.

The letters lean backward
Check your sitting position. Are your legs crossed? Is the paper in front of you, or a little to one side? This is a common occurrence with left-hand writing.

The descender of line A hits the ascender of line B
Reduce your descenders by a fraction, or leave off the last stroke, and only add it when the next line is written and space for it is there. Alternatively, leave a fraction more space between lines.

Double ascenders and descenders look odd
Play with the word and find an acceptable pattern and shape for the word. If in any doubt keep it simple.

The letters don't look even

Add some upright or angled lines to the practice sheet lines and let them guide your eye to establish an even look. It will come with practice.

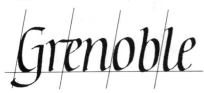

The poem needs illustration and you don't draw

Use dried flowers or cut out silhouettes, use designs from designers' reference books and don't attempt to be original. Ask an artistic friend to paint or draw an illustration to accompany your calligraphy. Several famous scribes have worked in this way.

Your poem is very long or would make an oddly-shaped piece

Divide it up into sections and place a section at a time on each page of a hand-made booklet or a long piece of card folded into a concertina.
You could also split it into two and arrange it like the double-spread of an open book.

The poem looks lop-sided; straight on the left hand side and very uneven lengths of line on the right hand side.

Stagger the right hand side using two margins and try indenting, or push out the first initial to lose the power of the straight left hand side. Keep plenty of space around the work so that the frame line does not echo the left hand side straight edge.

The poster looks too busy

Edit the information whenever possible, then write out everything. Take it to a photocopier to reduce it down in size and do a paste-up. Work to create space. Try very small capitals for details in tight rows and large minuscules for the main caption.

There's a lot to write and you're afraid you'll make a mistake

Divide up the project and tackle it bit by bit. Do the hardest thing first (letter cutters do). Sometimes ruling-up a second piece of paper ready to do a second attempt will help you to relax. Don't leave work until the last minute – rushing is fatal.

It's difficult to find time to practice

Make time. Try doodling with felt pens and a sketch pad whenever there's a moment. Put on some music and allow yourself just half an hour. Stop trying to find a free day – they're very rare!

Task
Double letters

Practice your Italic with a string of words, all of which contain double letters. Write each word twice; the second version should be an improvement on the first.

Task
Pen play

Play with a nib size or a pen which you don't like much in order to get the feel of it. If the nib is too rough throw it away. Check the writing angle and do some designs and doodling.

Task
No ideas?

It is important to have sources for your work. Collect postcards from museums and shops, old greetings cards, advertisements, packaging etc. Organize some files and boxes and start a collection. Use a filing system if possible.

Task
New material

If you are practicing your calligraphy it is important to have texts that interest you, so collect quotations and poems. Reread some poems you have not read for some time. Try out a few new poets and look into works of philosophy. Second hand bookshops are good hunting grounds.

Review

In this chapter we have considered techniques which you will need to know before you start some project work. Color schemes, layouts and paste-ups should now be familiar phrases to you. If you've experimented with these techniques by following the tasks you will be confident about starting projects. Techniques vary from person to person, and you will gradually develop your own way of working.

Alphabet in a circle
John Weber designed this logotype, intended for personal stationery, using both pen marks and letters. Half close your eyes and you will see how well the black marks balance with the white space between them. This is an idea you could use to create interesting designs. Draw a variety of open shapes lightly in pencil and fill in using both large and small nibs.

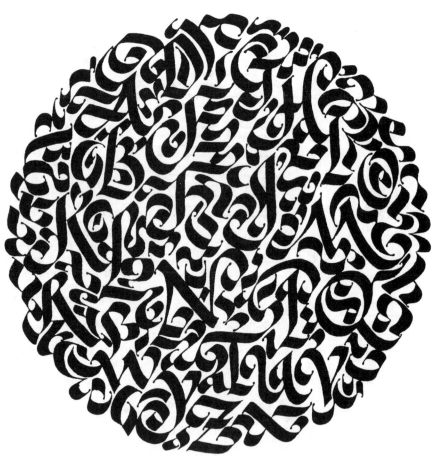

Task
Dramatic impact
Choose one word and letter it in various sizes, using various pens and nibs. Cut out the words and paste them down onto sheets of paper in dramatic positions. Consider several designs and gradually eliminate all but one. Store it safely for reference.

Task
Review
Get out all the work you have done so far. See how much you have learned and how much better your work is than at the beginning.

Task
Edge markers
Cut four long pieces of card with one side a light color, the other dark. These can be used as an adjustable frame to work out edges in project work. See page 45.

C H O R U S

IN AN OLD HOUSE there is always listening, and more is heard than is spoken.

And what is spoken remains in the room, waiting for the future to hear it.

And whatever happens began in the past, and presses hard on the future.

The agony in the curtained bedroom, whether of birth or of dying,

Gathers in to itself all the voices of the past, and projects them into the future.

The treble voices on the lawn

 The mowing of hay in summer

The dogs and the old pony

 The stumble and the wail of little pain

The chopping of wood in autumn

 And the singing in the kitchen

And the steps at night in the corridor

 The moment of sudden loathing

And the season of stifled sorrow

 The whisper, the transparent deception

The keeping up of appearances

 The making the best of a bad job

All twined and tangled together, all are recorded.

There is no avoiding these things

 And we know nothing of exorcism

And whether in Argos or England

 There are certain inflexible laws

Unalterable, in the nature of music.

There is nothing at all to be done about it,

 There is nothing to do about anything,

And now it is nearly time for the news

We must listen to the weather report

And the international catastrophes.

from "THE FAMILY REUNION" by T.S.Eliot OM

Layout technique

Here the scribe John Woodcock has used Italic and Foundational together. In the opening paragraph he has used the traditional technique of extending the initial letter and continuing to use majuscules for the opening phrase. Balance has been achieved with the Foundational hand by alternating between two left hand margins (staggering; see page 53). Notice the interlinear space which enables the reader to see the rhythm of the language. At the bottom you can see a colophon. This balances the whole piece and also serves to tell the reader where the text comes from and who the author is. It is common courtesy for a scribe to do this at the end of a piece. Modern calligraphers sometimes add their own initials and the Latin word "scripsit," meaning "I wrote it." If a piece of work is written for someone in particular, the recipient's initials can also be added at this point.

Task
Staggered margins
Find a piece of text at least 14 lines long. Write it out once with a straight left hand margin. Photocopy it and paste it up using a staggered margin. Compare the two layouts.

Task
Balanced headings
With the text you used for the previous task, create four different headings using majuscules, color, bold letters and decoration. Put each heading in turn against the piece of text and see which ones work best. Repeat this using the staggered version. Does one heading suit both, or do they have different effects?

©DIAGRAM

55

Chapter 4

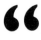 *I doubt if any (art) is so generally fitted for the purpose of educating the hand, the eye and the mind as this one of writing.*
W R LETHABY

It's very important when you complete a project to leave enough space around it. You might need it to be trimmed before framing, but you won't make this decision till later. An experienced frame maker will discuss with you the suitable types of frame. You can also choose from a selection of card what mount to use. It's quite usual for the mount to echo one of the colors in the artwork. Delicate calligraphy does not need an elaborate frame. These finishing touches are best made in consultation with others; an objective viewpoint is very valuable in this situation.

The power of letters
This lively version of the Italic hand by Peter Thornton celebrates the joy of lettering and proves that you need no greater text than the alphabet itself. Try to avoid writing silly trite quotations, but, on the other hand, don't be over ambitious with early project work. Do not copy other scribes' interpretations of texts. Develop your own versions and don't be surprised if you find you have several ideas for the same text.

Task
Project folder
Buy two large pieces of strong card and heavy adhesive tape. Place both pieces of card on the floor leaving a ¾in (20mm) gap between their long edges. Join them together with the carpet tape. Put tape all around the edges of the card, leaving one long edge open. This is now a safe place to keep all your project work.

Task
Restock
Replace any paper supplies, inks or nibs you need. Throw out rusty or awkward nibs. Buy a new craft (X-Acto) knife or blade, if you need one. Replace tired felt tip pens and make sure your quotation book is being used.

Task
Resource box
Find a box and start to collect samples of lettering from magazines and newspapers. This will be useful later when you're looking for inspiration.

PROJECTS

In this section of the book are eight projects, two of which involve print, all of which can be successfully completed by someone who still refers to himself as a beginner. Finishing a piece is part of the creative process, and until something is in the post, hanging on a wall or has been given away, it has not been completely finished. Calligraphy is to be read by others and that often only happens when the piece is completely finished.

The projects are varied, ranging from the very simple to the more challenging, so you need to be well organized. You can do these projects again and again

introducing new color schemes, alternative writing styles, and different texts to develop your calligraphic skills further. Practice your letters, continue to doodle and experiment, but from now on, work on completing projects to show to others.

Keep decorative pens for posters and projects where you are mainly celebrating the scope of the tool. When you write out poetry, philosophy, prayers and formal pieces you are almost completely involved in expressing that text. Try to keep the two apart at this stage.

Letters, these seemingly commonplace little signs, taken for granted by so many belong to the most momentous products

More powerful than all poetry, more pervasive than

A B C D E F G H

all science, more profound than all philosophy

I J K L M N O P Q R

are the letters of the alphabet,

S T U V W X Y Z

twenty-six pillars of strength upon which our culture rests.

of creative power. They are the abstract refinements of the creative imagination, full of clarity, movement and subtlety

©DIAGRAM

57

Labelling

This will give you many opportunities to use your calligraphy. Sometimes people will want your writing on something rather than their own. At other times it is more appropriate to have a calligrapher than a printer. Labelling can be used for: public notices, ex libris tickets, book marks, room name plates, conference plans, table place names, filing systems, storage in the kitchen, classroom or workplace, gift tags, drink labels, simple instructions, displays of merchandise and many other things. Take every opportunity that presents itself, and enjoy it!

The key points to consider when labelling:
● How is the label to be attached? Is it to be written on sticky paper, covered in transparent film, tied on with ribbon or string, standing by itself, hung up?
● Clarity of message
Would color be appropriate? Have you remembered to use different sizes of lettering, large for attention, small for detail? Have you left enough space around the message? Is the lettering in the appropriate style? Does the surface need protecting with fixative, sealant or a cover? Is it to be framed or mounted? Have you used the correct weight paper or card?
● Size
Always work out the size your labels need to be first. Write out the words (to less than your maximum label size) in the middle of a sheet of paper and trim afterwards, centering them, or positioning them as necessary.

Task
Book plates
Using a simple border from a reference book as a frame, write out your name, address and telephone number. Work in one quarter of a sheet so that you can photocopy four at a time. Reduce the design to six per sheet for smaller books. Stick into books using a line of paper glue along the top edge.

Zimmer frei

Jan & María

Silenzio

ABC DE FGH IJK LM NO PQ RST UV WX Y& Z

Task

Nameplate

Design a label for your possessions using a silhouette, a motif or a logo to enhance your name. Photocopy it several times at different sizes, using the same color paper. This could also be developed into a letterhead.

Producing labels (*below*)

1 Multiple copies

These can be made by pasting up four, six or eight labels onto one sheet. Write out one neat version and photocopy it several times, or write it out several times. Paste it up as shown. Add tiny black dots to mark the cutting lines (trim marks) before photocopying.

2 Individual copies

Draw guide lines in pencil on a large sheet of paper. Write each label neatly, leaving plenty of space around each one. Draw the trim marks after writing, so that each one looks centered. Leave a double space if making a stand-up card.

1

EX·LIBRIS Annabel Else	EX·LIBRIS Annabel Else
EX·LIBRIS Annabel Else	EX·LIBRIS Annabel Else
EX·LIBRIS Annabel Else	EX·LIBRIS Annabel Else
EX·LIBRIS Annabel Else	EX·LIBRIS Annabel Else

2

Pfeffer Salz Muskat

Knoblauch Oregano

Schnittlauch Thymian

©DIAGRAM

Giftwrap

This simple project combines two important aspects of calligraphy. First, the need to practice and get rhythm into your writing, and second, to progress to the stage where you can give your calligraphy away. You need an 18 × 24in (A2) layout pad, as smaller paper isn't big enough for wrapping most presents. Don't worry about buying such a large pad, because you can always cut it down if you want to work at a smaller size. Practice with the larger nibs in your collection, and with the decorative ones. An 18 × 24in (A2) paper is also a good size for working out poster designs, and for gaining confidence in using larger letters. If you do make a mistake, ignore it and continue writing, don't try to scratch it out.

Additions

To filled sheets of rhythmic writing you only need to add a dash of color and matching ribbon to get a very sophisticated effect.
- Color in the counters (the inside shape of the letter) with felt tip pens.
- Add lines of color between the writing lines.
- Add gold, silver, or multicolored stars and dots using stationery stickers.
- Add gold or silver with instant pens.
- Reduce a large design down to a small size for smaller gifts. Don't enlarge small writing as it will expose faults-whereas reduction hides them!
- Pen play designs provide an alternative to letters.

Task
Filling the page
Try to fill a whole page from edge to edge. It can be people's names, a long poem, or a stream of consciousness. Store your practice sheets and decorate when needed.

Task
Color
Build up supplies of wrapping paper by practicing Italic with a range of nibs and pens. Reduce down for small gifts. Store safely.

Task
Borders
Instead of letters, make borders based on letters. Feel free to turn the page round as you work. Fill the whole sheet with ideas. Photocopy the best ones for future reference.

Greetings cards: handmade

The one thing that a calligrapher can do with a greetings card that a printer cannot do is put the recipient's name on it. The card can be personalized by using a familiar quotation, a nickname or sharing a private joke. Calligraphy has a lot to offer here. Use the opportunity to say something personal with a handmade card and envelope. You may find that friends ask you to make cards for occasions such as 18th and 21st birthday celebrations, retirements and other occasions when congratulations are in order. These personal communications can be very enjoyable.

Task
Cards for friends
Go through your calendar and make a list of birthdays and anniversaries for which you will need cards. Store each card safely when finished. This way you can work without the pressure of a deadline.

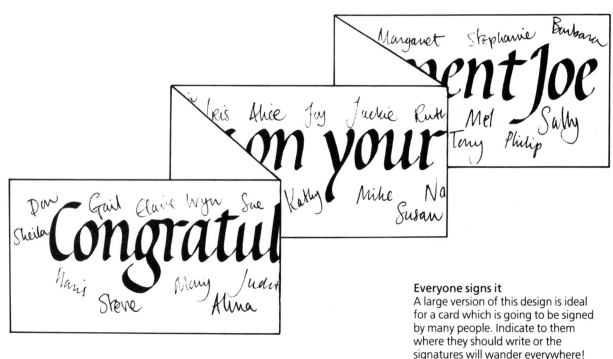

Everyone signs it
A large version of this design is ideal for a card which is going to be signed by many people. Indicate to them where they should write or the signatures will wander everywhere!

Suggested procedure

1 Use stiff thick paper or Fabriano HP paper. (This is made with 50% cotton and is quite heavy). Cut the sheet into strips, each 4in (100mm) deep. Draw writing lines along the length of each strip.

2 Make a pencil sketch of your idea on a strip of layout paper.

3 Fold the rough version of the design as in the diagram.

4 Write out your message on the card leaving 1¼in (30mm) clear space before you begin the first letter. When you have finished, trim off all but 1¼in (30mm) at the other end.

5 Measure the length of the card. Divide it into folded sections. It can be in four, six or even eight sections. Make sure that the beginning of the message is on the outside.

6 Write an envelope to match the color scheme. Use art fixative to protect the letters. Always buy a few spare commemorative stamps when they come out to use on special envelopes like this, they look much more attractive than ordinary ones! If you have a large envelope you could try using sealing wax, it would suggest that there is something special inside.

● You can make a very long card by joining two strips of card together with tape and treating the join as a fold.

Task
Trial run
Try out this formula for a greetings card BEFORE you actually need the card. Experiment with sizes, nibs, colored ink and papers. Use capitals, Italic and roundhand. Keep these as a reference for when you make a real card.

Task
Color designs
Using color, design some long cards for friends. Include dates and names where possible. Use decorative inks, nibs and flourishes. Go back to your resource box for inspiration.

Task
Matching envelopes
Practice your Italic handwriting and spend time developing stylish envelopes to go with cards you've made.

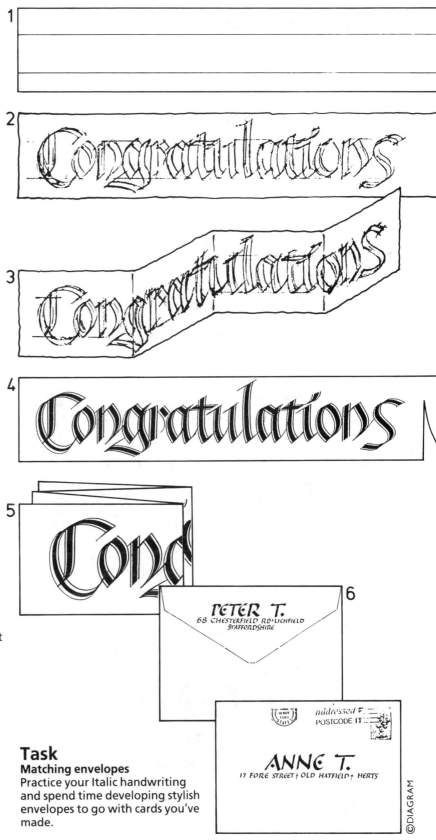

Greetings cards: printed

If you have any of your calligraphy reproduced, make sure you do it well, as multiple copies of a badly formed design or clumsy letters are hard to live with! Spend as much time as possible getting the details right, before going to the printer. On the other hand do not be discouraged from trying a small print run – it's good fun, and you can learn a great deal from it.

Design tips
There are a few points you should bear in mind as you design:
● As your design will end up being pasted together you can break it down into its elements at the beginning. This way you can concentrate on each one individually, then match them together later.
● Do a couple of photocopies of your final design before printing. This will show up any faults in positioning.
● Plan the colors at the design stage, not as an afterthought. Colors are more significant than merely brightness or contrast. Try to use the color sensitively.
● Consider if you want to use paper or card to print on. This may affect the way you do the paste-up as paper needs to be folded more than card to give it stiffness.
● Use decorative pens and interesting letterforms. Use color sparingly and refer to pages 46-47 and 62-63 before you start projects.

Task
Adding color after printing
Work out a card design and print it in black. After folding, add color by hand. Keep changing the color so that each card is an original!

Task
Matching envelopes
Print a set of cards using colored paper or card and then add other colors. This gives the effect of a multicolored print run. You can also put part of the design on the envelopes.

©DIAGRAM

64

Finishing touches
Cards can be printed in black and have finishing touches made by hand afterwards. This gives the effect of being a handmade card. Use gold and silver pens, and paint.

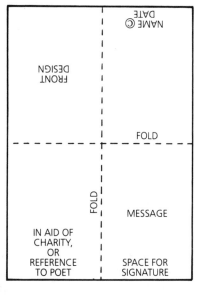

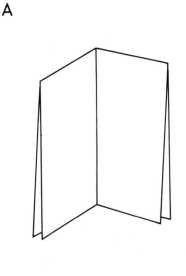

A

Paper or card?
If your design is being printed onto paper, then use it folded twice (**A**). If on card then only fold once (**B**). This way you will get one paper card per sheet with message printed inside, or two card greetings cards per sheet (the inside will be blank). Check the final size with your envelope size.

Task
Selling cards
Print a set of cards for your favorite charity, putting their name inside the cards and your name and phone number on the back. Keep two or three for reference and sell the rest.

Task
Extending the idea
Use this principle for something other than cards. Invitations, leaflets and price lists all work well. See if you can find a photocopier which uses colored inks. Use better quality paper if possible.

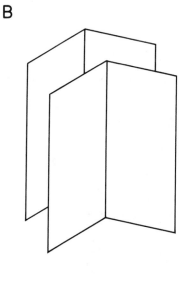

B

Copyright
You should not write out a poem or a quotation and then sell your design without checking the copyright. If you use the whole poem or piece and sell the card, then you will probably have to pay a fee. If you're not going to sell the cards, then you may not have to pay for using the words.

Special occasions

This project is as much about organization as it is about calligraphy. A wedding or similar occasion is an ideal opportunity for you to use your calligraphy – as long as you've been practicing! Printing and handwriting names combine to make this a big project, but you don't have to do it all at once. If you feel daunted by the idea of doing invitations, menus, place cards and seating plans, just think of them as centered lists or labels.

The flexibility of Italic makes it ideal for this project, and you can play with a few flourishes if you like. People are often delighted when they see their names beautifully written, and it may be the first time they've seen what design lies within it. One or two ideas are given here, but only use them as starting points. You'll find that new ideas come to you as you go along.

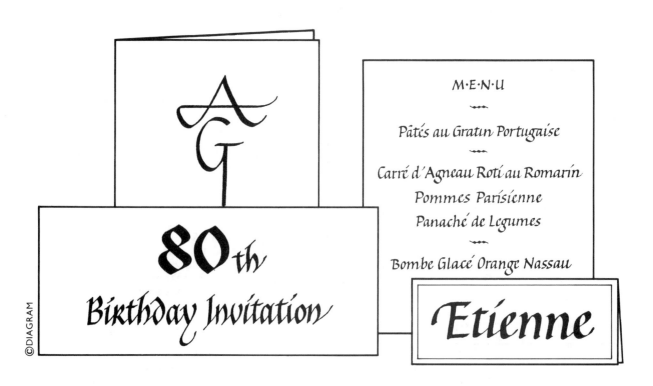

©DIAGRAM

Invitations
These are traditionally centered so you've probably already learned most of the skills needed (see pages 44-45). Use a larger nib for the name of the celebrating person or couple and leave extra space around it to help people focus on it. You might like to add a design or use a color which will link up with the occasion itself. Your printer will be able to advise you on weight of card and color effects. When you have completed your design, mount it on card to protect it. An alternative to the single sheet card is to use a paper insert, possibly in a contrasting color. If you work to a size larger than the final printed size, then bear in mind what effect the reduction process during printing will have. Generally speaking, it's a good idea to work slightly larger, but check with the printer. Remember to check the spelling carefully (ask a friend to help) and always check the details with the hosts before going to press. Ask the printer for a sample of the card so that you can try writing on it. Make sure that the pen does not snag and that the ink does not "bleed" into the card too much. Try to obtain a typed guest list to work from, to avoid mistakes. If you use paint, remember to protect the words with fixative after writing.

Menus
Menus are usually done some time after the invitations, and you may like to do them in the same style to give an impression of unity. Make sure you check the spelling with the manager of the venue. A pleasing effect can be obtained by matching color schemes, lettering or design, or adding the same motif throughout.

Placecards
The name of each guest can be written on a small stand up card. You may like to add a motif or illustration, or match the color of the ink with table decorations, flowers or linen.

~D~		
Mrs Joyce Dickenson	1	
Mr Norman Dickenson	1	
Irene Dickenson	1	
Micheal Dickenson	1	
Stephen Dickenson	1	
Mrs Joan Dickenson	2	
Mrs Mary Dickenson	2	
Mr James Darling	4	
Mrs Harriet Darling	4	
Mr Tom Davis	2	
Mrs Joanna Davis	2	
Keith Duman	4	
Sue Duman	4	

~L~		
Steve Lamer	3	
Alison Lamer	3	
Samuel Lamer	2	
Alistair Lucas	2	

~G~		
Mrs Harriet Griffen		

Preparation

When the hostess has received all the replies you can start the seating plan. The details may not be finalized until shortly before the event, but you can do some preparations beforehand to save time.

• Rule up card ready for the alphabetical guest list:

• Make place cards for all the guests who were invited and throw away any unwanted ones later.

• Design the overall layout of the plan. Write out the banner heading to draw as much attention as possible. Choose the color of the background card and a picture or photograph for the centre.

Leave details such as actual table positions until the hostess has made her final decisions on the arrangement.

The seating plan

This is done as a series of lists, one for each letter of the alphabet. They are written out on separate sheets of card and then mounted on large sheets of background card. The reason for breaking it up in this way is that if you do go wrong, it only affects a very small part of the overall plan and can easily be redone. Buy some large sheets of background card in a color which goes with the decor and the flowers etc. Rule up lines on the writing card approximately ½in (12mm) apart. Use a hard pencil and keep the lines as faint as possible. Find the longest name and write it out. This will give you the width of the lists. You will need to add space at either end of the name and also space for the table number. Start 4in (100mm) down from the top of each sheet and allow the same space again for the big initial letter. Leave same space once more between the bottom of the big letter and the first name on the list.

When you have been given the final list you can trim the cards ¾in (20mm) after the last name in each alphabetical group (don't trim until then!). When all the lists are done, lay them on the floor on top of the background card and play with the arrangement until you find one you like. Use a set square or a T square to keep them straight. When you have decided on the final layout mark the corners of each list with a pin prick and then stick down one by one. You might like to add a central image to the plan as a focus. Perhaps some initials would be appropriate for a wedding, or dates or a photo for an anniversary.

Task

Seating plan

This project involves ruling up and planning. Do a mock up of the whole plan as if for real. Find out the pitfalls before a real occasion comes up.

Designing posters

Posters are fun to do, but never underestimate how long it takes you to make a successful design; you will make several changes before you achieve a good result. If some handmade posters are required, a few short cuts are worth knowing. If your design is for print you can cut and paste to get it just right. Either way you will want to display good letterforms and use space and color to arrest people's attention. Write out the various pieces of information and play around with them until the positions look right; tape in position and ask others for their comments; make final adjustments and write out one for final approval; then mass-produce them.

Points to consider:

● Use a grid to help you align information vertically as well as horizontally. This can either be a pattern you have drawn yourself, or you can just put a piece of squared or graph paper under your sheet of layout paper so that the lines show through and act as a guide.

● Make plenty of rough thumbnail sketches of various ideas before you start to write out the calligraphy.

● Don't be afraid to edit the information and check the spellings.

● Check that the text gives all the necessary information. What? Where? When? Why? How much? Who? Try showing a rough sketch to a friend – they will have a more objective view than you, and may be able to spot errors and omissions.

● Have more paper available than you need, and be prepared to waste some experimenting with color and pen size.

● If you can't decide which of your sketches has the most potential look at them in a mirror. This enables you to judge which one arrests your attention when you are not distracted by reading.

● Work as large as possible. You can photocopy the design, reducing it for use as handbills. If you need handbills but find that your poster loses too much in the reduction process, then do a simple design at the smaller size.

● Use colors appropriately. Don't ignore the potential of black and white which can be very arresting in a busy environment.

● If you feel the poster needs some illustration, add logos, motifs and drawings. If you don't draw, look in your resource box, trace a picture or use a silhouette. Alternatively, ask an artist to help you. Children's art can work very well.

● Sometimes people will not display a large poster as they look intrusive, so several smaller ones work better. They can be used singly or in multiples.

● Posters generally need to be protected from the weather if used outdoor in public places. This can be done by spraying, covering with transparent film, or putting them into a frame.

Task
Two versions
Design a poster with one of these texts. Use a double pencil and decorate the letters. Find a silhouette or other design motif and complete the piece. Date it and redo the design after a gap of about three months. Date this later version also.

Task
Colors for reference
With your sketch pad make some rough designs using the texts here. Use felt tip pens to suggest colors. Collect a swatch of colored papers from an art shop and store safely for reference.

Task
Three colors
Use one of the texts given here to do a poster design. Make one finished copy from your final draft. Use three colors and time yourself when you make the copy.

Task
Criticizing your work
Using one of the texts shown here, design a poster using 11×14in (A3) paper. Take it to a photocopier and enlarge it to double the size of the letters. Criticize the letterforms. Redo the poster at 18×24in (A2) size and see whether the lettering gets better or worse.

Texts for poster exercises
These have all been deliberately chosen to cause you a few problems! Don't be put off, you can achieve a good result with a little effort. There are no definite rights and wrongs – only several alternative solutions to each problem.

Beckford Junior School Orchestra Spring Concert
In the School Hall Friday 3rd March at 2pm. Parents and friends welcome. Tickets 50p and 25p for children.
Refreshments will be served afterwards in the canteen.
All proceeds go to the school travel fund.

Downtown College of Further Education
Calligraphy class Monday
 2-4pm
 Tuesday
 7-9.30pm
Enrolling this week in the Main Hall 10am-6pm. Reduced fees for local residents, retired citizens and students.

Stop smoking. It damages your body. Today is no smoking day. Take a big step for humanity and stop smoking. If you smoke 20 cigarettes a day, it costs you £500 a year, so think of all the things you can do with that money. Are you capable of such a big step?

Garage Sale. Saturday 8th October 1pm-dusk
17 Stratford Rd., NW4. Proceeds to Save the Children Fund.

Producing posters

Handmade posters

If you need only one or two posters then making them by hand is the best way. Printing is economical only when quantities are needed. The major advantage of making a number of posters by hand is that they can all be slightly different, with varying colored elements or decoration, and yet still be the same basic design. There are lots of things to do which will add interest to your design:

● Make stencils and cut out motifs or individual letters from card, paper or felt. Stick them on, creating a collage effect.
● Write out your letters in outline and flood in with color, or pattern them.
● Spray, stipple and blot color on your work.
● Add rubbings and other interesting textures.
These ideas can complement your basic calligraphic designs and make each poster quite individual. The theater poster on the right is a good example of an effective black-and-white handmade poster.

Printed posters

Having posters printed offers options. Color is expensive to print, but if you use colored paper and black print, you achieve a colorful effect at minimal cost. Long print runs are cost effective and free your energies to concentrate on the design quality.

Preparing for print

Photocopying is the cheapest method of printing for a print run of up to 500 copies. The largest size most photo-copying shops have is 11 × 14in (A3). You can use black and white most effectively and add color by hand afterward. Splattering, streaking, using colored washes and sticking on colored paper are all possible ways of doing this. A black and white poster stuck on a colored background can be most effective. The real bonus of a print run is that you can reduce your lettering, motifs and logos when you are pasting up.

You need not conform to the tradition of making posters portrait shape (upright). Good lettering on a simple design will convey information clearly. It is therefore a good idea to concentrate on the quality of your lettering rather than on an over elaborate design. Refer to pages 48 and 49 for instructions on paste-ups.

Exhibition posters

These two posters solve the problem of presenting the reader with a list. In each case the answer was to use capitals closely stacked and plenty of space. A list which has a straight left hand margin (left justified) is easier to construct than one which is right justified. Centering and right justifying both need to be pasted up, whereas left justifying only needs the length of the longest line to be found. That distance is then measured in from the right-hand side, and the resulting point is where the lettering can start from.

Sizes and proportion

Work twice as large as your final design. Reducing the size minimizes unevenness in your writing. Also, you can print twice or four times as many small posters for the same price as large posters. Use the same design as the posters but reduce the size for handbills (1 large poster=4 small posters=16 leaflets or handbills, *left*). Bear in mind that many people are unwilling to display large posters, so have plenty of smaller versions to hand.

Method of working

If you have to make more than one copy of a poster your method of working should be designed to minimize time wasting. The following points are useful to remember:

● Always do plenty of preliminary roughs first, then write out your text using a variety of pens in different styles and sizes of letterforms. Make a final paste-up when you are satisfied with your design.

● When you have completed one good paste-up lay it over several sheets of the paper you are using for your poster, and prick through the positions of the writing lines and beginnings and endings of large letters. This saves a lot of time and avoids inaccuracies arising when you want all copies to match each other.

● Additional dots for your eyes only can mark the positions of letters within a word, so you avoid ending the line with too little or too much space.

● It will be upsetting to go wrong at the end of a piece of work so, rather than completing each poster in turn, the rule is to do the most difficult part of the design first (usually the eye catching lettering) on all posters you plan to do. Then you do the next most difficult part in the same way. This method means that you can abandon a bad poster at a relatively early stage. It also helps prevent getting nibs and colors mixed up.

● After completing each area of lettering, hang it up or lay it down on a flat surface to dry. If you think your ink might run, then perhaps you're using too much.

Task
Working with a grid
Choose one of the poster texts from the previous page and design a poster. Use a grid, either draw one of your own, or add vertical lines to the one on page 78.

Task
Resources
Look for logos in advertisements and refer to them when making posters. Silhouettes and pictures of buildings, plants, animals and people can all be used to complement your lettering. Keep resources like these in a box or a file. They can be traced off, photocopied, reduced or enlarged, and stuck on, either singly or in groups.

71

Poetry and prose

Writing out any text requires a certain amount of planning – a fact which may not be obvious when looking at the finished piece! Good writing needs rhythm, sharpness and a sense of freedom. You can achieve this if you plan everything BEFORE you begin your final version.

Planning a layout

1 First, consider the meaning of the poem, quotation or piece of prose. Check spelling, author and punctuation. At this stage you only have to choose between Italic and Foundational hands. Later on you may acquire more skills and have other hands to choose from. Consider what sort of size or shape you might be required to adhere to.

2 Make some thumbnail sketches using handwriting. Always draw a shape around your ideas.

3 Write out your text using different sized nibs and capitals for some sections. Use a larger nib but SAME SIZE LETTERS for pieces you want to emphasize; this is an alternative to using capitals. Photocopy at this stage if you can.

4 Do a paste-up. Adjust anything which needs to be changed and consider weight and balance carefully. Is there harmony in your color scheme? Does it all hang together well? Above all, can it be easily read?

5 When you're satisfied with your paste-up, use a pin to prick through where lines are to be drawn. Rule up on your best paper and write it out. Refer to your final paste-up whenever you wish. When your work is dry, begin finding the edges of your piece by moving four long strips of card around the sides. Leave as much space as you can around the piece, in order to set off the words.

A Most people would succeed in small things, if they were not troubled by great ambitions *Longfellow*

B Most people would succeed in small things, if they were not troubled by great ambitions *Longfellow*

C most people would succeed in small things if they were not troubled by **great ambitions** *Longfellow.*

D most people would succeed in small things, if they were not troubled by great ambitions.

E MOST PEOPLE would succeed in small things if they were not troubled by GREAT AMBITIONS *Longfellow*

F most people would succeed in small things if they were not troubled by great ambitions. *Longfellow*

Comments on thumbnail sketches
A A large initial overpowers three lines.
B Has possibilities.
C Written this way round it becomes too staccato. It's a good idea, but does not work for this particular quotation.
D Simple – but a long shape. Author?
E The capitals certainly draw the reader's attention. Worth writing out a second time; balance the weight of lines 1 & 4 with 2 & 3.
F Similar to B; must watch how lines sit under one another.

MOST PEOPLE

no 3 W.M. Pen.

would succeed in small things

if they were not troubled by

GREAT AMBITIONS

LONGFELLOW

most people

no 3½ W.M. Pen

would succeed in small things

if they were not troubled by

great ambitions

LONGFELLOW

Toward the final version
From the various thumbnail sketches two ideas have been developed further. In the first version the capitals do not relate to the rest of the text. It is as if they are shouting at the reader. In the second version the lines need rearranging to form a harmonious shape. Nevertheless this one would seem to be the most effective. Often simple ideas are best.

Task
Hot and cold
Take a short quotation and, using paint, write out a "cold" version and a "hot" version, just by changing colors. Cold colors include gray, blue and green. Hot colors are yellow, orange, pink and red. Does one color scheme suit it better than another? Consider some other quotations in the same way.

Task
Experiment
It is a good idea to paste up using photocopies if you can and practice experimenting. If you are too anxious to progress, you won't experiment enough. This can force you to settle for something which looks adequate, but may not be the best design you are capable of. Take a well known proverb or saying and see how many possibilities there are.

Review

Throughout this section there have been constant references to practice. The tasks will have taught you a variety of skills and have structured your experience. It is only by using tools well, employing useful techniques, understanding basic letterforms and attempting projects that you will gain the experience you need to enjoy calligraphy.

Each chapter sets you tasks to ensure that you learn gradually the basic skills every newcomer to calligraphy needs to know. There will always be pieces of work you are not satisfied with, so repeat and improve on tasks and projects you enjoyed doing.

However limited you may feel your calligraphy skills are, be generous to yourself and persevere with it as long as it gives you pleasure. It is unlikely that you will be completely satisfied with your work and it is important to complete projects and not merely doodle with your pen.

For a long time it had seemed to me that life was about to begin–real life. But there was always some obstacle in the way. Something to be got through first, some unfinished business; time still to be served, a debt to be paid. Then life would begin. At last it dawned on me that these obstacles were my life.

B. HOWLAND · Calligraphy by David Mekelburg

Obstacles
This freely-written Italic hand conveys a rather profound and very touching statement.

Task
Framing
Calligraphy enables us to read poetry easily. A handwritten poem is worth displaying. Buy a simple clip frame and put one of your best pieces of work in it. Using a clip frame allows you to change the poem for another.

Task
Quotation
Using a piece of thin card folded into a concertina shape, write out a favorite quotation for a friend. This makes it more special than a greetings card, but not a formal piece of calligraphy. Use color, and perhaps make an envelope to give the work in.

Task
One for yourself!
Go through some poems and make some thumbnail sketches of ones that are important to you. Allow yourself as much time as possible. Finally, write out one just for the sheer delight of writing.

Christmas card
This multi-lingual Christmas card is white on a dark ground. Dark blue, dark green, brown maroon, etc, are all ideal backgrounds for crisp white letters.

Task
Pleasure
Even if time for practice is limited, go to exhibitions, collect good samples of calligraphy and lettering, and enjoy the pleasure that good lettering can give.

Quotation
Lines from the poet John Clare by Wendy Westover using brush and pen, white and brown paint on Kraft paper.

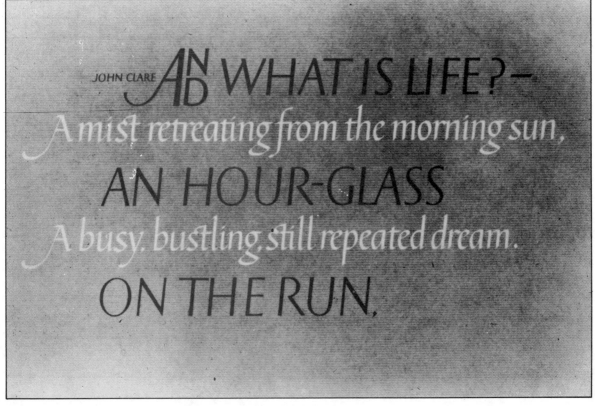

JOHN CLARE AND WHAT IS LIFE? –
A mist retreating from the morning sun,
AN HOUR-GLASS
A busy. bustling, still repeated dream.
ON THE RUN.

©DIAGRAM

Guidelines

These guidelines can be simply traced off or photocopied. If you enlarge or reduce them you get a set of lines to work with nibs of various sizes.

Foundational

Aaph

Foundational

Aaph

Formal Italic

Formal Italic

Basic templates

Calligraphic terms

Ascenders
Pen strokes which project above the writing line. For example, b, d, h, l.

Carolingian
From the time of Charlemagne – a period of great calligraphic value.

Colophon
An endpiece to a piece of work, often tiny, referring to the author, date etc.

Counter
The inside shape of a letter.

Cursive
A "running" hand in which the letters are joined up, for example, Italic handwriting.

Descenders
Strokes which go below the writing line. For example, g, y, p, q.

Flourishes
Ribbon-like pen strokes used with Italic lettering.

Foundational hand
Edward Johnston's teaching script, developed from traditional sources.

Gloss
A translation or explanation. Often added to a manuscript much later than the original script, either in the interlinear spaces or in the margins.

Illumination
The process of decorating manuscripts. It literally means to "light up" a manuscript by the use of raised gold (gilding).

Initial
The first letter of a piece of work or of a verse, often colored and decorated or illuminated in manuscripts.

Italic
A generic term meaning a writing form developed in Italy, characterized by its slant and cursiveness.

Justification
A typographic phrase meaning to align rows of letters so that their edges form straight lines.

Ligature
The small joining line between two letters in a word.

Lower case
"Little" letters, often having ascenders or descenders, as opposed to capital (or majuscule) letters.

Majuscules
Capital letters. See – upper case.

Minuscules
Calligraphic term for "little" letters. See – lower case.

Monoline
Letters without thick and thin strokes. For example, skeleton letters and any letters written with a ball-point or "roller ball" pen.

Parchment
Stripped sheepskin, used instead of paper for pen lettering.

Pen angle
The angle between the writing line and the thinnest stroke of a broad edged pen. For example, Foundational hand is written with a writing angle of 30°, Italic with an angle of 45°.

Serif
A small finishing stroke for letter strokes.

Stress
The angle of the thickest stroke in a letterform.

Swashes
Extended strokes on letters which convey elegance.

Thumbnail sketches
A first draft for a text. A pencil or ball-point pen may be used for this set of sketches to explore opportunities.

Upper case
Typographic term for capital letters, also called majuscules. Upper and lower case refer to the flat trays (cases) which printers used to store metal pieces of type in.

Vellum
Calf skin or goat skin treated for pen lettering. Expensive and very beautiful to write on.

Weight
The "heaviness" or "boldness" of letters. Determined by the height of the letter in relation to the width of the nib used.

X-height
The height of lower case letters excluding the ascenders or descenders.

SECTION 2
TRADITIONAL PENMANSHIP

This section is based upon the idea that calligraphy can be learnt by students understanding the structure of the letterforms and attempting to make letters themselves. This is what is needed rather than developing accurate copying skills.

Over the centuries, calligraphy has contributed much to the richness of lettering. The letterforms that were originally made by scribes endeavoring to write clearly and beautifully have developed into plastic, metal and wooden letters; type and print variations abound, and modern technology provides us with moving letters and numbers as well.

The scribe cannot compete with this progress, but, like other craftsmen, works within natural laws, and continues to write beautifully for discerning people everywhere.

If you are keen to learn calligraphy, follow the section, give yourself time and be prepared to enjoy yourself as you progress and follow the art of traditional penmanship. It aims to show you just how the letters of historical manuscripts were constructed. The tools that were used then are still used today. Tasks which accompany the alphabets enable you to begin work on each set of letters, and they can be used more than once if you wish to monitor your progress.

More powerful than all poetry, more pervasive than all science. more profound than all philosophy, are the letters of the Alphabet, twenty-six pillars of strength upon which our culture rests.
OLAF LAGERCRANTZ

Chapter 1

 Oh! nature's noblest gift – my grey goose quill:
Slave of my thoughts, obedient to my will.
Torn from thy parent bird to form a pen.
That mighty instrument of little men!

BYRON

Task

Workspace
Make a small workspace where you, your desk and a container for your tools can fit.

● The light source should be even and fall from the front or the opposite side to your writing hand.

● The work surface should be at a slope but the tools will need to be stored on a flat surface.

● A small wall area on which you can display your work or the work of other people to give you inspiration and confidence.

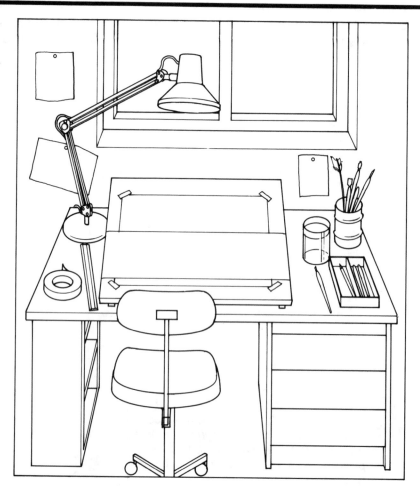

TOOLS AND MATERIALS

Traditional letterforms are the result of using traditional tools. The marks are made by hand-held implements and not by machines. Later, typographical designers faced with producing new alphabet forms returned to these original shapes and incorporated them in their designs. This chapter introduces you to the tools which have been used for over 5000 years. You can construct your own tools from both natural and synthetic materials, or you can use readily available tools to make traditional marks similar to those made by scribes of earlier times.

Prepare a drawing board
1 If you do not have a drawing board, you can make one. Find a strong, flat board with straight edges. Prop it up at an angle of 45° using bricks or books. Make sure it is firm.
2 Tape three sheets of good thick paper securely to the board to create a firm but "sympathetic" writing surface.
3 Use a sheet of ruled lines as a guide underneath the sheet of paper you're writing on.
4 Write onto a sheet of layout paper which is not taped down. This paper needs to be free to move upwards as you write down the page so that your hand stays at the same level on the board at all times.
5 Use a sheet of layout paper to protect your work from grease and splatters, etc.

Posture
Body weight should go through the spine. Legs and both feet should rest squarely on the floor. Avoid weight going forward into the arms. This position should give you:
● Steady ink flow
● Good view of your work
● Relaxed working posture which will not tire you

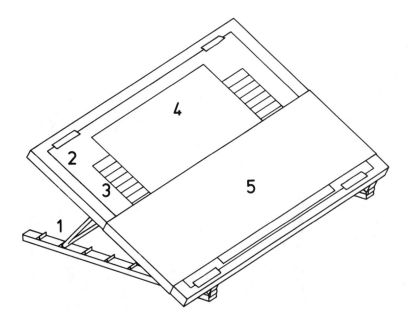

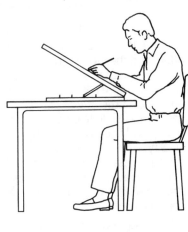

© DIAGRAM

A brief history of writing

The development of knowledge and the spread of ideas has relied upon the use of the written word – which, in turn, relies upon the use of convenient symbols and letterforms. Early man, drawing pictures on clay tablets with a stick, was limited in what he could record. So limited that developments such as reed pens and papyrus writing material represented a giant leap forward – just as great a leap as pen and paper would later be.

As new tools arrived, they were not just more convenient; they also changed the marks that were made. Sometimes the changes made writing quicker, sometimes they permitted elaboration. Sometimes they allowed more writing to be crammed on a page and sometimes they encouraged the writer to turn his script into an expressive art form. The essential elements of writing are what the tool will permit and what the hand can achieve.

In a book like this it is not possible to present a detailed history of writing; we can only briefly introduce a fascinating subject. Sadly, we cannot ever discover more than a small fraction of the history of our writing. While man has used marks and signs for tens of thousands of years, we can only trace our historical scripts back for about 3000 years.

At that time, the Phoenicians were the great trading nation of the Mediterranean. Successful trading requires good written records and the Phoenicians used a script based on 22 letters, some of which we would recognize today. This alphabet was taken up by the Greeks who made some modifications. The Romans adopted it and, through conquest, spread it across the western world.

Any European looking at a Roman inscription will recognize the symbols even though he may not understand the words. There was nothing inevitable about this; the symbols have survived because they are convenient to use. Roman numerals, on the other hand, were difficult to read, almost impossible to do arithmetic upon, and have consequently been replaced by Arabic numerals. This is typical of how writing has developed – it has been a process of selection and refinement and it has not ended. Indeed, today's technology may actually be speeding up the development process once again.

Early Roman letters
Examine a Roman inscription carved out of stone and you will see capital letters only. Big, graceful

Earliest alphabet
Phoenician letters from the Moabite or Mesha Stone, dated to 842 BC. The writing ran from right to left.

Chiselled capitals
Letters from a Greek inscription in white marble, 4th century BC.

Roman monumental
Roman capitals on the tombstone of Gaius Valerius Victor (from Lyons), standardbearer of Legion II Augusta at Isca (Caerleon), South Wales, after AD 74.

and square, they were well suited for use on inscriptions. However, they would not have been an ideal written hand because they were slow and exacting.

Rustica

The Romans therefore needed another writing style for everyday use. This had to serve for letters written on papyrus using a square-ended reed pen. It was a compressed style because writing materials were expensive, but it was a flowing style because it needed to be written quickly. The success of Rustica is evident in that it survived to the end of the Western Roman Empire. Even after that, it persisted as a decorative hand for the opening letters of chapters or paragraph.

Uncials

Improvements in writing implements eventually led to the adoption of Uncials as the favored script of Western Europe. Its rounded letters were quicker to write than Rustica; a factor of increasing significance in the first millennium after Christ. The spread of Christianity led to an ever growing demand for bibles and religious texts which were copied by monastic scribes. Because this was their main purpose in life, the scribes were encouraged to use the rounded style to produce beautiful flowing writing worthy of its message.

Half-Uncials

Half-Uncials were a further development. Again, it seems likely that their adoption was due to the need for increased speed in producing texts. Within this hand there began to emerge the ascenders and descenders that we now associate with lower case letters. It was the forerunner of all of today's minuscule letters.

Carolingian

As Western Europe broke up into new Romano-Christian influenced but nevertheless barbarian kingdoms, consistency in scripts across Europe was lost. Local regions developed their own hands and, although many were clearly derived from Uncials and Half-Uncials, there were considerable variations. Shortly before AD 800 there arose a new European leader in Charlemagne who, although he could not read, was shrewd enough to recognize the power of the written word. His was the initiative to re-establish standard letterforms.

Named after him, the Carolingian form was the first true minuscule hand. It was elegant with long clubbed ascenders and descenders that needed four guidelines for each line of writing rather than the two needed by capital hands. It established

Roman hands
Roman and Rustica capitals from a graffiti painted on a Pompeii wall before AD 79.

Church writing
Uncial script from ecclesiastical regulations in Latin, 6th or 7th century.

Celtic flair
Half-Uncials from the Gospels in the Insular style, almost certainly Irish, 8th century.

Carolingian Renaissance
Very early Carolingian form from a Salzburg manuscript of Alcuin's letters, written 798–99. Alcuin of York, 311 of whose letters in Latin survive, was the powerhouse of the Carolingian Renaissance.

A brief history of writing

itself as the formal bookhand in Europe and survived in that role for nearly 300 years. It was one of the most significant developments in the history of writing and its influence on today's printed material is still apparent.

Gothic
In the Middle Ages there were increased demands for documents with secular purposes. They led to a severe shortage of vellum and to a consequent sharp increase in its price. There emerged the need for a hand which was as quick to write as the Carolingian, but which was sufficiently dense to make economical use of the available vellum. The answer to the problem was Gothic, a neat compressed style which sacrificed roundness and cut short ascenders and descenders in order to get as much text as possible onto a page.

Gothic variations
Though the term Gothic derives from the name of the Old German people, the hand was widely used across Northern Europe. However, it was not a single style, rather a whole family of hands. The variations tended to develop regionally but the essence of the style is so strong that the family relationship is always clear.

Rotunda
Though most of Europe adopted a standard Gothic form with heavy angularity, Italy showed a marked resistance. There, a compromise style was adopted between Gothic and other earlier forms. It is known as Rotunda and, while its Gothic influence is apparent, so too are the rounded letters from which its name derives.

Italic
The Renaissance began in Italy and had a profound effect upon the calligraphic hands. Gothic was swept away and back came the stylish influences of Carolingian. Now, however, they were more pronounced, with long and flowing ascenders and descenders. The script bloomed into Italic, a family of hands that re-established elegance. The style emerged in the 15th century just as the first printing presses were appearing and was promptly adopted for use in typography. It has remained for over 500 years as part of a popular repertoire of type.

Copperplate
While Italic remained as part of the typographer's stock in trade, hand scripts moved on. The arrival of the quill pen allowed scribes to mimic what had once been a style of copper engravers. While

Northern Gothic
Gothic Textura from the Kinloss or Boswell Psalter, Cistercian Abbey of Kinloss, Scotland c1500.

Southern Gothic
Gothic Rotunda from a Florentine liturgical text, written c1500.

Venetian Italic
Italic from the regulations to be kept by the Procurators of the Basilica of St Mark, Venice, written by the priest John, 1558.

Eighteenth century Copperplate
Copperplate by Joseph Champion from George Bickham's *The Universal Penman* 1743.

similar to Italic in its elegance, Copperplate has a fine gradation in line thickness which encourages style and ornamentation. The engravers achieved this with a fine cutting tool, the calligrapher thanks to the quill's flexibility. Copperplate or Roundhand soon became the accepted hand and lasted into the 20th century. However, before that, the quill had long been replaced by metal pens that were mass produced for the schools attended by many of our parents and grandparents.

Foundational hand

Toward the end of the 19th century William Morris (1834–1896), whose interest lay in medieval designs, created the Arts and Crafts Movement in England as a reaction to mass-produced products. Morris had a direct influence upon Edward Johnston (1872–1944) who, having studied old manuscripts at the British Museum, became fascinated by the tools and techniques used to provide them. He rediscovered the old skills used in creating various letterforms and went on to teach them to a new generation of calligraphers. To facilitate his teaching, Johnston developed his own calligraphic hand. This he called the Foundational hand. He based it on the Carolingian letterforms in the 10th century Anglo-Saxon Ramsay Psalter.

Foundational hand
A basic teaching hand, the ideal alphabet to start calligraphy.

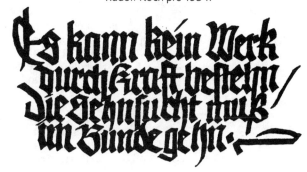

Modern revival
Black letter or Gothic pen hand by Rudolf Koch pre-1934.

Modern developments

In 1906 Johnston published what has become the basic reference manual for calligraphers today – *Writing, Illuminating and Lettering*. It is full of practical advice on how to make letterforms and how to design books and manuscripts.

Johnston was not the only one to be interested in the traditional letterforms. In Germany, Rudolf Koch (1876–1934) was familiarizing himself with old manuscripts and, because of his Germanic roots, he concentrated on developing the Gothic form. Like Johnston, Koch drew to him a new generation of calligraphers.

Some members of this new generation, in both England and Germany, had a wider interest in lettering. They designed new hands; for instance, Alfred Fairbank developed the chancery Italic hand into a simple model for Italic handwriting. Others were more active in designing new typefaces. The

1920s saw a blossoming of many that we treat as standard today: Gill Sans, Futura and Optima, for example. Often they are clear and without serifs – a design development which divorces type from its roots in calligraphy.

In England we still see the London Transport letters that Johnston himself designed in 1916. His student Eric Gill (1882–1940) became one of the best-known typeface designers and letter cutters in the country, while in Germany, Koch's students Imre Reiner and Hermann Zapf produced new alphabets in rich profusion.

Today, printing is moving on, revolutionized by the use of computers. Once again there is a reaction to mechanically-produced letters, and a great number of people have reacted by simply taking up the broad-edged pen and beginning to learn the art of traditional penmanship.

Using pens

Brushes and pens are both traditional tools which have been used by scribes for over 5000 years. Dipping into a liquid and writing with it is a rhythmic writing technique, which we still use today. We call the fluid "ink", but it can easily be diluted paint. The pen needs to be kept clean so that the ink flows freely down the nib slit to the writing edge. Reservoirs help to hold the ink so that the dipping procedure is regulated. Some reservoirs can be slipped onto the nib and lie underneath like a shallow cup, while others sit perched on top of the nib. Either way they tend to hold the sides of the nib and make it a less flexible tool. Metal reservoirs and nibs have to be degreased before use, otherwise the ink will run off the nib and retract from it. Sucking them, boiling them in water or running them through a lighted match are all possible methods of doing this.

Nib widths
Nibs are available in an enormous range of widths. The wider the nib, the greater the contrast between the thick and thin strokes produced. Two manufacturers' nib sizes are shown here.

William Mitchell roundhand nibs	Brause nibs
0	5
1	4
1½	3
2	2½
2½	2
3	1½
3½	1
4	¾
5	½
6	

Ink reservoirs
Having to dip the nib frequently into the ink can often slow down the rhythm and the flow of the line of text. Modern nibs are often supplied with a reservoir, a container which holds a pool of ink on the nib. These are either detachable clip-on reservoirs which go above or below the nib or form an integral part of the nib itself.

1 Clip-on reservoir. This slips underneath the nib and forms a shallow cup which just touches the underside of the nib points. It should not force the slit open as this is likely to cause flooding when in use. This type of reservoir can be removed for cleaning.

2 The clip-over. This is attached to the top side of the nib on the shoulders of the nib away from the writing edge. This type can also be removed easily for cleaning.

3 Automatic lettering pens have a diamond-shaped gap inside the nib, between the two blades. One edge of the nib has tiny grooves cut into it. This edge is held uppermost when writing and the grooves help the ink flow.

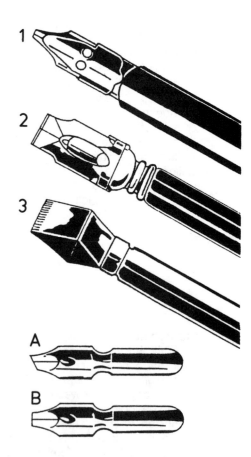

1

2

3

A

B

Left-handed calligraphers
If you are left-handed you may find left oblique nibs (**A**) easier to use than square cut ones (**B**). You have to decide what is best for you. Several first class calligraphers are left handed so it is no excuse for not succeeding!

Pen and brush care
When pens are not in use, do not store in airtight boxes. Leave them in a jar or pot, in the air, so they don't rust.
- Rusty nibs and nibs which split open when you write should be thrown away.
- Scratchy nibs can be sharpened on fine emery paper.
- Left-handed scribes might like to steepen the oblique angle of their steel nibs using a stone if one is available, or emery paper if not.
- Brushes should be reshaped when washed and when quite dry they can wear a cardboard collar to protect the hair.

Pen angles

1 This is the general handwriting position. There is a "controlled leak" ink supply from a roller ball or a fountain pen which works well with a flat writing surface. Ink from a dip pen, however, would run down the nib too quickly and blobbing would result.

2 For display work and large letters a gentle slope is best. You don't want the paint or ink to run down the letter and collect at the bottom of it.

3 Traditionally, a writing desk was always sloped and until recently even school desks were too! This position is for general calligraphy. Notice the steep angle of the pen to the paper. The pen rests on the knuckle of the forefinger, NOT in the soft flesh between thumb and forefinger. This is a common error.

4 For fine calligraphy you need to sit as upright as possible and keep your weight OFF your writing arm. Don't be tempted to lean forward when writing small. You will get tired and stiff with too much concentration! Body weight should be held in the spine, and the feet flat on the floor help to support your frame. This body posture leaves your arm free to move easily with the pen.

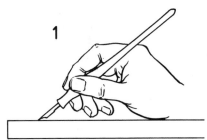
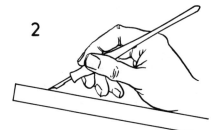
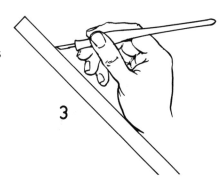
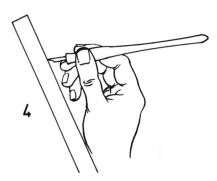

Task

Working positions

It is essential that you experiment with these basic positions before you learn to write. Practicing hard will mean you concentrate and that will lead to tension in the body and in your writing. Simply use a felt pen and layout paper to acquaint yourself with pen strokes. Be aware of your board angle, pen angle, seat height, hand position, etc. Make any adjustment necessary *before* you learn the alphabets.

For Copperplate writing

When using a *flexible pen* left-handers have the advantage for once! Right-handers may well prefer to use the elbow joint nib (page 91) to help with the extreme angle of the letters. Turning the paper can help also.

Hints for left-handed calligraphers

● Left oblique nibs can be purchased. If required, the angle of the nib can be increased by rubbing with FINE silicon carbide paper.

● Tilt the paper or steepen the angle of the drawing board to make yourself more comfortable.

● Keep work to the left hand side of your board. Turn your head a little to the left and don't write across your body – only as far as your chin. Keep your elbow tucked into your waist.

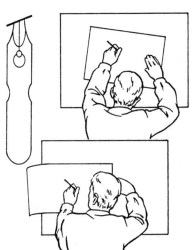

Task

Preparing nibs

New nibs need to be cleaned before use, otherwise the ink will not flow freely. Remove the manufacturer's lacquer from both nibs and reservoirs, either by boiling them in water or by putting them into the flame of a lighted match and then wiping clean.

© DIAGRAM

89

Choosing pens

These two pages illustrate a variety of writing implements available. The ones marked with an asterisk (*) are the ones you need to start with.

Since it's the size of the nib that dictates the size of your letters, try to assemble a variety of nib sizes. Don't be tempted to write small if you are a beginner. The shapes of your letters will be easier to criticize if you make them at least ½in (1cm) high. Pens are very personal so don't allow others to borrow them!

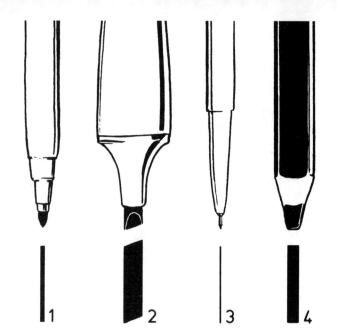

1 Instant marker pen.
2 Chisel-ended felt tip pen*.
1 and 2 are ideal for practicing and planning layouts. They are available in a variety of widths and colors.
3 A fine tip pen is useful for ruling-up templates.
4 A carpenter's pencil for practice and experimenting with different layouts.
5 The double pencil is the most useful dry pen of all. Simply bind two pencils together at the top and bottom with tape or rubber bands to produce an outline pen which shows

clearly the letter construction. To make a broader pen, place an eraser between the two pencils and then bind them together. If you want a narrower pen, shave off some of the wood from the pencils along their lengths before binding*.
6 Chisel-ended felt tip pen which has had small wedges cut out of the tip with a scalpel, producing a decorative mark.
7 Reed pen. These can be made from bamboo, honeysuckle and other tubular stems. The reed pen is the original broad-nibbed pen and is ideal

for large letters. (See instructions for pen-cutting on pages 92-93.)
8 A synthetic "reed" pen. Nylon tubing from a hardware store can be made into a synthetic "reed" pen. The nib can be cut into to make a pen which produces a double line.
9 A quill. This is made from a cured flight feather of a goose or swan. It is cut in the same way as a reed pen. Pens 7, 8 and 9 can be used with reservoirs added (see page 95).
10 Homemade poster pen. Made by covering a piece of balsa wood with felt and gripping them together in a

Task
Collecting pens
Start collecting and making pens. Store the pens with the nib pointing upward, not flat in a box. A jar is ideal for this. Having several pen holders will avoid the need to change nibs too often – this can damage them.

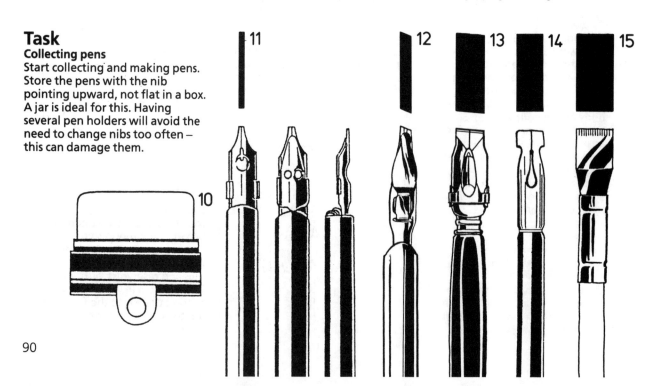

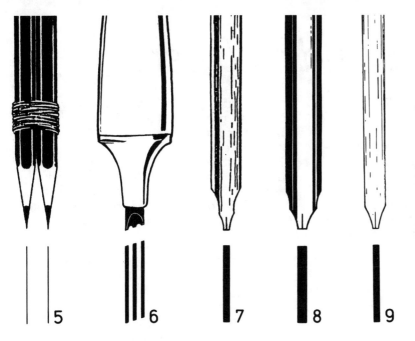

Task
Making mountains
Rule out some writing lines 1¼in (30mm) apart on A3 paper. With the double pencil pen (no.5) make mountains with a 45° angle. Keep the angle constant. Repeat, but use a 30° angle instead. These exercises are helpful even before you start writing.

5 6 7 8 9

bulldog clip. This produces an inexpensive pen with a broad nib which is useful for display work and experimenting with design.

11 William Mitchell Roundhand nib with a slip-on reservoir (top, bottom and side views).

12 Brause nib with its reservoir on top of the nib. Both 11 and 12 are available in a range of widths.

* You will need either 11 or 12.

13 Poster pens also have their reservoirs on top of the nib and a right oblique writing edge. This pen is ideal for display work.

14 The Witch pen has a writing edge which copes with textured papers very well.

15 Boxall Automatic pen. This range includes a variety of nib widths.

16 Boxall Automatic pen with a decorative nib.

17 Scroll nibs are available in sets consisting of a variety of widths, all giving a double line.

18 The Decro Script pen is useful for practicing skeleton letters in various sizes and weights.

19 Coit pens are expensive but have a variety of writing edges which

produce decorative marks, and are ideal for display work.

20 Fountain pen. Using a fountain pen with an Italic nib for your everyday writing will help to improve it*.

21 A shadow fountain pen nib gives two lines. This is ideal for analyzing your strokes as well as being decorative.

22 Regular shaped nib for Copperplate and Roundhand scripts.

23 Elbow joint nib used exclusively for Copperplate writing.

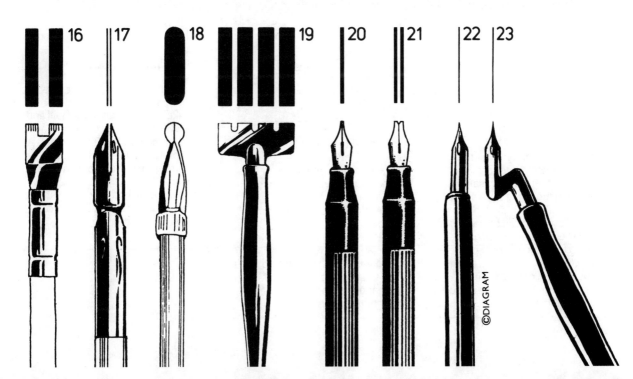

16 17 18 19 20 21 22 23

©DIAGRAM

Making quills and reed pens

The reed pen was the earliest broad-edged pen. It was replaced by the quill which was exclusively used in the West for many centuries before the steel nib was invented in the early nineteenth century. The very word "pen" comes from the Latin *penna* (feather), a recognition of the quill's long dominance.

Flexible springy writing tools can be made from reeds, feathers or lengths of nylon tubing. The tool is made by cutting away at the hollow barrel and making a slit to allow the ink to flow. The result is a lightweight pen where the maker can easily adjust both the length of the pen and the width of the writing edge.

For pen cutting you will, of course, need a pen knife. Its blade should be hollow-ground and sharpened to cut precisely. Choose one with a good handle so that you can exert some pressure (this will be necessary when cutting bamboo).

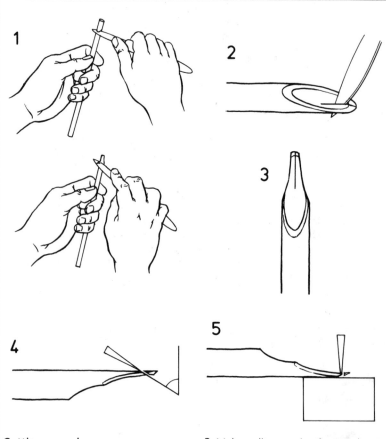

Cutting a reed pen
A reed pen is traditionally cut from the tall reed *Phragmites communis* that occurs in freshwater margins from the Arctic to the tropics (not readily available in Britain), but any other hollow stem can be used. Two alternatives are honeysuckle and bamboo (not strictly a reed pen).
Instructions
1 Cut a length of reed 6¼in (160mm) long, and cut one end off at an angle of 45°.

2 Make a slit opposite the cut about ⅕in (5mm) long.
3 Shape the pen either side of the slit, making the two "shoulders" even.
4 Slice into the tip with the knife at an angle of 60°.
5 Rest the pen on a smooth, flat surface and cut across the end of the nib. Do this with the knife held at 90° to the slit. Use a square cut for right-handed scribes and an oblique cut for left-handers.

Instructions for curing a feather
The process of hardening by heating will make the quill strong and durable.
1 Remove the wide barb and cut off the end of the barrel. Soak the feather in water overnight.
2 Remove feather from the water and hook out the membrane from inside the barrel using a blunt instrument.
3 Heat some silver sand (the type used in potter's kilns) in a deep frying pan. Maintain a low temperature throughout the process. Using an old spoon, gently fill the barrel of the quill with the hot sand. Plunge the quill into the sand for 2–3 seconds. Take care not to overheat the quill by pushing so far into the pan that it nears the bottom. Remove.
4 Check the quill:
● if it has blistered, the sand was too hot
● if it has not turned clear, the sand may not have been hot enough. Try again.
● if it has become clear without blistering, then it is fine. The slit should run clean and straight when the knife is used.
5 Shake the sand out of the quill and wipe it with a coarse cloth to remove the outer membrane. This resembles a thin plastic "skin" on the outside of the barrel. The barrel should now be clean and shiny.
When you have had practice, you will be able to do several quills at once. Use ordinary feathers to practice with.

Choosing a feather

The best feathers to use are the first flight feathers of swans and geese. These birds moult each summer, so you may be lucky enough to find the feathers you need. Flight feathers have one narrow and one wide barb. On other feathers the two sides are more evenly matched. Place the feather in your hand as if to write with it. It should curve over your hand (see *below*). If you are right-handed, you will need a feather from the left wing, and vice versa.

Cutting a quill pen

1 Remove the barb from the lower end of the feather.

2 Hold the feather with the tip of the barrel pointing away from your body. Using a sharp knife, cut off the tip of the barrel at an angle of 45°. (When using a sharp knife, always take care to cut away from yourself.)

3 Cut a slit in the center of the barrel. Stop cutting when the crack appears. If the feather has been properly tempered, the crack should run straight.

4 Turn the pen over and cut away a piece from the side opposite the slit. This piece will be roughly half of the circumference of the barrel.

5 Shape the "shoulders" of the pen on either side of the slit.

6 Gently scrape away at the underside of the nib to make the surface flat and smooth.

7 Place the pen on a flat, hard surface with the underside of the nib downward and the nib pointing away from yourself. Move the blade forward at a shallow angle to cut a small piece from the tip.

8 Keep the quill in the same position as in (**7**) and cut vertically downwards to neaten the end of the nib.

1

2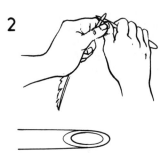

3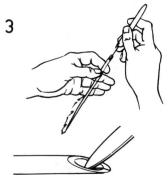

4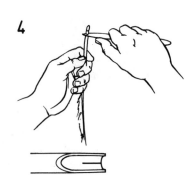

5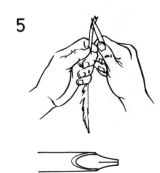

6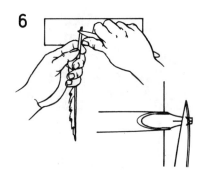

7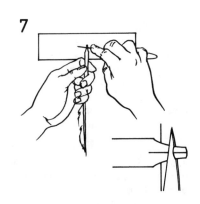

8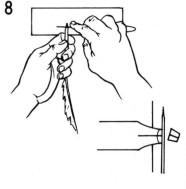

Inks and paints

There are basically two types of commercially produced inks: those solvent in water, which can be diluted to produce thinner body and color; and waterproof inks, which have a gum base and which cannot be diluted successfully.

Soluble inks flow more freely, do not clog the pen and can be washed away easily but may produce lines of varying intensity depending on the amount of ink released from the nib and absorbed into the surface.

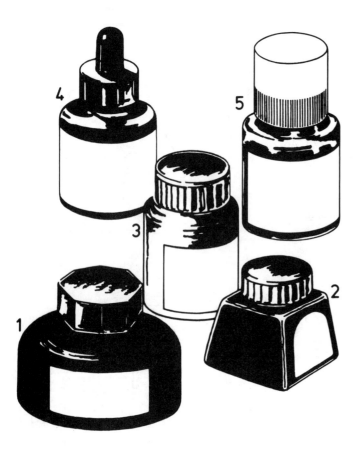

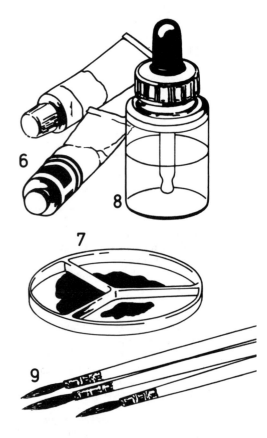

Inks
Experiment with different combinations of ink, and paper to find out what suits you best. When choosing ink always make sure it is *non*-waterproof. Waterproof inks contain gum which will clog your pen.
1 Ordinary permanent black fountain pen ink is the best ink to practice with.
2 Black indian ink is good for finished work as it is dense and very black.
3, 4, and **5** There are many other inks on the market, experiment with different colors. Secure ink bottles to the table to avoid spillage.

Paint
6 Gouache. Some gouache paints (designer colors) will add a new dimension to your work. The following colors would be useful to have: Zinc (Chinese) white, cobalt blue, lemon yellow, emerald oxide of chromium (mix in lemon yellow to give it body), spectrum red or vermilion hue.
7 A mixing dish for preparing paint. If you already have watercolors you can use them and add zinc white to give opacity to your letters when it is appropriate to have bold opaque color.

8 A dropper bottle filled with distilled water is ideal for mixing paint. Always add the water to the paint *drop by drop*. If you are using paint for a long piece of work, add drops of water occasionally to compensate for evaporation.
9 Use cheap brushes for mixing paint and for transferring paint from the mixing dish to the nib. Shorten the handles on them to prevent accidents.

Stick color
It is possible to buy modern stick inks and paint in good art supply shops; they are available in several colors, although the traditional colors are black and red. The stick is ground by being held upright and rubbing it into a pool of water on a special palette; this requires patience, if you want to obtain a good consistency.

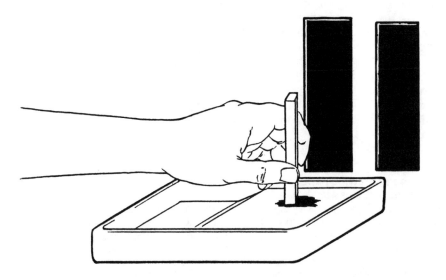

Quantum
Don't separate out paints from ink. They both make useful writing fluids and work well together on the page. Traditionally black Gothic minuscules work well with vermilion capitals. Red, blue and green majuscules make effective headings for black manuscripts. Don't be afraid to use well diluted paint to write your text. Store the paints safely, they can be reconstituted whenever you wish, you just need a milky consistency.
1 Pen strokes using vermilion paint.
2 Brush strokes using vermilion paint.
3 Pen strokes using black stick ink.

Task
Patterns
Acquaint yourself with your new pens by experimenting with ink and paint. Notice how often you have to dip into your ink, and develop a rhythm; Don't attempt letters, rather make patterns.

Task
Mixing paint
The paint will never flow if it is too thick. Make a milky consistency and concentrate on allowing the fluid to flow from the nib. Dilute paint to a gentle line and work with a small nib. Store color in airtight jars. If it is too thin, simply leave the top off and allow it to evaporate a little!

Task
Make your own ink reservoir
If you make a reed pen (pages 92-93) you may decide to make a reservoir to go with it. Cut a thin strip of aluminum from a soft drink can. It can be curled by rubbing hard on one side.

Loading the pen
Calligraphy pens are best *not* dipped into writing fluid, *not* even ink, as this creates uneven ink distribution. A controlled ink flow is best provided by wiping the pen and reservoir with an ink/paint laden brush. With this method there need be no blobbing onto the page. Work with the fluid and brush on your non-writing side and bring the brush to your pen. It is not an easy process to start with, but after practice it is far superior to relying on a "dip and shake-off method"!

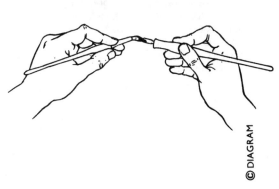

© DIAGRAM

Papers and parchment

The traditional surfaces for fine writing in books and manuscripts are *parchments*. These are specially prepared animal skins, the finest of which is *vellum*; this is usually calfskin. Other parchments are made from goatskin and stripped sheepskin.

The belly of the animal has the softest skin so this is used to make parchment; white thicker areas provide material for the bookbinder. The special preparation that turns an animal skin into a parchment is lengthy and messy, but is still carried out by craftsmen today. The processes include soaking skins in lime, scraping, drying and stretching them. After the best parchments are selected for writing upon, the scribe still needs to add a few finishing touches. Pumice is used to remove grease from the surface and to raise the nap for the pen strokes. The surface needs to have tooth to it, but must not be absorbent and allow ink to bleed into the fibres. Lines for writing on are drawn with a hard, sharp pencil. By pricking through to the next page, the sets of lines on the following pages can be made to match the first one.

The word *paper* derives from *papyrus* which was the ancient Egyptian word for writing material they made from the water plant. By cutting the stem into narrow strips, placing them in layers, beating and compressing them, then drying them in the sun, a flexible writing material was manufactured for over 3500 years.

Since then techniques have been developed to turn other vegetable matter such as linen, cotton, hemp and wood pulp into paper.

Art shops stock a bewildering variety of paper, most of which is unsuited to the needs of the scribe. Work with a more restricted choice, but select the paper carefully for the effect you want to achieve. Here are some ideas to choose from:

Layout paper
This comes in pads of various sizes. It is smooth and translucent, so you can use guidelines under your writing page. Ideal for practice and pasting up.

Textures
Generally speaking, calligraphers require a smooth textured surface for their work. Sometimes, however, interesting effects can be used by using a highly textured surface and a large pen. Witch pens with their particular writing edge do not snag on uneven surfaces and are therefore particularly useful. A spontaneous effect is achieved by simply ignoring the fact that occasionally the ink fails to mark the paper. Small pens, however, are more likely to snag on such a surface and are not recommended.

Cartridge or drawing paper
This comes in various sizes, in pads or in sheets. Good quality, heavyweight cartridge paper is suitable for finished work.

Kraft paper
Otherwise known as brown wrapping paper, it has lines within it, ideal for writing on. Use the matt side only.

Handmade papers
Experiment with these, they vary enormously. You need flat-pressed paper with a smooth finish. Rule up carefully. Don't presume any corners are square.

Selection and storage
Look for Fabriano papers for texture, Ingres paper for subtle colors, and textured papers for special effects. Avoid coated surfaces, ideal for print but problematic for writing on. Keep a record of the papers you buy so successful ones can easily be re-ordered. Store flat between strong card covers and keep dry.

©DIAGRAM

Vellum offcuts

It is not recommended that you begin work on parchment or vellum without referring to *The Calligrapher's Handbook*, edited by Heather Child (London 1985). It is however possible to experiment with these fine writing surfaces by acquiring offcuts. Even these odd end pieces need preparing by the scribe before writing can begin:

1 Rub pumice powder into the surface to raise the nap using a small block of wood covered with the finest grade of wet and dry abrasive paper.

2 Brush away the resulting dust and rule up using a very hard pencil.

3 Dab a resin powder onto the surface to prevent the ink from spreading in the fibers and brush away any excess. Resin is best used in a dolly bag and applied sparingly.

For parchment, vellum, pumice and resin you will need a calligraphy supplies shop. Paper shops can often put you in touch with suppliers who will mail goods to you direct.

offcuts

Drawing equipment

The drawing equipment shown here helps you to prepare the writing surface for your calligraphy. Traditionally, pages of a book matched each other because the scribe used a stylus to prick through the position of his writing lines onto subsequent pages. These lines were scored with the stylus before pencils were invented. To avoid ink seeping into the score marks the writing was done between the guidelines. The other side of a ruled up page would therefore have a raised line; thus the two sides of a page were ruled up at once. You can best use a very hard pencil (4H) for your writing lines, a compass point for pricking through and walk your dividers down the page (see *below*) for ruling up in the traditional way.

1 T square
2 Triangles (set squares)
3 French curves
4 Flexible razor blade (for erasing on parchment)
5 Protractor
6 Ruler
7 Dividers
8 Compass
9 Pen knife
10 4H pencil

Task

Finding drawing equipment
Some of these tools might be around the house, left over from your schooldays! If not, they are readily available from stationery stores and art shops. They facilitate *accurate* drawings on your writing surface prior to pen work. Use a hard (4H) pencil and do not erase your writing lines, or the ink will smudge.

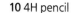

Review

Do not underestimate the importance of using well-prepared, clean and sharp pens. You will learn from experience that a rusty nib does not allow the ink to flow well; that too much pressure on a nib forces it to open when it should not; and that you must remember to prepare each new nib and reservoir before using it. Much of this is common sense, but better results can be obtained by treating your tools with respect.

Papers and paints also need care, but most of all you have to experiment with them. If you buy single sheets of paper, this need not be too expensive. Paint will only be wasted if you dilute it too much in vast quantities. Dried paint can always be reconstituted. Experimenting with your tools to familiarize yourself with them will be well worthwhile as the more confident you become, the more proficient your work will be.

my hand is tired from writing

my sharp pen is not steady;

the pen, a slender beak, spouts a dark stream of blue ink, an unceasing stream of wisdom pours from my brown, shapely hand; it spills its flow of ink from the blue-skinned holly over the page. I send my wet little pen over a whole fair of lovely books without ceasing, for the wealth of great ones, and so

my hand is tired from writing

ST.COLVMBA

Home truths
Certain quotations will always attract calligraphic responses. Scribes over the centuries have felt the weariness described here by St Columba. This version is by the present day American scribe Maura Cooper who has chosen Uncials in two sizes.

Task
Pen play
Using a felt marker pen, play with the pen, making swirls, zigzags, and horizontal and vertical strokes. Remember to move the paper as you fill it up so that you are always writing directly in front of you.

Task
Doodling
Fill a whole page with doodles using pen and ink. Experiment with pulling strokes and try to get used to the wetness of the ink.

Task
Visit museums
There are many valuable old manuscripts in museums from which you can obtain a great deal of inspiration. They will intrigue you and a visit will help you understand the development of writing a little more. Buy postcards of the ones you like best.

Task
Read on
Get to know this workbook. Read through the book and acquaint yourself with the task program and the jargon. Decide how you will use the book to maximize the learning process.

1 *uine*

2 *dublin*

3 *Köln*

4 *MOSCOW Algiers*

5 *Stavanger*

6 *AVIƷNON*

7 *HongKong Melbourne*

8 *London New York*

Examples of pen marks (all actual size)
1 Double pencil, shaved lengthwise to decrease the "width" of the "nib".
2 Felt pen
3 Automatic No. 9 pen
4 Monoline pen
5 Automatic No. 3 pen
6 Reed pen
7 Swan quill
8 William Mitchell No. 2 pen

©DIAGRAM

Renaissance letters

Constructed Classical Roman capitals designed geometrically in the 16th century by various European writing masters and typographers:

1 Marco Antonio Rossi (Rome printer flourished 1598–1640) from *Giardino de scrittori* (1598).

2 Juan de Yciar (1522– post 1555) from his *Arte Subtilissima* (Saragossa, Spain 1548).

3 Gianfrancesco Cresci of Milan (Vatican scribe 1556–72) from his second alphabet 1570.

4 Luca Horfei da Fano, student of Cresci and author of 1589 writing manual.

5 Johann Neudörffer (1497–1563), greatest North European writing master, published two writing manuals at Nuremburg; the B is from a c1540 alphabet.

6 Geoffroy Tory (c1480–c1533), French typographer and royal printer, from his 1529 alphabet.

7 Giovanni Battista Verini of Florence from his 1526 *Luminario* alphabet.

8 Fra Luca de Pacioli (c1450–c1520), Franciscan mathematician patronized by Duke Federigo of Urbino, from his 1509 alphabet.

9 Francesco Torniello from his 1517 alphabet published at Milan.

10 Ludovico degli Arrighi (d1528), Vatican scribe, from his second writing manual (1523).

LETTERFORMS

The various alphabets in this chapter were all developed from the Roman majuscule ("upper case or capital") alphabet. Roman, Rustica, Carolingian, Uncial and Half-Uncial only have one form, either majuscule or minuscule. The other letterforms in this chapter have both majuscule and minuscule forms. Minuscules ("lower case" or "little" letters) were developed from majuscules in order to speed up the process of writing. As the letterforms evolved they generally became easier to write quickly, but the Roman numerals were cumbersome to write and so Arabic numerals were adopted instead.

This chapter begins with the skeleton letterforms. Learning these will teach you the basic proportions of the Roman majuscules and of the minuscules which are used with them. The Romans did not use minuscules, but it is useful to learn the basic shapes at this stage because they form the basis for the other minuscule letterforms in this chapter. The Romans didn't use the letters U, J and W so in some alphabets these have been invented for modern usage.

It is not necessary to follow the exact order of the other letterforms given here, but avoid jumping from round letters to ones with sharper angles and back again as this may confuse you and can affect the quality of your letterforms.

> **"** *The excellence and beauty of Formal Penmanship is achieved chiefly by three things – SHARPNESS, UNITY & FREEDOM.* **"**
>
> EDWARD JOHNSTON

Ladders
The height of each style of letterform is set at specific number of nib widths. Therefore the nib you use acts as a measuring unit to find the height of the letters. The nib widths are made with a pen angle of 90° and are piled up in a formation known as a ladder. You must make a new ladder each time you use a different size of nib or change lettering style. In this way, whichever size nib you use, your letters will always be in the correct proportions. For example, Foundational majuscules (**A**) are 6 nib widths high and the minuscules are 4½ nib widths. Italic majuscules (**B**) use 7 nib widths and the Italic minuscules are 5.

A

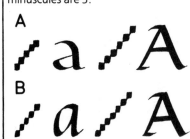

B

Guidelines
Guidelines are lines which act as a guide for the proportions of the letterforms. These proportions are found by making a ladder and then ruling pencil lines from it. They can either be fine pencil lines ruled on the writing sheet itself or templates placed under the writing sheet so that the lines show through.

Pen angles
The pen angle is the angle between the flat edge of the nib and the horizontal writing line. This varies depending on which letterform you are writing.

90° for ladders

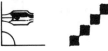

30° for Foundational hand

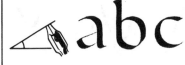

45° for Italic

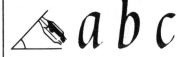

©DIAGRAM

Skeleton Roman

These basic letterforms are designed to acquaint you with proportion and a general understanding of Roman-based pen lettering. You need to draw out the majuscules and make yourself familiar with the several groups that they fall into. Unlike the other alphabets, skeleton letterforms do not rely on the "thick and thin" effect of the broad-edged pen so they can be made with any implement. The shape of the letters you draw will improve if you keep in mind that they are all based on combinations of the straight line and the circle.

Specification
The majuscule letters, ascenders and descenders are almost double the minuscule x-height. Numerals are formed slightly higher or lower than the x-height.

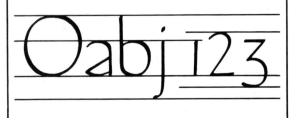

ABCDEFGHIJJK

LMNOPQRSTU

VWXY&Z

C D G O Q *A H N T U*
V X Y Z

M W *B E F J K L P*
R S

Forming the letters

These letters are not easy so give yourself time to practice them and don't expect good results instantly! They divide into the four groups (shown *left*). Remember the W extends beyond the basic square; the S should not look bottom heavy, but turning it upside down will prove it actually is. If you misplace the midpoint of R P K B E F G H X Y your letters will look either top or bottom heavy.

You can use any monoline pen or a soft pencil. The sentence "the quick brown fox jumps over the lazy dog" not only uses every letter but also tests spacing problems.

Task
Capitals
Using a soft pencil draw out these capital letters, paying attention to the proportions. Repeat without looking at the examples. Redo letters which are wrong.

Task
Minuscules
Using a soft pencil draw out minuscule skeleton letters, observing closely the proportions. Close the book and go through them again. Correct any mistakes.

abcdefghijklmnop

qrstuvwxyz

1234567890

Classical Roman

Roman capitals such as these have inspired lettercutters, typographers and signwriters for well over 2000 years. They were originally drawn with a brush before being cut with a chisel and mallet. They aimed to convey the power of the Roman Empire. In the illustration (*right*) of part of Trajan's Column in Rome, you can see that the letters on the top lines have been cut larger than the ones on the lower lines. This was so that to a person on the ground looking up at the huge memorial all the letters would look the same size. This subtle device matches the elegance and splendor of the letters themselves. Each letter is approximately 3ft 3in (100cm high). Even today official forms command us to write in BLOCK CAPITALS. This serves two purposes. Lettering is more legible than writing and capitals reflect the formality of the business. When you begin to draw Roman Classical letters use a carpenter's pencil, a broad edged nib or a flat brush. Despite their apparent uniformity, the letters have many thick and thin variations and their serifs or finishing strokes require agile pen-work.

```
SENATVSPC
IMPCAESARI I
TRAIANOAV
MAXIMOTRIE
ADDECLARANI
MONSETLOCVSTA
```

ABCDEFG
OPQRSTU

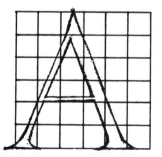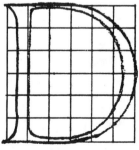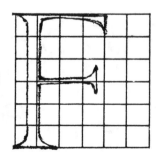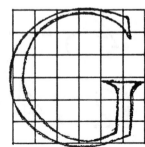

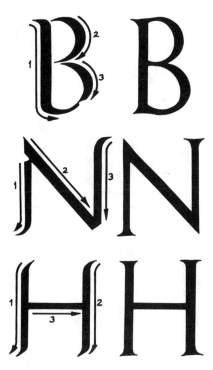

Forming the letters

Roman capitals are written with a broad edged pen held at 30° to the writing line. This angle varies, for diagonals steepen it to 45°. Flatten it for the middle stroke of Z. The serifs and finishing strokes need manipulation of the pen. In order to imitate the chiselled serif the pen serif is completed with the corner of the nib. This technique will only be perfected by practicing it.

Task

Roman capitals stroke by stroke

When you feel ready, start to work your way through the alphabet, making two copies of each letter. Use the stroke order diagram and make each letter 7 nib widths high. Date these sheets when you have finished. Remember to steepen stroke angles on diagonals.

Task

Proportions

Squared (graph) paper can help if you are having trouble with the proportions. Squared paper can be bought in pads from stationers and the paper is suitable for pencil or pen work.

HIJKLMN
VWXY&Z

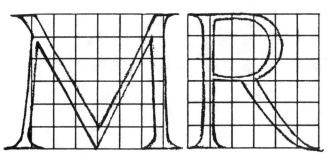

©DIAGRAM

Foundational

This is the hand that calligraphy reformer Edward Johnston (1872–1944) developed at the start of this century for students of calligraphy to begin their studies. Johnston was inspired by a 10th century manuscript, the Ramsay Psalter, to create a lively, springy minuscule which is used with Roman-based majuscules. The latter stem from Roman Capitals.

The pen angle varies a little to achieve a harmonious result. For example, on the diagonals the pen angle is steepened to avoid a weak, thin stroke. The structure of the letters should be analysed and understood before progressing to other hands.

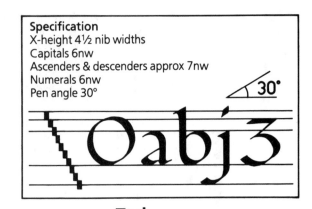

Specification
X-height 4½ nib widths
Capitals 6nw
Ascenders & descenders approx 7nw
Numerals 6nw
Pen angle 30°

Task
Serifs
The triangular serif (**A**) is particularly elegant, while the slab serif (**B**) gives added power to a letter and is used on capitals only. So now work your way through the alphabet and give serifs to your letters.

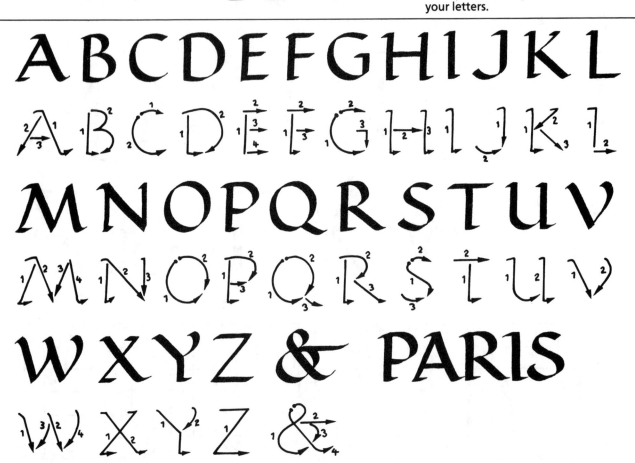

106

Forming the letters

Your capitals should be free and the strokes can end freely with a hairline that complements the minuscule letters. Do not weaken right angles on E L D H K N P R T when creating the serif or a horizontal stroke. Top serifs should not be too heavy either.

The minuscules sit on the line and there should be a continual repetition of the round shape whether it's o c d b g p or q. The letters do not lean forward at all, but tend to sit closely together and are quite free of swoops and swirls found in other hands. Avoid hooking the top of the f, the tail of the g y and the j. The diagonal strokes need a pen angle of 45° to prevent a weak thin line. The tail of the l and t should be generous and stabilize the letter. Don't allow the arches of h n u m and n to get too narrow or have pointed awkward corners. They are based on a segment of a circle and should therefore be quite wide and open. Leave a space only large enough for a minuscule o in between your words.

Task
Learning the stroke order
Take a large, broad nibbed pen and a large sheet of layout paper. Slowly work through both alphabets writing each letter several times to familiarize yourself and memorize the stroke order.

Task
Spacing
Work through the alphabet, using each letter as an initial , writing a short word for each letter. Try to stick to a single theme, such as towns, people's names, animal names, etc. Write once in majuscules and then again in minuscules.

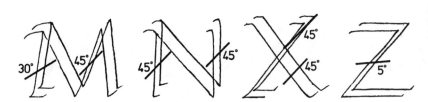

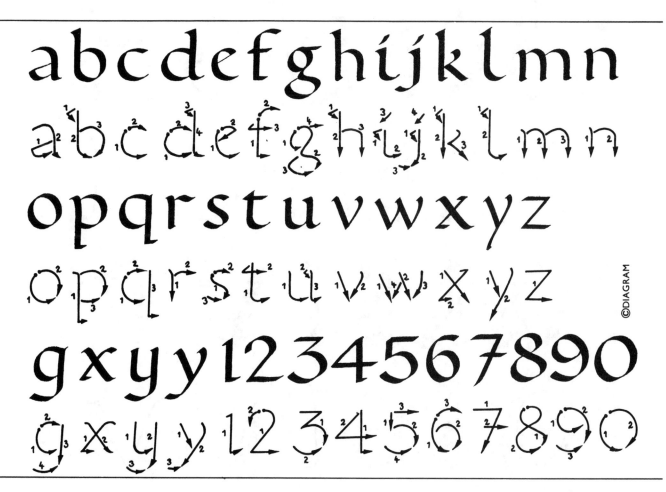

©DIAGRAM

Rustica

Not all Roman lettering was carved in stone. This script bears little resemblance to the fine majuscules chiselled by craftsmen into stone and marble. As its name suggests, this is a comparatively informal hand, but it has been used greatly over the centuries for headings and titles.

Rustica letterforms look deceptively easy, but the pen angle varies so much that developing a rhythm is difficult. It has a strong diagonal stress and is very compact. The forms are condensed and interlinear space is minimal.

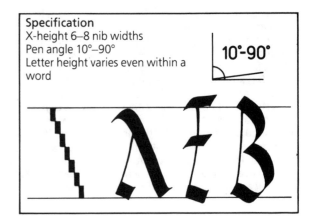

Specification
X-height 6–8 nib widths
Pen angle 10°–90°
Letter height varies even within a word

10°-90°

OCVLLSQVEMALIGLSERV

ABCDEEGH

ABCDEEGH

PQRSTVV

PQRSTVV

Forming the letters

Rustica is best learned with large letters, so you can clearly see the counters (spaces within letters). Use a large nib to contrast the thick and thin strokes. Rustica breaks all the rules for writing in other hands. There is a lot of freedom, based on the need to write fast. Without rushing, experiment with a traditional reed pen or a nylon pen. Writing on textured paper with improvised pens will give you a "rustic" or antiquated image.

A translation between lines of Rustica, called a "gloss," gives a useful explanation to the reader. Letter heights can vary quite a lot, keep your writing compact and springy with minimum interlinear spacing.

This example is taken from an election notice found on the walls of Pompeii (destroyed AD 79).

Task
Rustica and Foundational
Take a simple Latin phrase (a dictionary of quotations might be a good source) and write it with Rustica letterforms. Add a translation in very small Foundational capitals between each line.

Task
With music
Try working while listening to some music. Experiment with pen angles and get the feel of the diagonal stress which varies so much. Find some Latin and write out words and names just for fun.

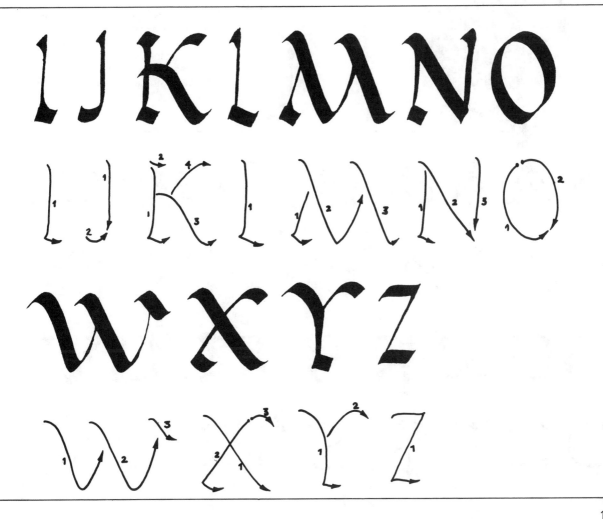

Antique Uncials

Uncial letters (so-called in the 18th century from the Latin uncia) emerged in the 2nd century AD at the same time as parchment and vellum, both of which have smoother skin surfaces than papyrus. Skins could be bound together into a codex (book) and overall the look of the written word changed radically. Uncial became popular with the expanding Christian Church as more dignified and beautiful than the simplified cursive Roman capitals. From the 4th to 8th centuries the Uncial hand virtually replaced Rustica for Christian books and in the copying of pagan literature. The chunky serif is a feature that distinguishes traditional Antique Uncial from its successors.

Specification
X-height 3½ nib widths
Ascenders and descenders 5nw
Pen angle 0°–5°
J K W and Y complete the alphabet
for modern usage
No diagonal stress

0-5°

Serifs
The Uncial hands you see here and on the following pages use the wedged serif, although Uncials may also have clubbed serifs. Wedged serifs are formed by first making a short hairline through pulling the pen sideways to the left. Then you pull the pen down at an angle for a short distance. The pen is then lifted and the full downward stroke is made.

Forming the letters

The pen angle for Uncials is flat, so you will find it useful to keep your elbow tucked into your side in order to maintain the correct angle as you progress along a line of writing. The predominant shape is the flattened O which is found in M H W and T as well as the obviously round letters.

Task
Circular writing

Draw two concentric circles, one with a diameter of 6in (15cm) and the other with a diameter of 5½in (13cm). Write in the area between the circles. Choose a short quotation and turn the paper round often, so that you are always writing directly in front of your body.

An example of Antique Uncials from a psalter written in England in the 8th century. The interlinear words (gloss) were added later in Anglo-Saxon minuscule hand.

Task
Large names

Use a very large pen and write some friends' names in large Uncial letters. Use diluted fountain pen ink, or gentle color for some names and bright colors for others. Add their birthday dates in very small letters within the design. Keep for future reference.

Task
Music and Poetry

The rhythm of music makes an ideal accompaniment to this very rhythmic hand. Music can allow you to distance yourself from your surroundings – quite appropriate with Uncials and Half-Uncials. Irish poetry might also provide interesting and fitting texts.

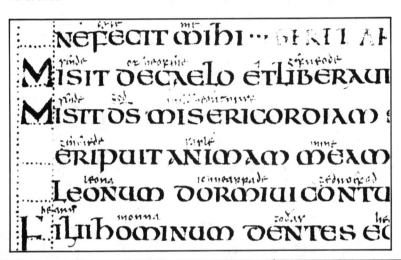

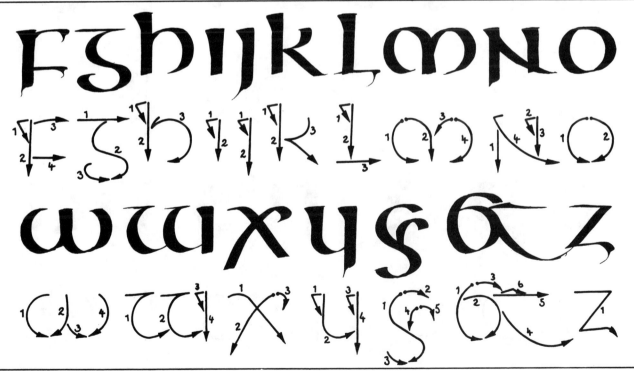

Modern Uncials

The modern form is a derivation from the traditional Uncials. The modern scribe is keeping the spirit of the letter with its chunky serifs and flattened round counters. All antiquated letterforms such as A F G H M are abandoned and the modern versions are used. The pen angle is slightly steepened to facilitate faster writing, and this means that vertical strokes are a little lighter and serifs have a diagonal rather than horizontal top line. You will find this new pen angle easier than the flattened one for Antique Uncials. Finishing strokes taper away to the left.

If you want to write a piece with a Celtic image, this hand is appropriate to use. Many advertisers and graphic designers know this very well and make free use of this hand in their work.

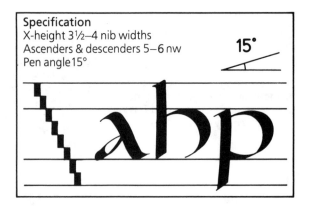

Specification
X-height 3½–4 nib widths
Ascenders & descenders 5–6 nw
Pen angle 15°

15°

BAYEUX DUBLIN NîMES
LA GRANDE-MOTTE ORANGE

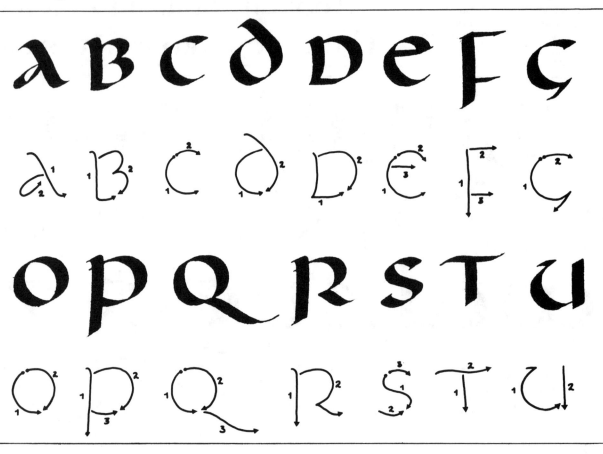

Forming the letters

The pen angle allows you a little more freedom with your arm than you had with Antique Uncials. It is still important to maintain a regular pen angle – this is 15°.

ANTIQUE MODERN

Task
Roundness

Modern Uncials are springy and very rhythmic when well done. Fill a page with writing. Leave only 8 nib widths between writing lines. You should end up with ribbons of writing that when turned upside down look like a free, open pattern. *Never* attempt to squash up the letters. Fill spaces at the end of lines with pen patterns the same weight as your letters.

Task
Double pencils

Use your double pencil and write "the quick brown fox jumps over the lazy dog" so you have used every letter of the alphabet. Compare your version with the letters shown here. The double pencil clearly reveals the structure. Is your angle correct? Do the strokes develop smoothly without creating badly-shaped counters?

Task
The Celtic image

Find a piece of lyrical Irish poetry or prose, so that your text will harmonize with your hand. Work a short piece until it becomes a finished piece, in plenty of space, with or without some appropriate color. Green or red would make the result powerful and vivid. Light blue or gray would add a subtle touch.

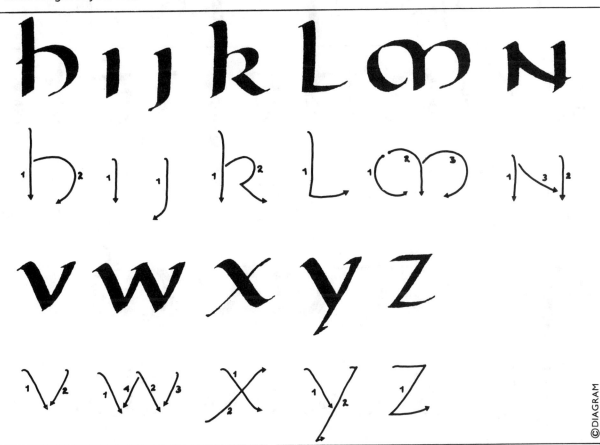

©DIAGRAM

Antique Half-Uncials

Half-Uncials are NOT the minuscules for Uncials. They developed slightly later than Uncials to answer the needs of busy scribes who wanted to write beautifully but more speedily. The letters have a sense of roundness, a heavy wedged serif and are written with the pen angle flattened.

Half-Uncials in the Insular style carry a connotation of Celtic culture. The famous Book of Kells, which is kept at Trinity College, Dublin, was written AD c800 in Insular Half-Uncials, as were a number of other famous manuscripts of that period. The term Insular refers to the islands of Britain and Ireland during the Dark Ages. Half-Uncials anticipate the development of minuscules.

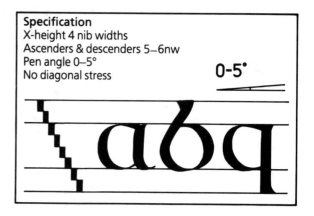

Specification
X-height 4 nib widths
Ascenders & descenders 5–6nw
Pen angle 0–5°
No diagonal stress

0-5°

Forming the letters

Keep the Celtic image, the roundness and the chunky serifs. The new letterforms allow the scribe to keep the pen stroke flowing, rather than build up a letter with four or five separate strokes. The g shows this most clearly. You can use these letters for headings also and, if you wish, paint in the round counters to give the heading more emphasis. Add tiny black dots around the colored counters for a Celtic effect.

The ascenders and descenders are short and headings need very little interlinear space, thereby adding more weight and greater contrast compared with the text. Serifs are formed as in Antique Uncials.

A detail from an 8th century Irish Insular manuscript.

Task
Think "round"
Practice the letterforms, concentrating on the roundness of them. Use diluted ink and write Latin, or use names, so that word patterns can develop.

Task
Line fillers
Half-Uncials look very chunky, so design complementary line fillers. Use the monsters from old manuscripts for inspiration. Use rows of dotted lines around the beginnings of names and color in the counters (spaces within letters) with paint.

©DIAGRAM

Modern Half-Uncials

Antique Half-Uncials, although quicker than Uncials, are still quite slow to write. They serve the patient scribe copying old manuscripts, but are unsuitable for the needs of calligraphy today. Twentieth century calligraphers, by turning the pen to a 15° angle and modifying some of the letterforms, produced a hand known as Modern Half-Uncials. The very round letters, with their short ascenders and descenders, can be written quickly and rhythmically, but retain much of the original Celtic image. For this reason they are often asked for by graphic designers and typographers.

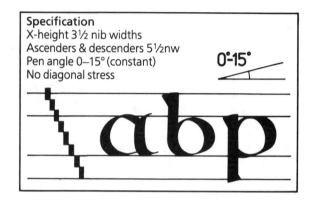

Specification
X-height 3½ nib widths
Ascenders & descenders 5½nw
Pen angle 0–15° (constant)
No diagonal stress

0°-15°

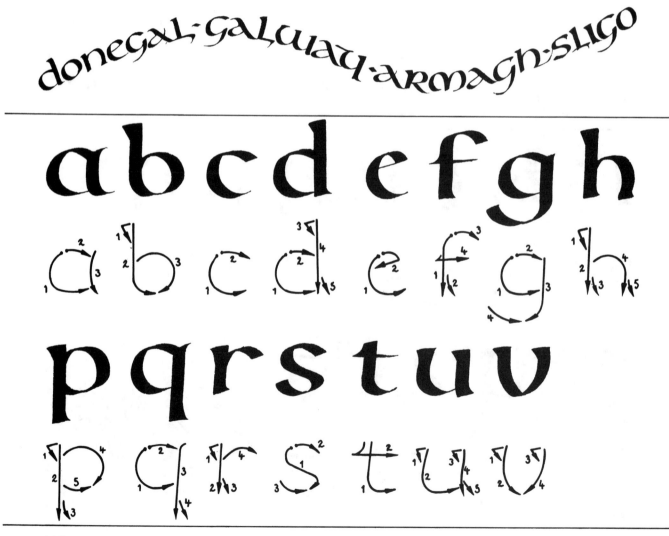

116

Forming the letters

In the examples (*right*) we can clearly see the difference between the Antique (**1**) and the Modern (**2**) Half-Uncial hands. The antiquated letterforms are absent in the modern hand which looks much more like the lowercase alphabet we know today. Concentrate on the roundness.

¹INTERROGABAT

²bokklubben

Task
Shapes

Uncials form ribbons, so consider writing in two columns or around a circle and on wavy lines (these are drawn with a flexi-curve). One quotation could be written in a variety of shapes, all of which are appropriate to Uncial letters.

Task
Texts

You can break with tradition on occasion and use Uncials merely because the lyrical quality of the letters suits your text. Poems, prayers, and philosophical prose can all work well with Modern Uncials. Look widely for possible texts.

Task
Compare details

Write "the quick brown fox jumps over the lazy dog" in Uncial and Half-Uncial using both modern letterforms and the antiquated letters. Look at all four versions and see the subtle differences. Date these examples and store for future criticism and comment.

irish linen

i j k l m n o

w x y z

Carolingian

The Carolingian hand was named after Charlemagne (reigned 768–814), an emperor who never learned to write! However, he understood the power of the written word and commissioned Alcuin of York and his scribes to rewrite many manuscripts. The distinctive book-hand which they created was the forerunner of the letters you see here.

Carolingian was the first genuine minuscule. It has no majuscule form. Usually combined with Roman, Versals or Uncials, it was the most commonly used hand until Gothic took over during the 12th century. It has one letterform with which you may not be familiar – it resembles an elongated r and was adopted because it has fewer strokes than the usual s. Observe the very long ascenders and descenders. They require the lines of the Carolingian hand to be well spaced.

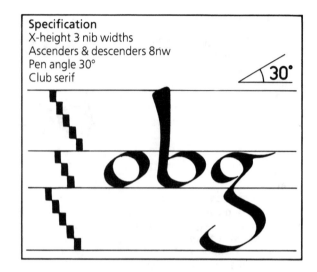

Specification
X-height 3 nib widths
Ascenders & descenders 8nw
Pen angle 30°
Club serif

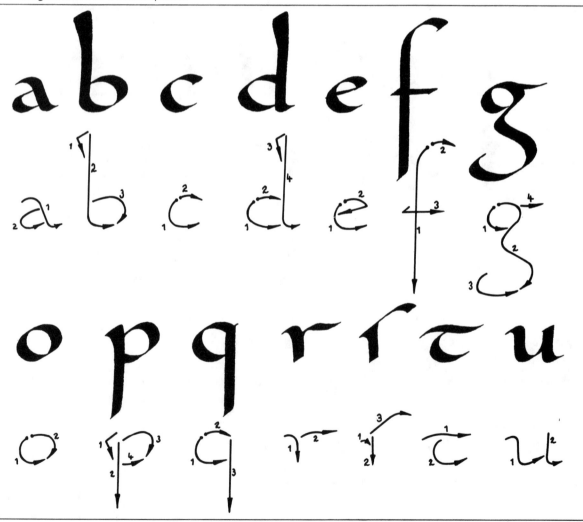

Forming the letters

The Carolingian hand needs plenty of interlinear space as the ascender, with its heavy serif, needs height, and the descender balances it below the writing line. The serif is the device to concentrate on. The two strokes need to blend accurately into one mark; this will come with practice. After learning the antiquated s form, it can be abandoned if you consider the regular s to be more appropriate. The 30° writing angle and very round counters are important characteristics of the hand.

Serifs

The characteristic clubbed serif of Carolingian is formed in a similar way to that of the Uncial hands. Make a hooked downward stroke first (**1**); the long upright stroke (**2**) butts up to it.

Task
Elegance

Find a text which you feel Carolingian elegance would be ideal for. Work it into a finished piece and make it a gift to an elegant person. Try using handmade paper, if possible, and use shades of blue. If you need capitals use Foundational majuscules.

Task
Samples

Write out "the quick brown fox jumps over the lazy dog" several times. Concentrate on long elegant ascenders.

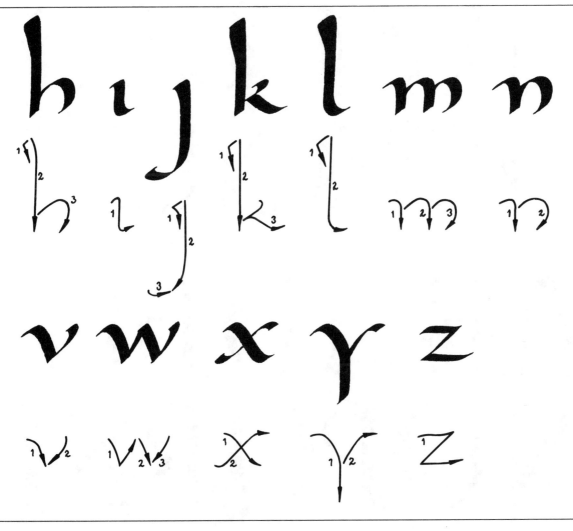

Versals

These elegant capitals are used for headings and to begin verses, hence their name. They combine well with Carolingian Foundational, Italic and Uncial. Traditionally, Versals were outlined with red paint using a fine pen and the gap filled with the same paint using a fine sable brush.

Where a series of Versals was needed down a page, a sequence of red/blue/red/green was usually adopted. Versals were often gilded.

Forming the letters
Versals are built-up letters and are drawn, not written. Draw the inner stroke first to establish the shape of the counter, then add the outer stroke. With vertical strokes aim for the subtlest of shapes, slightly waisting the stroke in the middle. Don't exaggerate this feature. Hairlines should be lightly drawn with the pen held 90° to the writing line. Dilute your paint as it gradually dries out and gets too thick for penwork.

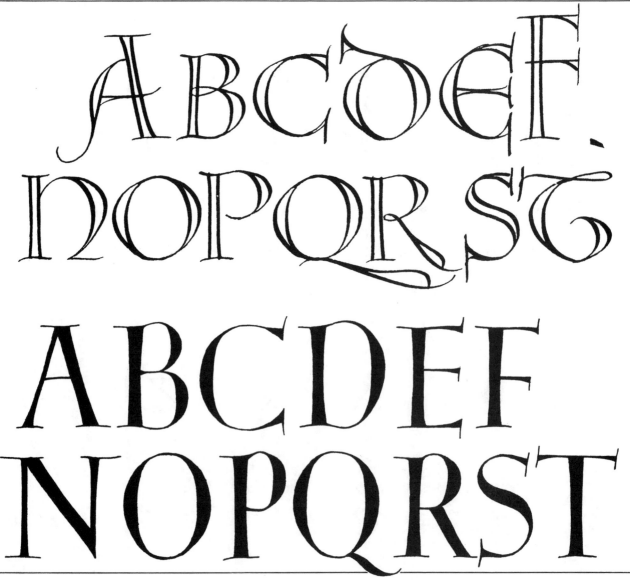

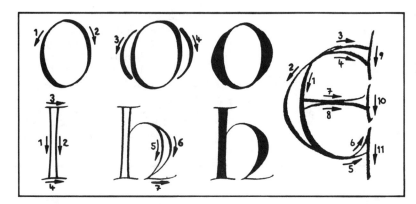

Task
Practice Versals
Using red paint mixed to a milky
consistency and a fine nib, draw
the outlines of these letter shapes.
Turn the pen for the hairlines and
the thin strokes. After five or six
letters, flood the letters with the
paint using a fine sable brush.
Check your proportions and stroke
widths.

GHIJKLM
UVWXYB

GHIJKLM
UVWXYZ

Lombardic Versals

These extravagant letterforms are produced in the same way as the Versals on the previous page. They were first created in medieval northern Italy as their name implies. They can be a superb design feature, but need to be used sparingly as they tend to overpower a text.

Three types of versals
1 Lombardic letters by the American typographer Frederic W. Goudy (1865–1947) published in 1918.
2 Spanish 16th century Versals with elegant waisted strokes and exaggerated hairlines.
3 Dutch Decorated Versals by Evert van Dijk with diamond shape pattern and embellished hairlines.

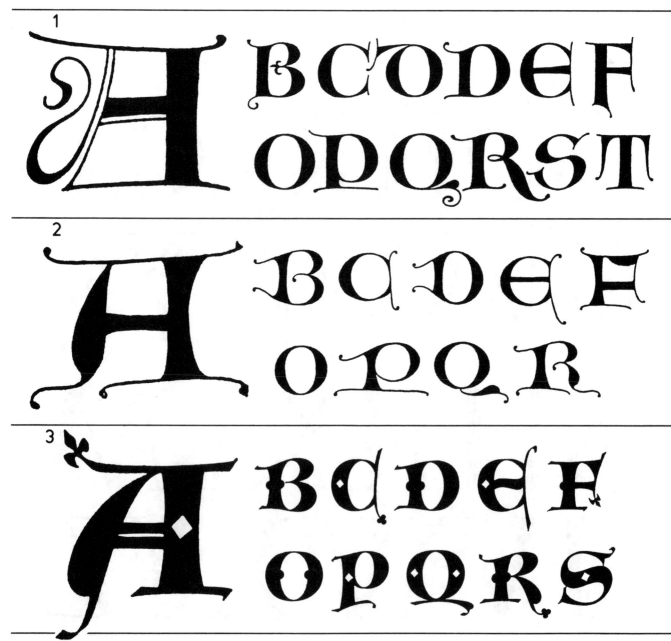

Task
Family names
Develop some family names with Lombardic Versals, using color appropriately. Keep the very round quality of the individual letters and add patterns and devices to the large colored areas. Aim for an heraldic image.

Task
Huge
Use Lombardic letters at least 2in (50mm) high so there is plenty of room for a detailed pattern within the strokes. Work in black and white on one short word or name. Trace or photocopy the result many times and make a repeat pattern of your design.

Task
Miniature illustration
Use Lombardic initials as frames for tiny detailed paintings in the counters. Obviously O D C H N P and Q are ideal. Your initial could be ¾in (20mm) or 1¼in (30mm) high. Gain inspiration from old examples. Watercolors and sable brushes are best for this illumination work.

Basic Gothic

There was a powerful economic reason for the introduction of Gothic letters. Increased production of books had led to a shortage of vellum and parchment and therefore an increase in its cost. Calligraphers had to get more writing on each page! For this reason Gothic has little space between lines, the letters are tightly packed and the penforms are angular – even the o has corners. For further compactness ascenders and descenders are short and letters are compressed, sometimes to the point of sharing a common stem. Abbreviations are widely used.

It is the compactness on the page which gives Gothic writing its nickname Black Letter. The density of a page of Gothic is enlivened by the use of vermilion majuscules, whose roundness contrasts with the angularity of the minuscules. However, both majuscules and minuscules are difficult to read unless they are carefully spaced.

Technique
Turn your wide pen 90° to the writing to make Gothic serifs and capitals.

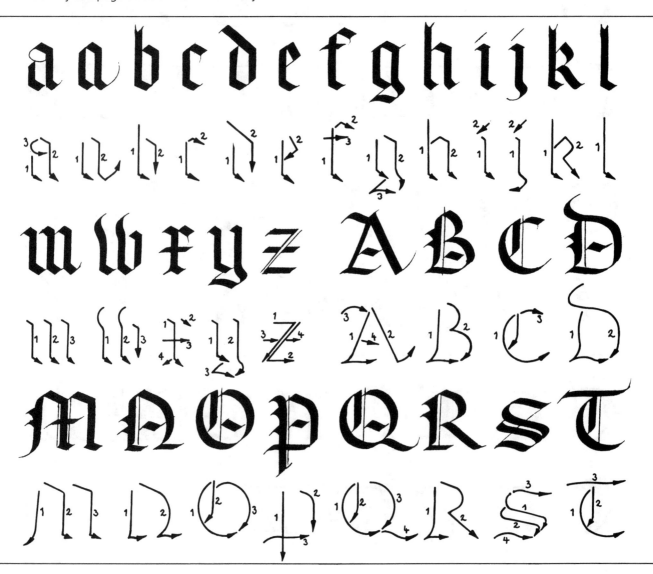

Specification
X-height 5 nib widths
Capitals 6nw
Ascenders & descenders 7nw
Pen angle 45° (90° for hairlines)

Task
Practice spacing minuscules
The basic stroke is the letter i. Aim to balance white space with black mark. Check your work by turning it upside down. Words should resemble a set of railings (*see below*).

Task
Building up majuscules
Use a double stroke automatic pen or another large nib. Practice majuscules until you are familiar with them.

minimum

mnoqprlsstuv

EFGHIJKL

UVWXYZ

©DIAGRAM

125

Traditional Gothic variations

There are a lot of Gothic variations. Beware trying to write one that was originally a typeface! You need a variation that was originally a pen form, in order to study and emulate it. The basic requirement is legibility, so beware the ornate versions such as the Textura on this page when writing a long text. There are only a few opportunities to use Gothic calligraphy. When they occur give yourself some time to revise your knowledge of the letterforms. The time will also build up a confidence that will give you the regular rhythm that Gothic requires.

With Textura the "basic" stroke is, in fact, 3 individual strokes and this will mean you write slowly and lift the pen more often than with other Gothic hands.

ABCDEFGHIJ

KLMNOPQRS

TUVWXYZ

abcdefghijklmno

pqrstuvwxyz

1234567890

Textura Gothic
A Textura Quadrata script written in France in the early 14th century. The letters have a rhythm which prevents the page looking heavy and dull. The fine hairlines are achieved by turning the nib onto a corner and using little or no pressure on the pen (*below left*).

Dürer's Gothic
Gothic capitals designed by Albrecht Dürer in the early 16th century are not easy to learn, but very lively. They contrast with his traditional Textura Gothic minuscules which tend to be very formal and regular (*below*).

Task
Rhythm
The strong rhythm of Gothic means that this hand is ideal if you have had a long break from calligraphy and need to practice. There is a strong vertical stroke which will encourage you to hold the pen at a consistent angle.

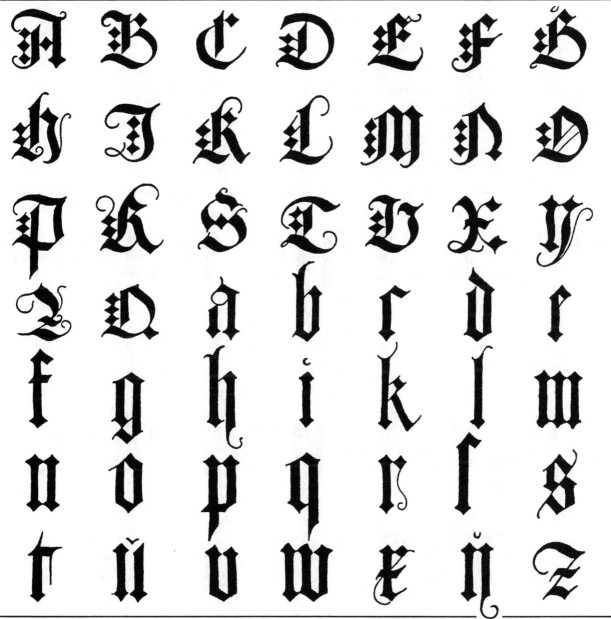

Modern Gothic variations

There are two variations of Gothic which mix Gothic characteristics with Italic influences. The difference between them can clearly be seen here. With the modern condensed hand there is an air of formality. It is suitable for writing prayers, instructions and rules, and conveys dignity and authority without being archaic. Foundational capitals work very well with it and their roundness balances the angular minuscules in the traditional way.

With the pointed Italic you can see Gothic arches are mixed with the Italic proportions and rhythmic flow. The result is an informal lively hand, crisp and sharply defined. It is ideal for light prose, greetings and witty texts. It also works very well on an undulating writing line drawn with a flexi-curve. The long ascenders and flaring descenders demand more interlinear space than is usual for Gothic. It looks effective written in color, but should be avoided when writing a book or narrative, as it lacks the regularity and steadiness needed for a long text. Use Italic capitals, either simple or with swashes, with these thoroughly modern letters.

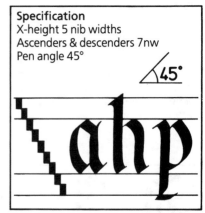

Specification
X-height 5 nib widths
Ascenders & descenders 7nw
Pen angle 45°

Task
Condensed only
Write out a prayer using this hand. Compare it with a traditional Gothic version. Develop the version you prefer into a finished piece of writing. Exhibit for criticism and comment.

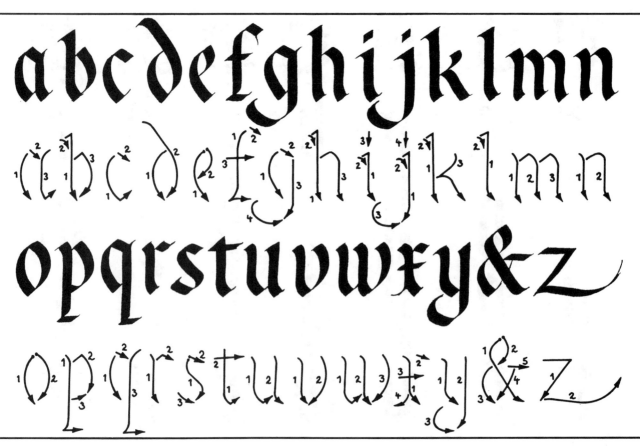

Specification
X-height 5 nib widths
Ascenders & descenders 7–8nw
Pen angle 45°

Task
Initialled greetings cards
Using textured card or paper make a simple greetings card. Write initials in red on the outside of the card and put your message on the inside. A set of cards with large initials on the outside and blank inserts could provide you with your own distinctive stationery.

Task
Pointed Italic only
Find a witty text and, using a flexi-curve, draw gently undulating lines instead of traditional straight ones. Develop this into a finished piece using color. Avoid a rainbow effect, work in tones of one color. Date and exhibit for criticism.

Modern Gothic

pointed italic

abcdefghijklmn

opqrstuvwxyz&

©DIAGRAM

Rotunda Gothic

Southern Europe suffered the same economic pressures that led to the introduction of Gothic in Northern Europe. However, Italian and Spanish scribes rejected the rigid angularity of its letterforms. They therefore produced a hand which, while a true Gothic, is also a compromise with earlier letterforms. The rounded letters got the hand its name – Rotunda. It is robust and round, but retains a compactness with its short ascenders and descenders, and needs little interlinear space. It works well with musical notation.

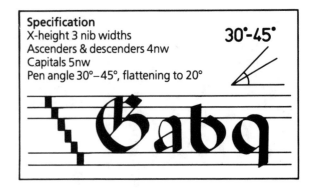

Specification
X-height 3 nib widths
Ascenders & descenders 4nw
Capitals 5nw
Pen angle 30°–45°, flattening to 20°

30°-45°

rundgotisch

abcdefghijklmno

pqrſstuvwxyzß

&tch!?1234567890

Forming the letters

Be prepared to adjust your pen angle. The serif is made with two strokes, and the pen is flattened to complete the serif and at various other times (*see below*) forms a flattened top to the ascender. Flatten the pen angle for the serif, for dots, full stops (periods), and crossbars. Turn the pen for the thin lines on the capitals.

Task
Round and sharp

Rotunda combines Roman roundness with Gothic sharpness. You need to practice the shapes and the spacing, so write *words*. Retain the roundness in the counters and sharp corners at stroke junctions. Don't extend ascenders and descenders. Date your practice sheets.

Task
Capitals

The roundness in the capitals is similar to others, so some letterforms will seem much like other Gothic variations. Some letters, however, are strange and

Task
Minuscules

Take a short text, prose or poetry, and use it to practice with. Start writing with a steel nib and then an automatic pen. Don't forget to vary the size of the letters, but not the number of nib widths. When you feel confident, make a final version of your text with letters only ¼in (6mm) high. Date this and store for reference.

need more time spent on them. Study this alphabet with your double pencil pen, then a large steel nib and finally an automatic or a Coit pen. Date and store practice sheets.

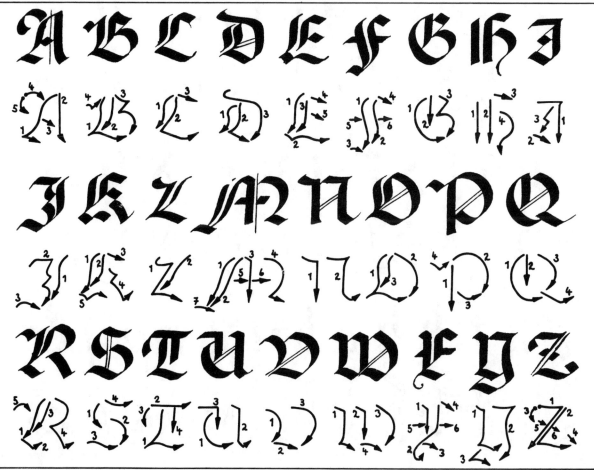

Formal Italic

While Germany developed the tight and economic Gothic script, it was Italy which created the most elegant of letterforms – Italic. This again is a generic term for a family of hands all of which have the same characteristics but which also have many variations. What they all have in common is the branching arches and the elliptical o shape.

As you continue your study of Italic letters you will find a considerable number of variations. It is a letterform that lends itself to decoration and embellishment. To begin with, though, look at Italic in one of its simpler forms. When ruling up allow plenty of space for long ascenders and descenders and avoid being angular as you write. The 5° lean to the right will develop as you learn to write with speed and rhythm. Do not aim for speed at the beginning, it will tend to distort your letters!

This flexible letterform will serve you well and you may find yourself using it more than any other for your project work.

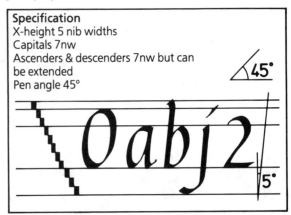

Specification
X-height 5 nib widths
Capitals 7nw
Ascenders & descenders 7nw but can be extended
Pen angle 45°

Forming your letters

A constant angle and parallel strokes are essential. Italic letters without ligatures (joining strokes) are more formal. Ligatures tend to speed up the writing, which in turn creates a more informal look. This is known as cursive. Avoid using all variations or the serif in one piece of work!

Task
Letter Construction

Using the double pencil, write out the alphabet, both majuscules and minuscules, so that the construction of the strokes and serifs is understood. Use large sheets of layout paper. Date these early attempts.

Task
Double pencils

Using double pencils, write out "the quick brown fox jumps over the lazy dog". Check for bad habits such as sloppy strokes, weak joins, squashed counters and bunched-up words. Turn your work upside down for criticism and rewrite the sentence. Date the second version and store safely.

Sample

Here we see the regular rhythm of formal Italic at its best in a French manuscript of 1550. It was written in Rome by Victor Brodeau for the French Ambassador to the Apostolic See (right).

Pour charite, vne occulte venoence,
Pour humble port, vne estreme arrogance.

ABCDEFGHIJKL

MNOPQRSTUVW

XYZ 1234567890

Italic with swashes

Swashes are decorative extensions of the letterstrokes. While they add nothing to the meaning of the writing they can, nevertheless, imbue the text with a feeling of grace and elegance. They are often used for display work, for greetings and on stationery.

On the minuscules swashes are extra long ascenders, curved tops or long flaming descenders. Swashes serve as introductions to the majuscules and in a text are used as headings or initials. Hairlines often extend the line of the swash. To work well, a swash needs to be a confident line. This comes with practice, as does knowing when and where it is appropriate to use swashes. The danger lies in doing too much to your text with the result that the words become too cluttered and the reader is distracted.

1 ABCDEFGHIJKLM

2 ABCDEFG
OPQRST

3 abcdefghijklmnopq

4 abbcdefghijklmnop

Italic variations
1 Elegant majuscule alphabet in basic Italic with added swashes.
2 More ornate capitals.
3 Minuscule alphabet which can be used with **1** or **2**. It has hooked ascenders and generous hairlines.
4 Minuscule alphabet with x-height extended to 6 nib widths which makes a light elegant hand ideal.

Task
Small letterforms
Use a fine nib (W. Mitchell No. 4 is ideal) or quill to write names and practice swashes on majuscules. Then practice minuscules by writing lines of names. Develop a name into a design by extending the capital letter and then experimenting with ascenders and descenders available.

Task
Large letterforms
Use a Coit pen, an automatic pen or a large felt tip to write these swashes as large as possible. Use 11 × 14in (A3) size paper and work freely. Look at the counters and the shapes of swashes when assessing your attempts.

NOPQRSTUVWXYZ

HIJKLMN
UVWXYZ

rstuvwxyzß&&ﬆ

pqqorstuvwxyyyy!?

©DIAGRAM

135

Roundhand or "Copperplate" 1

Copperplate is a general term for a family of Roundhand writing styles which developed from Italic in the 16th century. This new style was flowing and looped and the pen was not lifted from the paper. Variations of this basic Roundhand, which was introduced by Gianfrancesco Cresci of Milan in 1560, soon spread throughout Europe except Germany which retained the Gothic image. The new style suited the new printing method of engraving onto a copperplate. Pictures and writing reproduced well and Roundhand writing became known as "Copperplate".

It is used today whenever a formal look is needed.

The traditional tool is a fine flexible pen. This was originally the quill. Since the invention of the steel pen in the 1830s there are two sorts of nib, broad edged and fine pointed. For Copperplate writing you need a flexible pointed nib and the technique is to apply controlled pressure on the *downward* strokes. Finishing touches are permissible. Much practice is needed, not only to acquaint yourself with the ornate letterforms, but also to gain experience of the pressure technique with the flexible pointed nib. Look at the next page before you start work on this alphabet.

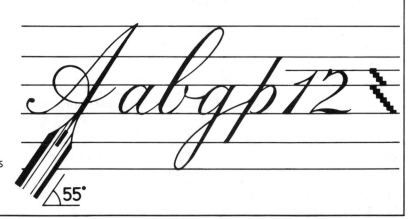

G H I J K L M N

V U W X Y Z

y z . 1 2 3 4 5 6 7 8 9 0 .

Roundhand or "Copperplate" 2

On this page is another Roundhand alphabet. This elongated version is extremely fine and shows some letterforms to work on. Observe the lack of looped ascenders in this minuscule hand which looks deceptively simpler than loops, but in practice this is not the case!

Strokes
There are four strokes for Copperplate.
1 Part of the letter is formed with hairlines as the nib travels across the paper.
2 When pressure is applied the nib widens and forms swells that begin and end in hairlines.
3 Some strokes have square ends.
4 Hairlines joining letters are known as ligatures.

Hand, pen and paper positions
1 Right handed 55° Copperplate angle.
2 Left handed 55° Copperplate angle.
3 Elbow joint pen designed to help right handers.
4 Adjusting the paper position also helps you write at 55° to the writing line.

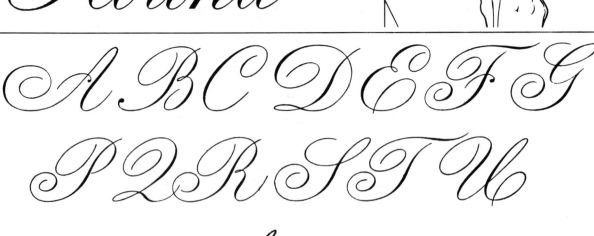

Forming your stroke

Practice the basic strokes. Learn to mark lightly then apply pressure on the down stroke and release it by the time you reach the writing line. Curves and loops are created *without* pressure, while the down strokes are thick from creating considerable pressure. The nib opens a little with the additional pressure allowing the ink to flow freely and make a wider mark. Reduced pressure gradually closes the nib and so narrows the ink flow. For the final curve of the stroke a light touch is needed, to narrow the nib back to a fine point.

Practice strokes

These five patterns below will help you to establish your pressure and release technique with the flexible-pointed nib. Do each exercise over and over again until you can keep all of the strokes consistent. Music can help you acquire regular pattern marks.

Task
Technique

Experiment with the pressure technique by creating repeat patterns out of several of the letters, lo bi pr qu wo, etc. Too much pressure will damage your nibs, which should then be thrown away.

Task
Minuscules

Old writing manuals had pages and pages of text to copy, so that school children would learn to write well. Select a text and keep writing, only using minuscules. Don't cross through bad letters, simply rewrite the word and fill the page with your writing.

Task
Capitals

After mastering minuscules, write a text with capitals beginning each word. Capitals on their own are impossible to read, rather like Gothic capitals. They work with minuscules. Take a few capitals at a time and learn their construction.

Review

Throughout this chapter you've seen numerous letterforms and followed a great number of instructions. Before you can write well and capture the spirit of the letter you need to see letterforms in context within words and written in lines. Here you see several examples by historical writing masters that should help you to assess the overall image of the letters. It is when you see whole pages, complete with headings, margins, illustrations and glosses that you begin to appreciate the subtleties of the letters and their cultural message. It is essential to see letters in finished manuscripts, to see the color, examine the texture and appreciate the sheer beauty of pen-made letters.

Historic manuscripts
1 Roman Rustica capitals from the *Codex Palatinus* in the Vatican Library, Rome, 4th to 6th centuries.
2 Uncials from an Anglo-Saxon written *Rule of St Benedict*, 7th or 8th century.
3 Insular Half-Uncials from the *Lindisfarne Gospels* written in NE England c698.
4 English Carolingian minuscules from the *Benedictional of Aethelwold* (Bishop of Winchester's blessings), probably written 963–984.

BEATI GREGORII

PAPE URBIS ROME

5 Versals from *The Dialogues of St Gregory*, 12th century French manuscript.
6 Page of Italic from Juan de Yciar's *Arte Subtilissima* (1550 edition published at Saragossa, Spain).
7 Gothic Textura from the English Queen Mary Psalter, 15th century.
8 Rotunda with musical notation from a North Italian Dominican Gradual or choirbook, late 15th century.

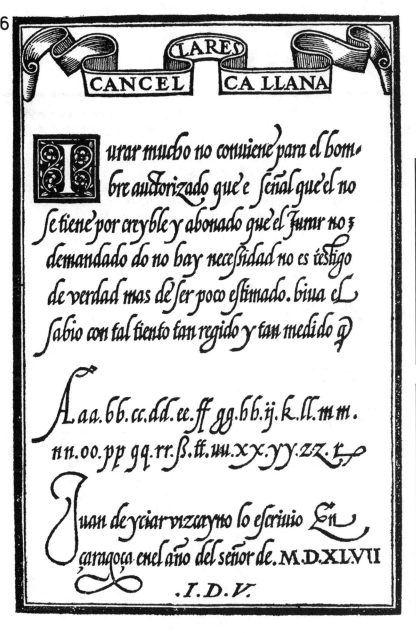

Chapter 3

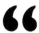 *The artist needs the letter, the letter needs the artist.*

RUDOLF VON LARISCH

It is necessary to learn about the method of ruling up and transferring down guidelines accurately before applying your knowledge of penmanship to finished pieces. There are several methods, some of which have been used by scribes for centuries.

Some are more complicated than others and all have advantages and disadvantages. Nevertheless, they allow the calligrapher to be accurate and make more efficient use of time, which in the end results in better work. Merely using the familiar ruler and a pencil will lead to inaccuracies. Equipment that makes lines square or parallel is well worth using. Soft pencil marks can easily be rubbed out if mistakes are made, but a hard pencil is best for lines which will never be erased. These should be hardly visible to the reader.

Pricking through
Careful examination of old manuscripts reveals this time-honored method. It saved the scribes time and ensured that all pages of a book matched. When you have successfully completed one piece of work, you can use it as a "master" by pricking through with a pin or other sharp point where each line starts and finishes. The prick marks will show on the pages underneath and can then be joined up in light pencil using a rule. The tiny holes can be hidden afterwards by rubbing gently on the back of the paper with a fingernail.

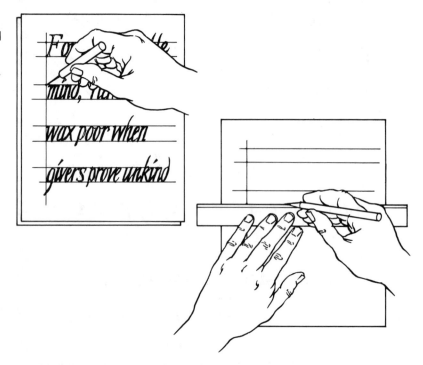

DESIGN AND DECORATION

This chapter is concerned with the preparation, handling and presentation of your written pieces. These are neither secondary nor ancillary techniques nor casual afterthoughts, but an essential part of the routine for planning and setting out your calligraphy to the best possible effect. They can both save valuable time and also do much more to enhance the appearance of your finished lettering.

Transferring lines
A paper rule is used for transferring measurements from an original in order to make accurate copies. You can make a paper rule from a piece of card. Hold it against the original margin and mark off the positions of the writing lines using a very sharp hard (4H) pencil. The rule is then placed against your fresh sheet and the marks transferred using your pencil. An alternate method is to use dividers to transfer measurements from the original to the copy (see illustration page 97). Remember to keep a record of the nib sizes and colors used in your work for future use.

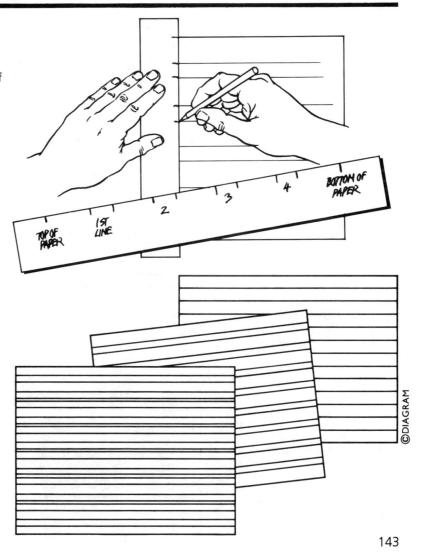

Pre-ruled sheets
These are sets of ruled lines that are placed underneath your layout paper and which will show through, indicating where you should write. Having several available, each one drawn to the correct size for the nibs you use most, will be very useful. You can also make up page layouts with marks indicating margins and spaces for large initials, headings, etc. Photocopied enlargements and reductions can be made.

©DIAGRAM

Layout

Your job as a calligrapher is to produce a good page or broadsheet. For this you need to know the traditional layouts that have served well over the centuries.

Margins are essential to present your writing and these must not be undervalued. If in doubt leave plenty of space and trim gradually!

Planning a text is essential at the beginning of a project. It is not an afterthought. Write out your words and then see which layout would present them best. Don't be too rigid, a left-hand margin is only *one* of many starting points. You have a lot of decision making to do. Your resource box is invaluable here.

Calligraphers, like actors, are interpreters of someone else's words so read through anything before you write it out so that you can pick out the subtleties, humor, pathos energy or any other human emotion which may lie within it and develop them. Remember, whatever is being expressed, it must be done so LEGIBLY. Your main objective is to render clearly your understanding of the author's words.

Historically, calligraphy competed with illustration and words became overwhelmed by artists whose pictures could be understood by non-readers. Don't be tempted to add too much decoration and embellishment to your page. Let the calligraphy breathe.

Alignment

There are five basic ways of aligning text:

A Justified; both the right and the left hand edges form a straight line.
B Ranged (flush) left; the left hand side forms a straight line.
C Ranged (flush) right; the right hand side forms a straight line.
D Centered; the lines are uneven in length – but the layout is symmetrical.
E Asymmetric; the lines are not aligned and are freely positioned.

Using columns

Traditionally, Bibles and religious texts have been written and printed in columns. This is an ideal way of putting a lot of writing on one page. If you are writing a book consider the effect of both pages being sewn together. Historically, if one page had a lot of illumination or headings, the other would be simple.

1 Versals used to introduce paragraphs.
2 The *verso* (left-hand) page is simple. The *recto* (right-hand) page is illuminated.
3 The right-hand column is the main text and the left-hand column is a translation which is in a different color and often using a finer pen. Translations are traditionally known as glosses.
4 The left-hand margin is staggered so that it complements the right-hand side.

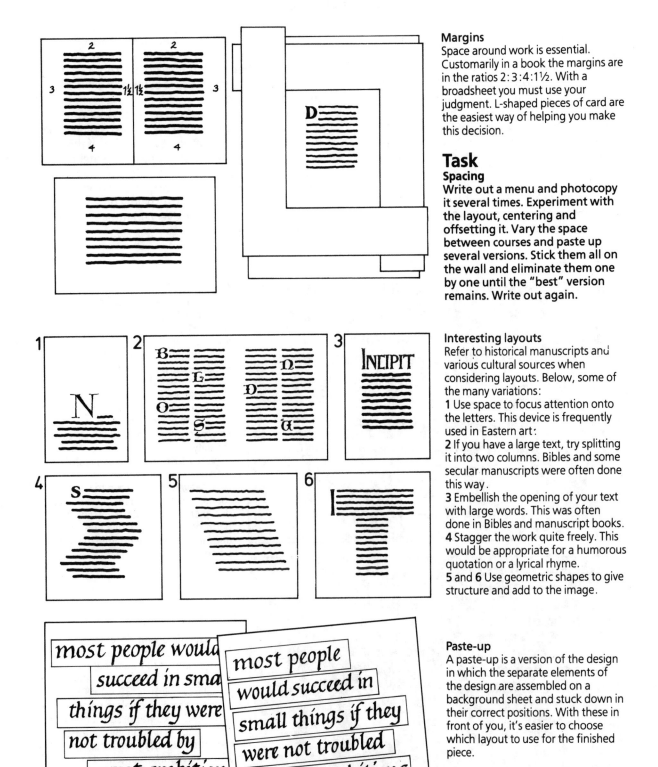

Margins

Space around work is essential. Customarily in a book the margins are in the ratios 2:3:4:1½. With a broadsheet you must use your judgment. L-shaped pieces of card are the easiest way of helping you make this decision.

Task

Spacing

Write out a menu and photocopy it several times. Experiment with the layout, centering and offsetting it. Vary the space between courses and paste up several versions. Stick them all on the wall and eliminate them one by one until the "best" version remains. Write out again.

Interesting layouts

Refer to historical manuscripts and various cultural sources when considering layouts. Below, some of the many variations:

1 Use space to focus attention onto the letters. This device is frequently used in Eastern art:

2 If you have a large text, try splitting it into two columns. Bibles and some secular manuscripts were often done this way.

3 Embellish the opening of your text with large words. This was often done in Bibles and manuscript books.

4 Stagger the work quite freely. This would be appropriate for a humorous quotation or a lyrical rhyme.

5 and **6** Use geometric shapes to give structure and add to the image.

Paste-up

A paste-up is a version of the design in which the separate elements of the design are assembled on a background sheet and stuck down in their correct positions. With these in front of you, it's easier to choose which layout to use for the finished piece.

©DIAGRAM

145

Illumination and color

We associate old manuscripts with gold and an abundance of color to enhance the writing. Traditionally, this was done by a rubricator who added red initials to the page and artists who filled counters with small pictures; the gilder applied the gold before the artists drew their designs. Nowadays you have to do all these jobs!

The basic rule to follow always when mixing paint is to add the water to the paint, *never* the other way round. This applies whether you are using cakes, tubes or jars of paint. Keeping colors such as vermillion and white in screw-top jars will encourage you to use them more. Diluting some black fountain pen inks will give a gentle grey-blue tint which is very subtle and effective. To avoid accidents when using colors, make sure your brush handles are short so that they do not knock over jars of paint. Securing bottles of ink and color to the desk also helps.

When using color on a long piece of work you may have to keep adding water to the paint to make up for moisture lost through evaporation. If this occurs, add just a few drops of distilled water using a dropper. Try not to do this too often or the color will fade toward the end of the piece of work.

Finally, always try to keep the paint consistency milky – thick paint can look very unattractive and is difficult to handle.

Illumination
Traditionally the manuscript was written before the decoration. Beware trying to perfect a piece of writing. The picture, the initial, the gold and the other colors are there to enhance the page not to compete with the text. When many people could not read, these pictures conveyed a lot of the meaning of the words and played a big part in communicating the Bible stories to the laity.

If you are no artist you can team up with an artistic colleague. Alternatively, simply keep to natural forms, or refer to old manuscripts or designer reference books. Traditional patterns are drawn with a fine nib and larger areas are flooded in using a fine sable brush.

Late Gothic ornamentation
These two manuscripts each have good examples of traditional illumination. The top one, a Latin missal from Milan (c1390–1400), has large Lombardic Versals in color to begin each paragraph, surrounded by simple line decoration. By contrast, the Dutch breviary from Utrecht (c1490) is highly ornamented (*left*), the large initial is filled with a painting, and decoration is based on natural plant forms surrounding the columns of text.

Sources of initials

Books of decorated initials are a great source when you are trying to design one for yourself. There is no need to try and be original; adapt what you find and retain the balance of weight between the design and your page of writing.

Task
Red and black

Using red and black on white paper write a piece using Gothic letterforms, red for the capitals and black for the minuscules. Consider using a translation here.

Task
Hot and cold colors

Draw some Versals and use the Foundational color scheme of red, blue, red, green. It can be a greeting or a quotation. Balance the hot and cold colors in your project.

Red letter days

When a medieval scribe wrote out a text he would leave spaces for the capital letters. The text would then be passed to the rubricator who painted in the red initial letters. When calendars were written out, the saints' days were usually written in red. Special occasions thus became known as "red letter days"

Task
Children's rhymes

Take a nursery rhyme and, using color to give charm and freshness, write it out. (Try not to make it look like a rainbow!) Pen drawings can also be used to decorate this if you wish. Try using either Carolingian, Foundational or Half-Uncials. Date and store for reference.

today is your red-letter day

© DIAGRAM

Gilding

Gold leaf, when applied to a slightly raised surface, catches the light. In a manuscript, this is known as illumination. The term now embraces the practice of painting pictures and patterns within and around initial letters.

An illuminated letter is usually in the Versal hand, and the cushioned surface which the gold adheres to is made from gesso, which is a mixture of chalk, fish glue and other ingredients. Gold leaf, once stuck to the gesso, is burnished until bright. The effect can be stunning! Using gold in the traditional way is not easy without practice, so two simpler methods are also illustrated here.

The traditional method of gilding
This process can be fraught with difficulties, but if you have ever seen an illuminated manuscript you may find the desire to try it for yourself too strong to resist!

1 Using a fine nib, draw out the shape of the Versal letter to be gilded. Move your work to a flat area and flood in the gaps within the strokes using a fine sable brush loaded with gesso. Work quickly and allow the gesso plenty of time to dry. It helps if a little color is added as milky gesso is not easily seen on the page.

2 Using a sharp knife, gently scrape the domed surface of the gesso "cushion". Aim to flatten its general shape and to remove tiny holes left by air bubbles.

3 Gently take a piece of gold leaf from its protective booklet by sliding it onto a leather cushion. Cut it into pieces about the size of a postage stamp. Take great care not to disturb the gold leaf with jerky movements, or it will float away!

4 Make a small paper tube (about the size of a cigarette). Breathe deeply down this tube onto the surface of the gesso. The purpose of this breathing is to dampen the surface of the gesso for the gold to stick to it.

5 Apply the piece of gold to the gesso with a pair of tweezers and a silk cloth to press it down. Then use an agate or hematite burnisher to rub the gold firmly, particularly around the edges.

6 Burnish the gold until it shines brilliantly. Remove excess gold from around the outside of the letter using a brush if it is loose, or the point of a sharp knife if it is sticking firmly.

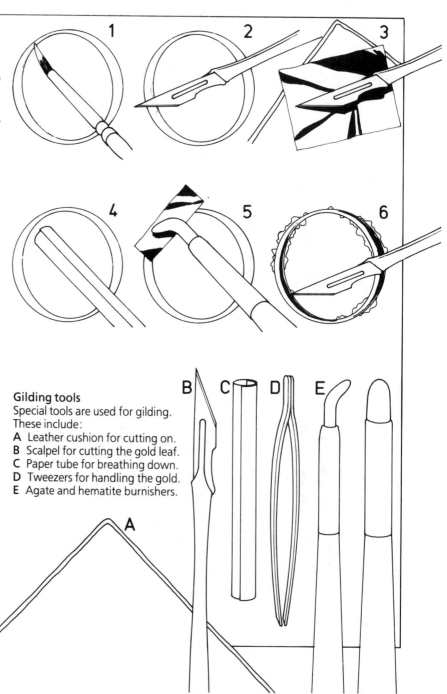

Gilding tools
Special tools are used for gilding. These include:
A Leather cushion for cutting on.
B Scalpel for cutting the gold leaf.
C Paper tube for breathing down.
D Tweezers for handling the gold.
E Agate and hematite burnishers.

Transfer gold

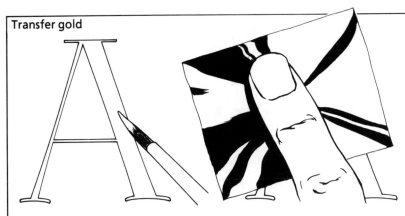

1 Use PVA (polymer emulsion) not gesso. This can be bought from art shops. Dilute with a few drops of water, and tint with a tiny amount of gouache before use. Draw out the letter and flood in the wide areas with a fine sable brush. Allow the PVA to dry for at least 30 minutes.

2 Breathe heavily on the PVA to make it tacky. Lay the sheet of transfer gold on the letter. Press down firmly on the back of the sheet, especially around corners and edges.

3 The gold is burnished indirectly, through a piece of clean transfer paper from the booklet of gold leaf. Rub the burnisher over the letter until the gold begins to shine.

Shell gold

Shell gold is available from specialist art shops. It is a form of gold paint which can be burnished.
1 Draw the outline of the letter with a fine nib in the usual way. Using a fine sable brush, fill in the spaces with an undercoat of colored paint (yellow ochre gouache is the most suitable). Allow plenty of drying time.

2 Stir the shell gold well before use and apply to the undercoat with a fine brush, covering the undercoat completely.

3 When dry, burnish gently to begin with and gradually apply more pressure, either through a piece of crystal parchment or directly onto the gold. Shell gold can be decorated in the traditional manner by making marks on its surface using a sharp instrument.

© DIAGRAM

Task
Transfer gold
Practice gilding using an offcut of vellum, PVA and transfer gold. Make notes on the details (amounts used, drying times, etc) so that you can benefit from these experiences.

Task
Shell gold
Experiment with shell gold on dark paper to create a dramatic impact. This can work very well with a text. The writing can be in white using white poster paint kept at a running consistency.

Task
Gift
Make a gift to a special friend by gilding his name or a short quotation on an offcut of vellum. If you decide to frame gilded work, always use a window mount so that the protective sheet of glass is held away from the raised surface of the gold.

SECTION 3
APPLIED LETTERING

Letterforms are an important part of our lives. They direct, inform, persuade and give us pleasure. Whether consciously or subconsciously we are drawn towards the "silent persuader." Many thousands of lettering styles in their differing shapes and guises, produced by various methods and in a myriad of materials, are continually beckoning us to read.

This section has been written for those with little or no previous knowledge of the proportion and construction of letterforms. The step-by-step instructions given will introduce the reader to the world of lettering from basic alphabet construction through to finished projects.

Materials, tools and surfaces, and a good working area, are an important foundation, but enthusiasm and patience are also vital ingredients if the subject of creating letterforms is to be mastered.

Different alphabet styles and a letter's constituent parts are discussed. After studying the topics of letter and word spacing, which are as important as the letterforms themselves, the student will begin quite naturally to question whether or not adequate space has been used in the design of a word or phrase. Suddenly, that which was once accepted and taken for granted becomes an issue.

The first Sans serif alphabet in this section is relatively easy to construct and has been included to dispel any doubts students may have about their ability to create letterforms.

Next the student is guided through the production of a freehand Roman alphabet. This will train both hand and eye as the student learns to draw the form that he or she sees, rather than what he thinks he sees.

Having gained a command of creating Roman alphabet freehand the student should then be ready to try the brush script. Detailed practical guidance on the techniques used in creating brushstrokes to produce letterforms is given.

Information on embellishing alphabets is included for those who are adventurous and wish to add that "extra touch" to their work. Chapter 4 also includes ideas and practical advice on how to apply letterforms in project work such as stencil making and signboards.

Lettering and its application open up an entirely new world and understanding of the forms that surround us. After having worked through the book the reader should be more aware of the subtleties that exist in lettering and of the potential that exists within this subject area.

Chapter 1

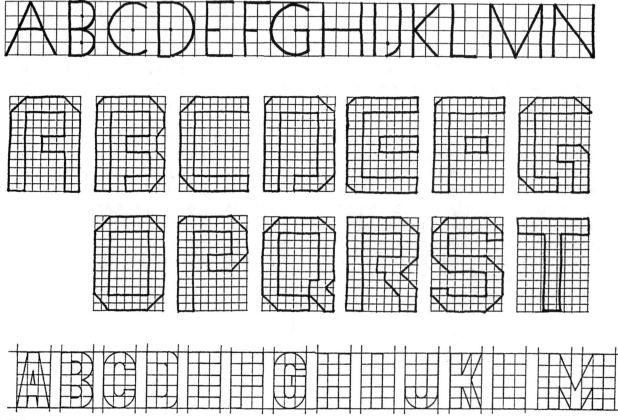

MATERIALS AND TOOLS

The words "applied lettering" cover a number of processes and methods adopted to put letterforms to good use. The subject is wide and requires patience and understanding if all the disciplines are to be mastered. Many instruments are used, with letters being created by pen, brush and scalpel and each tool requiring a different technique.

The eyes and hand are the only common denominator and they require training in order to achieve a satisfactory result. Learning how to produce letterforms that are dignified, well spaced and informative is an art which requires practice and dedication.

This chapter is about the work area, tools and equipment which you will require. A good, clean working attitude is an attribute — clean work surfaces, materials and equipment are essential, sharp pencil points on compasses a necessity.

On the following pages the tools, surfaces and mediums used in producing letterforms are illustrated. It is not necessary to buy all the equipment before you begin, only that which is required for each section as you progress through the book.

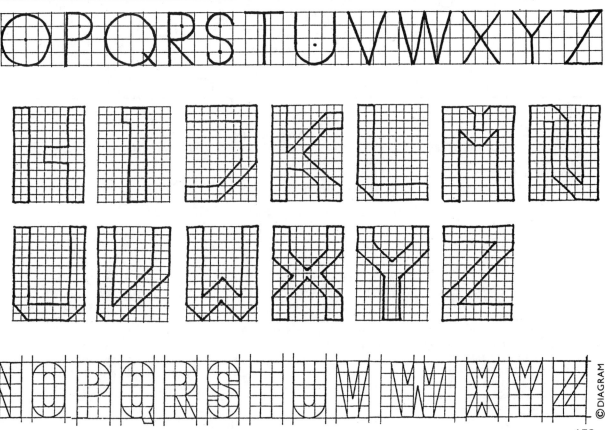

© DIAGRAM

Your work area

You will need a comfortable area in which to work. Good environmental conditions such as adequate lighting and space play an important part in helping you to produce work of a high quality. Lighting, wherever possible, should be natural and, for a right handed person, directed from the left, with the reverse being true for a left handed person. Make sure that you have plenty of shelving and flat storage space for copy, briefs or samples and your instruments, tools, inks and other necessary equipment.

The most important piece of equipment is a sloped drawing board, preferably with an adjustable parallel motion, although this is not essential. A fixed sloped position board and tee square will produce equally good results but a little more slowly.

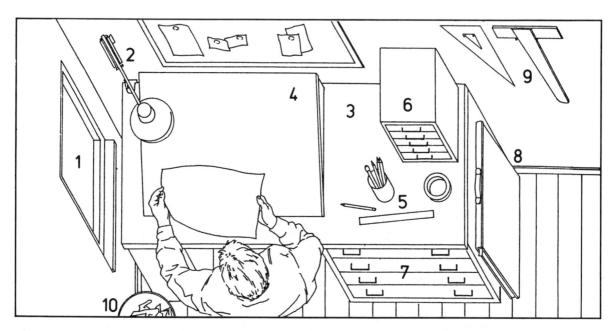

1 Natural daylight. Note that the work area is positioned so as to maximize the use of natural light.
2 Desk lamp.
3 Sturdy flat surface (desk top or table) on which to rest your drawing board.
4 Drawing board.
5 Space in which to keep your pens, pencils, ruler, eraser, and tape.
6 Stationery cabinet.
7 Drawer space.
8 Portfolio for keeping samples of your work.
9 Tee square and set square (triangle).
10 Waste paper basket.

Cutting area
You will need a flat work space on which to place a cutting mat. This can be simply a heavy strawboard or a self healing cutting board. The area allotted for trimming should be larger than the mat to give room for maneuvering large sheets. Your trimming knife and straight edge should be conveniently positioned within this area.

Material storage
A plan chest is useful for storing the papers and boards used in lettering. Alternatively a shelving system constructed from particle board may be used.

Equipment storage
A storage unit, preferably with drawers, is essential for storing tools and equipment. A drawer lined with thin foam will prevent tools from becoming scratched or blunted. A useful storage unit is a plastic vegetable rack, with removable plastic baskets.

1 Home made drawing board

This illustration shows a home made drawing board. It is adjustable to three positions and packs flat for storage. When using this type of board you will need a tee square for projecting horizontal lines.

2 Portable parallel motion drawing board

The portable drawing board is the most versatile as it can be used on a desk and then folded away to leave a useable desk top area.

3 Parallel motion drawing board

The motion allows horizontal lines to be drawn leaving the non-writing hand free. This type of board is available in desk top form or free standing on a fold-away frame. The desk top board is a permanent fixture usually bolted to a desk or work station. The free standing variety requires floor space and can stand next to a desk area, leaving a work surface available for use other than with a drawing board.

Task

Choosing your drawing board
Visit your art suppliers and look at the various boards available. With your work area in mind, and available storage space, decide on the type that will be best for you.

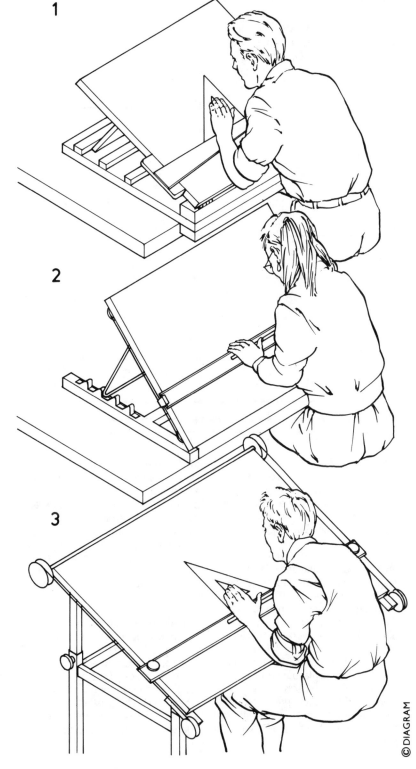

©DIAGRAM

Surfaces

The art market is flooded with a myriad of materials which can be used for writing or lettering surfaces. These range from papers through to laminate finished particle board, and from aluminum to stone finishes. A wide variety of mediums are used in lettering.

Surfaces

The surface chosen for a piece of work is usually determined by the envisaged lifespan of the finished product and its location.

In general, surfaces can be divided into the following groups:

1 Layout papers and bleedproof papers used for mapping out ideas and finished letterforms before tracing down.
2 Stiff papers and board used for indoor, short life (ephemeral) work.
3 MG (machine glazed) papers used for posters and notices where a certain amount of weathering occurs but the work is semi-permanent.
4 Art board and papers having a highly finished surface, used for producing artwork.
5 Painted woods, laminates, metals etc, used for permanent signs where weather proofing is essential.

Layout papers

There are two main types of layout paper; the first of these is ordinary layout paper, which is used for water based pens, and the second is bleedproof paper, which is used for spirit based pens.

Semi-translucent (such as greaseproof) tracing and ordinary layout papers are ideal for mapping out letterforms prior to tracing down the image onto the finished surface. They are suitable for pen, pencil and fiber (felt-tip) pen work, but because of instability do not accept brushed ink or paint readily without forming buckles. Ordinary layout paper is available in pads, sheets and rolls. Bleedproof paper is impregnated to allow the use of marker pens without the color merging. It is available in pads.

Stiff papers and board

Opaque paper, available in various weights and colors, is ideal for producing finished signs, posters and handbills for internal use. The surfaces vary from smooth, for fine detail work, to rough. It takes pencil, fiber and felt pens, both water and spirit based, but some markers bleed on this surface. It is available in pads, sheets and rolls.

Machine glazed (MG) poster paper

An opaque paper with a smooth writing surface that accepts waterproof inks and acrylic paints. The reverse side of the paper has a roughened finish for glue application when pasting bill posters. It is available in various colors including fluorescent, in sheets and rolls.

Art board and papers

These have an extremely smooth, white surface and are used for original artwork executed in black ink to be photographed for a printing process. Boards are available in sheets and the paper is available in pads and sheets.

Permanent surfaces

This group includes many materials which can be used for signs of a permanent nature. The materials include: exterior plywood (painted surface), laminates, plastics, styrenes, metals, plaster and stone finishes. The surface dictates the method of production used.

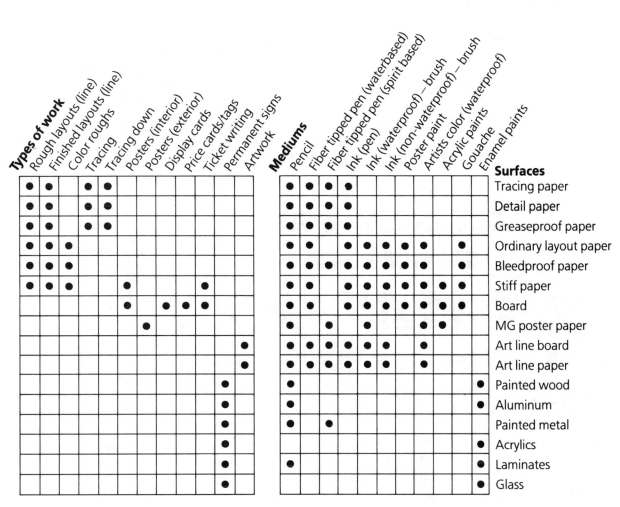

Types of work / **Mediums** / **Surfaces**

Mediums

The medium used in lettering varies with both the application method and the nature of the work. For internal posters which require no protection against the elements, poster paints, gouache, inks, fiber pens and brush pens are used. Where a more permanent sign is required, acrylic paints or enamels are used. Another medium used is self-adhesive film, where letterforms are cut out and applied to the board surface.

For external signs a number of methods are used, with the choice being dependent upon the surface to be decorated. Painted wooden signs may be lettered with enamel paint. Laminate signs may have acrylic letters affixed or the forms may be sprayed using an acrylic paint; wooden letters may be gilded or painted and affixed. Posters for use outdoors can be lettered in acrylic paints or waterproof inks, which weather reasonably well.

Cleaner

All liquid mediums require the appropriate thinner (reducer) and cleaner. For oil based paints, white spirit or turpentine substitute can be used. For acrylic paints and inks a suitable cleaning medium should be purchased to keep brushes and implements in good condition.

Task
Notebook
Buy a pocket size notebook for gathering information on materials that you may wish to use.

Task
Suppliers
Visit your art shop and wood and plastic laminate suppliers and make notes on the papers, boards, laminates and sheet timbers available. Pay special attention to their waterproof and weathering properties.

Task
Mediums
Investigate the paint and ink available at your local shops. Write in your notebook the brand names and types. Examine the tin, tube or bottle labels to ascertain the thinning or cleaning agent each requires and add to your list.

©DIAGRAM

Lettering tools

The writing tools and implements which will be needed in the construction of the alphabets are illustrated below.

The choice of equipment at any art material outlet is vast. When choosing your materials, always ask the assistant to show you a number of different makes of an item before making a choice. Generally the higher the price the more robust or accurate the item; however, this is not always the case and some products at the cheaper end of the market are quite adequate.

It is essential that all equipment be kept clean and pencil leads and blades sharp if accuracy is to be attained. The cleanliness and good state of your equipment will be reflected in the work you produce. Never allow other people to use your equipment. Pens and brushes take on the personality of the user and after being in someone else's hands will never feel the same.

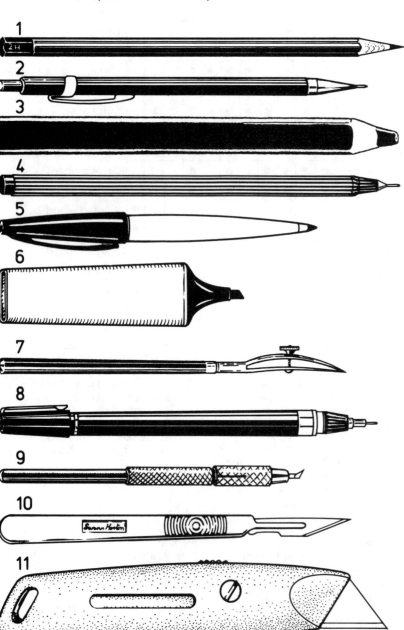

Writing tools
1 Pencils – HB, 2H and 4H used for sketching or roughing out lettering and projecting lines.
2 Technical, propelling or mechanical pencil used with HB, 2H and 4H leads.
3 Carpenter's pencil for filling in letterforms and producing roughs.
4 Fine tipped fiber pens, water soluble and waterproof, useful for mapping out lettering.
5 Medium tipped fiber pens for filling in letterforms when evaluating letter and word spacing.
6 Wide tipped fiber pens of various sizes used for roughing up color visuals.
7 Ruling pen used for ruling lines in any color on board and paper surfaces, with either inks or water soluble paints.
8 Technical pen (0.2) for mapping out letterforms or for finished artwork reproduction. A technical pen has the added advantage of fitting into a compass attachment for scribing circles.

Cutting tools
9 Swivel head cutter used when cutting stencils and cut out letterforms.
10 Scalpel for cutting out stencils, letterforms and general cutting (10a blades). An X-Acto knife with a no. 11 blade is similar.
11 Craft (mat) knife for heavy duty cutting of board.

Task
Collecting materials
Seek out several art supply shops and make notes on the quality and cost of individual items before committing yourself to purchase.

Useful tips

Compass points and blades should be protected. Use a wine cork to stick the point into, thus ensuring that points remain sharp and fingers uncut.

Keep brush ferrules upright in a jar or make a card strip with elastic to keep brushes in pristine condition.

Compasses

12 Small springbows, with interchangeable cutter, divider, lead and ink attachments, for constructing letterforms or cutting arcs and circles.

13 Large compass with interchangeable lead, technical pen, and ink attachments, together with the same compass fitted with an extension bar, for drawing extra large circles.

14 Compass attachment for holding all types of pens and pencils.

Brushes

15 Chisel ended, long hair sable for signwriting. A no. 4 is a useful size to begin with for sans serif letterforms.

16 Writer's (pencil) point brush, long hair sable for Roman and script letterforms.

17 Artist's pointed long hair sable brush for brush script letterforms.

18 Square ended sable ticket writer's brush, ¼" (6 mm) wide, used for brush letterforms.

General

19 Plastic type eraser.

©DIAGRAM

Task

Storage

Once you have collected your first few items, it is advisable to obtain a container to put them in. Plastic, wood or woven material finishes are preferable to metal as this can damage the equipment.

Selecting equipment

Selecting your equipment is important. You must feel at ease when using instruments, so choose carefully. Check the balance of a compass and the feel of a writing implement.

Aids to construction and accuracy

There are many items which are useful additions to a lettering artist's tool kit. As well as the usual measuring and projecting tools, there is a vast array of guides for drawing circles, ellipses and curves. Other useful additions include a pantograph and proportional dividers for enlarging, reducing and proportional work. You are the best judge of whether or not your require such aids, though generally, if a piece of equipment assists both in speed and accuracy, its purchase may be justified.

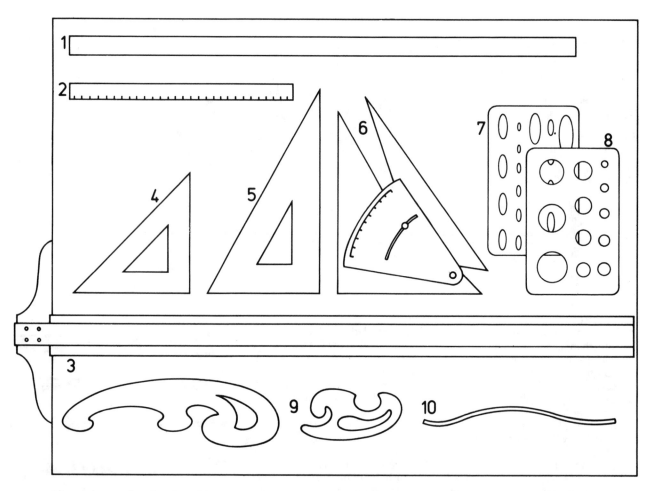

Measuring and projecting aids
1 Steel cutting rule for trimming work.
2 Clear acrylic plastic rule.
3 Tee square.
4 45° perspex set square – a useful size is 10".
5 30° and 60° perspex set square (triangle) – a useful size is 10".
6 Adjustable set square (triangle) which can be altered from 0 to 45° or 90° to 45°. These are ideal for projecting diagonal lines in letter construction; 10" and 6" cover most work.

Guides for drawing regular and irregular curved shapes
7 Ellipse guides – not essential but the 50° and 55° are quite useful.
8 Circle template – the smaller sizes are useful when a compass proves difficult to maneuver.
9 French curve set – a useful addition when accurate, quick curves are needed.
10 Flexicurves – PVC coated with lead core; these are good for joining up plotted points into a curve.

Cutting mats (*left*)

Cutting mats are amazing. As the knife passes through the work the surface of the cutting mat closes behind it leaving a smooth surface which cannot deflect the blade in the direction of a previous cut. The green non-slip, no glare surface of the cutting mat is printed with a grid as an aid to accurate cutting.

Translucent cutting mats

These possess all the qualities of the green cutting mats but have the added attraction of being suitable for use on a lightbox. Translucent cutting mats are ideal for film assembly where accurate cutting of back-lit transparencies is essential. As a further aid to precision the non-slip surface is printed with a 5 cm grid.

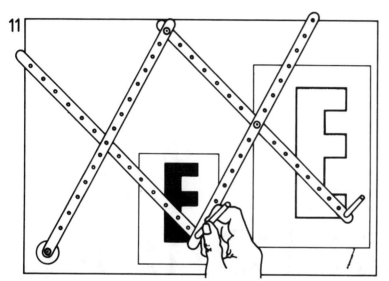

Enlarging and scaling aids

11 Pantograph – for enlarging and reducing letterforms, logotypes or drawings, etc, by copying the original.

12 Proportional dividers – for dividing lines into equal parts.

Pantograph

Pantographs are used to enlarge or reduce drawings, designs and layouts by copying from the originals. Wooden pantographs may be obtained with various ranges of settings as illustrated.

Task

Research and investigation
Go to your local suppliers and investigate the items described in this section. Make notes in your notebook.

Task

Awareness
Become aware of the signs and posters around you. See if you can discover which methods have been used to produce them.

Lettering guides
Technical pen guides

They ensure a constant ratio between letter height and line width. In addition, the letter forms are designed to minimize ink build-up or fill-in and to give maximum legibility, so they are particularly suitable for drawings where microfilming or reduction/enlargement is required.

This first chapter has shown the tools and materials which can be used to produce letterforms. Now that you have prepared your work area and become familiar with the materials available, you are ready to put them to use in letter construction.

Chapter 2

ABCDEFGHIJKLM

ABCDEFGHIJKLM

ABCDEFGHIJKLM

ABCDEFGHIJKLM

ABCDEFGHIJKLM

LETTER AND ALPHABET FORMS

This chapter is about alphabet forms. We begin by looking at the different alphabet groups, from serifed through to decorative, and the variations within the groups when letters are expanded, condensed, italicized and made bolder within their named style. We will consider the names used to describe the component parts of letterforms generally as well as within a style. Finally, we will look at the application of letterforms to the way in which letterspacing is determined, how word spacing is arrived at and how wide apart lines of words should be spaced to give good readability.

NOPQRSTUVWXYZ

NOPQRSTUVWXYZ

NOPQRSTUVWXYZ

NOPQRSTUVWXYZ

NOPQRSTUVWXYZ

©DIAGRAM

Alphabet styles

Letterforms or alphabet styles are divided into groups. There are thousands of styles in use so it is much easier to identify a particular typeface (lettering style) once the faces are grouped. Some of the groups contain numerous typefaces and others just a few, but all are given a name for identification.

In the simplest form of division the groups are: serifed, Sans serif, script and decorative. However, it is difficult to place a style just within a basic division because of the quantity of faces within a given group. Therefore, the groups are sub-divided in order to classify the style more easily. You will find it easier and more useful to read the whole chapter before studying the individual typefaces in any depth.

Serifed styles

These have serif endings to certain strokes which differ from style to style. They fall into the following sub-divisions.

1 Old style
This division includes letters which were originally based on pen forms but have subsequently been re-drawn. Letterforms (typefaces) falling into this category have the greatest diagonal stress. The example shown is Bembo Roman.

2 Transitional
Styles in this division include those in which the stress is still diagonal but moving towards the vertical. The example shown is Baskerville.

3 Modern
Here the stress is vertical and the thin strokes very fine. The letterforms in this category have hairline serifs. Bodoni bold, the example shown, is one of the best known in this division.

4 Slab serif (Egyptienne)
The serifs in this division are blocked and solid but unbracketed. The example shown is Rockwell.

5 Clarendon
Again the serifs are solid but here they are bracketed. The example shown is Clarendon.

6 Latin
This time the serifs are triangular in form. The example is Cortez.

1 ABCDabcd

2 ABCDabcd

3 **ABCDabcd**

4 ABCDabcd

5 **ABCDabcd**

6 **ABCDabcd**

Task
Scrap book
Buy a scrap book and divide into sections – one for each letter style. Pencil in headings (to be filled in at a later date) with a soft pencil.

ABCabc ¹ ²ABCabc

³ABCabc ⁴ABCabc

Sans serif styles

These are plain letterforms, without serifs, and they fall into four main sub-divisions.

1 Geometric
Letterforms which appear to be generated with compass and drawing aids with strokes of one thickness. The example is Futura Book.

2 Humanist
Styles which are based on the individual qualities of the letters themselves and do not project uniformity of shape as in constructive styles. The example is Gill Sans.

3 Grotesque
A large group of styles, all semi-constructive but still retaining individual letter qualities where the forms are not totally forced to produce uniformity. The example is Grotesque 216.

4 Neo-grotesque
Constructive styles based on the original grotesque but with certain letters forced to conform to the overall alphabet design. In the example, Helvetica Regular, the lowercase c is forced to fit the rounded letterforms.

Task

Tracing
Using a sheet of tracing paper, ruler and fine point fiber pen, refer to your scrap book and choosing a simple style, trace over the letterforms and afterwards fill in the centers.

¹ABCDabcde
²ABCDabcde
³A B C D abcde

Scripts

A division which contains many free styles – letterforms which are created without the use of drawing aids other than the instrument or brush with which they were written.

1 Brush scripts (round or pointed). Forms drawn with a brush. The example is Slogan.

2 Brush scripts (square). Drawn with a square ended pen or simulated to give that effect. The example is Ondine.

3 Pen forms. Produced with a pointed pen or simulated to give that effect. This example, Palace script, is a simulated copper plate pen form.

Task

Collecting styles
Using the examples as a guide, search through magazines, newspapers, leaflets or any printed matter for similar letterforms. Cut them out and stick into the appropriate section in your scrap book.

Decorative

A group containing many adorned styles based on the other groups mentioned. The embellished styles may, in essence, be from the serifed, Sans serif or script groups.
The examples shown here are:
1 Flash (Sans serif)
2 Astur (script)
3 Union Pearl (serifed)
4 Sapphire (serifed)
5 Romantiques no. 5 (a mixture of styles)

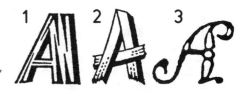

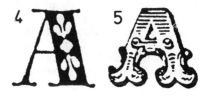

©DIAGRAM

Terminology

Some of the terminology (or nomenclature) commonly used when discussing the subject of lettering is given below. This nomenclature is frequently used in the analysis of particular styles. The component parts of letterforms named here (1 to 26) are based on a Roman serifed style. Different designs will have other names to define specific traits within the style, but general terms, such as cross stroke, main stroke and stress, for example, remain. The differences are in the way strokes are terminated or embellished.

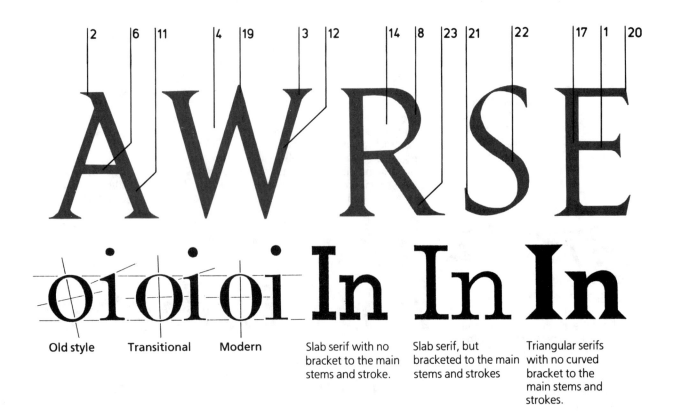

Old style Transitional Modern

Slab serif with no bracket to the main stems and stroke.

Slab serif, but bracketed to the main stems and strokes

Triangular serifs with no curved bracket to the main stems and strokes.

Stress
The stress of a style is related to round letterforms and appears in all styles where there is a weight difference between main strokes on the round letters and the thinning effect either near the x line and base line, or on them. The position at which stress (the thinnest part of the letter O) is positioned varies with each alphabet style. Compare the positions of stress shown in the examples of Old style, Transitional and Modern letterforms (*above*).

Degrees of stress
The degrees of stress fall into three main groups. Letterforms with maximum diagonal stress are called Old style. Letters with stress deviating only slightly from the vertical are called Transitional and letters with vertical stress are called Modern.

Serifs
In each instance the serif construction on straight or oblique letterforms within each group also varies. See the illustrations of the letter I and n (*above*) for examples of different types of serifs.

Shading
The widest part of a round letterform and the tapering to the thinnest part is known as shading. Shading varies with the stress of the letterform, but the widest part of the shading is always at 90° to the thinnest part (the stress).

Components of letterforms

1 Arm
2 Beaked serif
3 Bracketed serif
4 Counter
5 Cross stroke
6 Cross stroke or bar
7 Curved stroke
8 Curved stroke forming the bowl of the letter 'R'
9 Curved stroke forming the bowl of the letter 'g'
10 Curved stroke forming the loop
11 Diagonal main stroke or stem
12 Diagonal thin stroke
13 Ear
14 Inner counter
15 Ligature, two letters joined
16 Link
17 Main stroke or stem
18 Maximum point of stress
19 Pointed apex
20 Sheared serif
21 Sheared terminal
22 Spine main stroke
23 Tail
24 Terminal
25 Swash
26 Flag

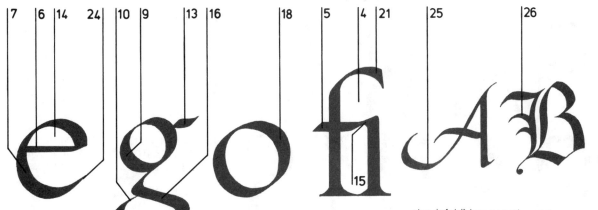

©DIAGRAM

Roman and italic letterforms

Vertical or upright letters are also called Roman, as compared to slanted or tilted letters, which are called italic.

Task
Recognition
Look through some fresh samples of lettering and try to put them in the right group without referring back.

Task
Stress and shading
Study the points of stress and shading and try to recognize them in your scrap book samples.

Emphasis

A number of styles have more than one weight of letterform. Such typefaces or styles are called families. A family consists of the normal weight, or "Roman" for the style, and there may be a light weight, a medium, a bold or an extra bold version of the style. Some styles also have italics which match the Roman weights. The question of emphasis does not end there as some even have condensed and extended versions of the style, where the letterforms are squashed or stretched.

Thirteen examples of letterforms, showing variations from Helvetica are shown (*right*).

Task 12
Naming the parts
Using the terms to describe letterforms, name as many parts of the traced letters as you can.

abcdefghijklmnopqrstuvwxyz
ABCDEFGHIJKLMNOPQRSTUVWXYZ

abcdefghijklmnopqrstuvwxyz
ABCDEFGHIJKLMNOPQRSTUVWXYZ

abcdefghijklmnopqrstuvwxyz
ABCDEFGHIJKLMNOPQRSTUVWXYZ

abcdefghijklmnopqrstuvwxyz
ABCDEFGHIJKLMNOPQRSTUVWXYZ

abcdefghijklmnopqrstuvwxyz
ABCDEFGHIJKLMNOPQRSTUVWXYZ

abcdefghijklmnopqrstuvwxyz
ABCDEFGHIJKLMNOPQRSTUVWX

abcdefghijklmnopqrstuvwxyz
ABCDEFGHIJKLMNOPQRSTUVWXYZ

abcdefghijklmnopqrstuvwxyz
ABCDEFGHIJKLMNOPQRSTU

abcdefghijklmnopqrstuvwxyz
ABCDEFGHIJKLMNOPQRSTUVWX

abcdefghijklmnopqrstuvwxyz
ABCDEFGHIJKLMNOPQRSTUVWXYZ

abcdefghijklmnopqrstuvwxyz
ABCDEFGHIJKLMNOPQRSTUVWXYZ

abcdefghijklmnopqrstuvwxyz
ABCDEFGHIJKLMNOPQRSTUVWV

abcdefghijklmnopqrstuvwxyz
ABCDEFGHIJKLMNOPQRSTUV

Letter spacing

We have so far looked at alphabet designs and
their constituent parts. Now we are going to look
at the spacing of individual letters to form words.

1 PARIS

2 PARIS

3 PARIS

4 PARIS

5 PARIS

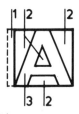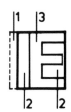

1 Air space.
2 Negative space.
3 Positive space.

Harmony of letterforms
Both the legibility and readability of a
piece of work are determined by the
sensitive use of space. The space
between letterforms is as important
as the space within the letter – the
counter and inner counter – and the
letter itself. It is the balance of the
counters that is crucial to letter
spacing. The negative areas, those
surrounding and within the letter,
must be in harmony with the positive
areas, the letterforms themselves.

Optical spacing
The letters have to appear equally
spaced optically. Letter spacing cannot
be done mathematically because
letterforms have different shapes and
therefore different spacing
requirements. Compare example 1 of
the word PARIS, which is spaced
mathematically, with examples 2 to 5
which are spaced optically.

Criteria
This exercise illustrates that the first
two characters lettered govern the
spacing for the rest of the word. In
the fifth example it can be seen that
the A and R almost touch because the
I and S were too close in the original,
causing a tightly spaced word. The
reverse can be said for no. 2, for with
the space between the P and A too
great, the result is an overspaced
word.
Of the remaining two versions, no. 3
and no. 4, the latter is the better
spaced. The word looks well spaced,
has rhythm and the forms are in
harmony without appearing
overspaced. It also leaves room to
maneuver.

Examples of the word PARIS spaced mathematically and optically

1 Mathematically spaced, ie, equal
amounts of space between the
letters.
2 Optically spaced using the space
value between the P and A as the
criterion for the rest of the word.
3 The spacing between the A and
R in **1** used as the criterion, then
optical spacing of the P, I and S.

4 The spacing between the R and I
in **1** used as the criterion, then
optical spacing.
5 The spacing between the I and S
in **1** used as the criterion, then
optical spacing.

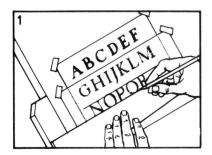

The three letter method

This is an easy way of judging the spacing to use, but remember to always analyze the letter combinations of the word before commencing.

1 Tape a sample alphabet sheet to the drawing board, overlay with tracing paper, and draw in a base and cap line to the size of the alphabet.
2 Trace carefully over the P with a black fiber tipped pen.
3 Move your tracing sheet to the letter A on the alphabet sheet and letter space the P and A. Remember it is the space you use now which will set the standard for the remainder of the word.
4 Move your tracing sheet to the letter R. Blank off the letters on either side using white paper.

This will ensure the Q and S do not interfere with your judgement of the optical space. Move the tracing sheet left and right until you feel the space between the A and R is the same as the P and A.
5 Letter in the R.
6 Move the tracing sheet to the I. Blank off the H and J and position the I so that the optical space between the A and R equals that between the R and I. If in doubt, mask off the P for it may be clouding your judgement. When you are happy with the position, letter in the I.
7 Reposition for the S, masking the letters either side and, if necessary, the P and A. Optically space the S and trace off.

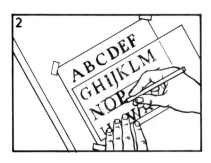

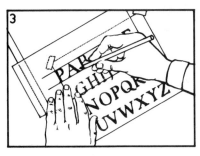

Patterns

Look for letter combinations with similar patterns. Study the word INDIANAPOLIS and note the combinations. All straight to straight letters require the same amount of space, round to straight the same as straight to round, straight to oblique the same as oblique to straight and so on. Patterns are there and can be found in many words.

Letter combination

Before deciding on the letter spacing to use, study the combinations of letterforms. Establish the rogue combinations which create lots of air space when next to each other. Here are some examples:

AA LA TT TV TW TY WY

ft fy rf rt ry ty

If there are straight sided letters followed by round letters, leave sufficient space between the straight forms to allow for the round forms to be closely spaced. 00 together create lots of air space.

Task

Cut-out

Cut out some fairly large lettering and practice letter spacing by arranging in various positions.

Task

Tracing

Now try tracing some words of your choice and use the three letter method to determine the spacing.

Word and interlinear spacing

When more than one word is to be lettered, the words require spacing. This word spacing is strongly linked to letter spacing in that if too much space is left between the words the rhythm of a line is broken and readability impaired.

LONDONIHEATHROWIAIRPORT
LONDON HEATHROW AIRPORT
LondoniHeathrowiAirport
London Heathrow Airport

I method
A useful method of spacing words is to insert either a capital I or a lower case i, depending on which form the lettering is in, between the words. The rhythm this creates is in complete harmony with the letter spacing adopted, because it is based on the same letter space value either side of it.

Example
In the above example the letter I or i is letterspaced between the words. Here LONDON is treated as if the I is part of the word. The H for HEATHROW is now spaced as if it were part of the first word and so on to the end. The spacing I's are lettered in pencil and removed when the work is finished.

Task
Using i's
Space the phrase using a different type style. Use a fiber pen on tracing paper and letter in the i's with an HB pencil.

LONDONrHEATHROWrAIRPORT
LONDON HEATHROW AIRPORT
LondonrHeathrowrAirport
London Heathrow Airport

R method
For those who like their words a little more widely spaced, the lower case letter r can be substituted for the i, giving a more open line. Under no circumstances should a wider letter be used as it would result in a totally overspaced line.

Example
In the above example the lower case letter r is included as part of the text for spacing purposes.

Task
Observation
Now that you understand letter and word spacing, look at signs, magazines and newspapers and make judgements on the spacing used.

Napoleon Wellington Waterloo

1

Napoleon Wellington Waterloo

2

Interlinear spacing

There is another element of spacing which needs to be looked at and that is line spacing. This spacing left between lines of lettering is called interlinear space.

Clashing

When using capitals and lowercase (small letters or minuscules), it is necessary to insert extra space between the lines to prevent the descenders of one line clashing with the ascenders of the next. This space can be minimal when only single words are placed one above another, but where longer lines of lettering are used it is essential that sufficient interlinear space is used, otherwise readability can be affected.

Examples of different line spacing

Example 1 illustrates close line spacing in which the ascenders and descenders of individual lines touch. It can be seen quite clearly that the letter p in Napoleon and letter l in Wellington clash as do the letters g and l in the second and third lines. Example 2 illustrates open line spacing. Here it can be seen that an adequate amount of space has been left in order to prevent the ascenders and descenders of two lines of text from clashing.

Readability

The readability of text is dependent upon letter spacing, word spacing, line length and interlinear spacing. When reading a sign, poster or text, the eye scans from left to right to read the line of text and then must travel the whole line length back to the left before reading the following line. If the interlinear space is too little, the eye may read the same line twice. The line length is also directly related to the interlinear space required – the longer the line length the more interlinear space needed.

Line length

An optimum line length is 10 words or 60 letters (or characters) including spaces and punctuation when calculating. However, line lengths of 8 to 12 words are acceptable.

Task

Differing styles

Using the words in the example, letter them out in various styles. You will see that alphabet styles which have large x heights require more interlinear space than styles with small x heights. This is because small x height styles visually create space between lines, whereas large x height styles do not.

©DIAGRAM

Chapter 3

This chapter discusses three different ways in which alphabets can be generated. The first example, a Sans serif style constructed with a compass and set square (triangle) is designed to give you a quick result. The emphasis here is on the accurate use of equipment and following instructions. The drawing aids will give you confidence and, handled properly, will enable you to create a useable geometric style.

The second example is a Roman serifed style. The skill required here is in copying the

Capitals, lower case and numerals for the three alphabet styles in this chapter:
1 Sans serif
2 Roman
3 Brush script

¹ ABCDEFGHIJKLMN
abcdefghijklmnopqrst

² ABCDEFGHIJKLMN
abcdefghijklmnopqrstu

³ ABCDEFGHIJKLM
abcdefghijklmnopqr

172

TECHNIQUES

letterform outline via a square grid. The letters are plotted using the grid reference points and then the points are joined up to form the letter. In producing this style you will learn how to coordinate a critical eye with command of hand.

The third alphabet is brush script, a free hand letterform which gives the informal feel of having been created spontaneously – that just whizzed-off effect. There is actually nothing further from the truth – to create the relaxed feeling of the form

demands complete control over eye, hand and finger movements. The knowledge that has been gained from constructing the first two alphabets will be of great help in producing brush script.

You will also find hints in this chapter on equipment, methods and sequences to aid in the construction – read these carefully and you will save yourself a considerable amount of time.

OPQRSTUVWXYZ
uvwxyz 123456789

OPQRSTUVWXYZ
vwxyz & 1234567890

NOPQRSTUVWYXZ
stuvwxyz123456789

Sans serif: proportions

In the next eight pages we show you how to construct a Sans serif alphabet. This compass constructed alphabet is built up on a grid to enable you to produce regular letterforms in a consistent style. We will begin by looking at the relative positions of the capital and lower case letters, together with some of the terminology used in the construction details given in the following pages. Instructions on how to construct your grid are shown opposite.

Tools and materials
To produce the Sans serif alphabet you will need the following:

1 Drawing board
2 Tee square
3 Adjustable set square (triangle)
4 Compass
5 Ruler
6 2H pencil
7 Eraser
8 Masking tape
9 Tracing pad
10 Stiff paper

Relative positions of capital and lower case letters
Newcomers to lettering often become confused as to the relative positions of the lower case letters when combined with capitals.

The grid lines used to align characters are the capital or ascender line, x line, base line and descender line.

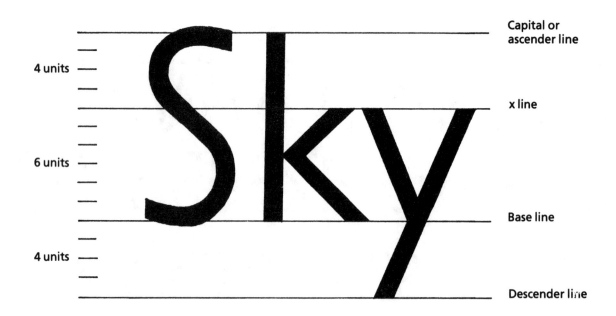

4 units

6 units

4 units

Capital or ascender line

x line

Base line

Descender line

Task
Constructing the grid
Decide on the height you wish to draw your capital letters, take a sheet of stiff paper, tape it to your drawing board and draw cap and base lines to your chosen height. Divide the height into ten equal parts. Extend the cap and base lines to the right of your unit line and draw up the grid.

Capital or ascender line
All capital letters, which are 10 units high, sit on the base line and extend to the cap line.

x height characters
x height characters are 6 units high. The x line to base line forms the x height and contains the following letters – a, c, e, i, m, n, o, r, s, u, v, w, x, and z. All of these letters, with the exception of the dot on the letter i, are x height letters.

Ascending characters
Ascending characters are 10 units high. All ascending characters b, d, f, h, k, l and t sit on the base line with the ascenders projecting from the x line to the capital or ascender line, which is called the ascender area.

Descending characters
Descending characters are 10 units high. Characters which have descenders, namely g, j, p, q and y have their x height area between the x and base line and their descenders project from the base line to the descender line – the descender area.

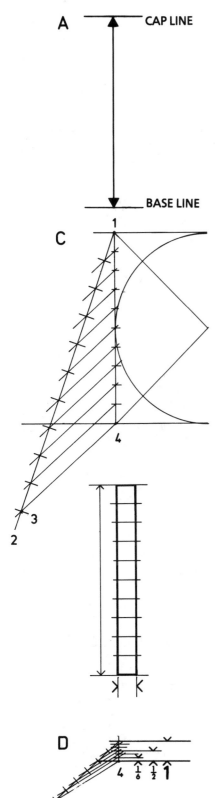

A CAP LINE

BASE LINE

B

Constructing the grid

A Tape a sheet of stiff paper to your drawing board and proceed as follows. Select the height of your capital letters; this obviously determines the height of your base line to cap line and therefore your grid. You may find it easier to begin with a height of 2″-3″ (50 mm-75 mm) (*see left*).

B Draw a square, two diagonals and a circle as shown (*right*). Draw in a dotted compensation line ⅙ of a unit above and below the base and cap line for positioning round letterforms. For details of how to calculate unit measurements used in the construction of the sans serif alphabet see **C** and **D** below. In the illustration (*top right*) we have shown reference points 1, 2, 3 and 4, which may be used in the construction of letterforms. Other reference points are gained by projecting lines or stepping off widths of the stroke.

C Divide the height of a letter into 10 equal units (*see left*). From 1 draw a line at an angle away from the upright, ie towards 2. Using a ruler, measure 10 equal parts down the line. Any measurement can be used provided there is enough room on the sheet. From 3, the last equal part, draw a line linking it with 4. Using an adjustable set square, set to the angle formed by line 3/4, make and project parallel lines from the divided line so that they intersect with the left hand side of the grid. Now draw short lines horizontally to complete the scale.

D Obtain ⅙ of a unit using the following method. Transfer a tenth unit and subdivide it into six equal parts using the same method given in **C** above. Mark the units onto the edge of a piece of card. This is used for transferring measurements (stepping off units) when constructing letterforms. Keep the card in a safe place – it will be used throughout the alphabet construction (*see bottom left*).

Compensation line

When round letters are drawn to the same height as straight ended letters they appear smaller because the head and base of straight letterforms are solid in comparison to the thinning out of a rounded letter, which if positioned on the cap and base line has only a small proportion of the form touching. An adjustment of ⅙ of a unit is made so that round letters appear optically the same height as straight letters. A dotted compensation line is used in the construction of round letterforms.

Sans serif: construction techniques

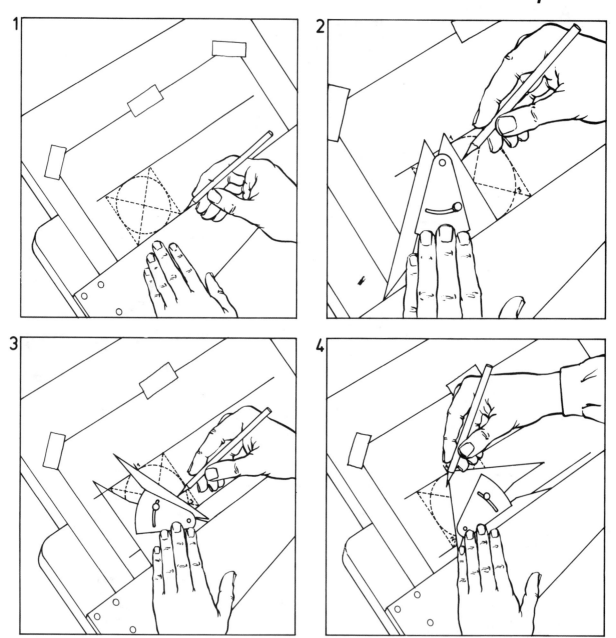

Step by step

1 To draw the letter A (see page 180) place tracing paper over the grid and draw cap and base lines.

2 Draw a vertical line through the center of the grid.

3 Using an adjustable set square (triangle), join 1 to 3.

4 Turn the set square through 90° and join 1 to 2.

5 Take a card unit gauge and mark a ½ unit either side of the diagonal lines.

6 Using an adjustable set square project parallel lines from the units marked in step 5.

7 Take the gauge and measure two units down from the center of the circle.

8 Project horizontal lines for the cross bar of the letter A and finish the letterform at the top and bottom.

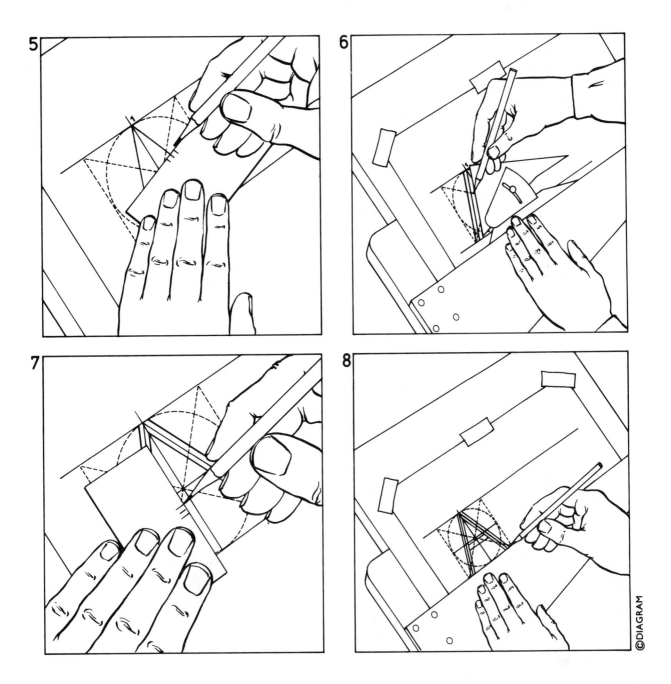

Task
Construct a letter A, following the step by step instructions, using a 2H pencil on tracing paper and working over your grid. Make careful note of the reference points before beginning.

Task
When you are satisfied with the construction of your letter A, continue with the rest of the alphabet.

Accuracy hints
1 Make sure that you can see the line being drawn as you work.
2 All preliminary drawings should be carried out with a sharp 2H pencil.

©DIAGRAM

Sans serif: capital letters 1

To help you gain a basic understanding of the system, the letter S has been produced in stages; this is probably the most difficult letter to generate and therefore deserves more attention. If you feel you would like to begin by producing the letter S, do so, as once this form has been mastered the remainder of the alphabet is relatively simple.

A Draw a line at an angle of 45° from 1 and where this intersects with the grid diagonal, draw a vertical line, 2 (new center line). Step off ⅙ of a unit at the cap line,3, and base line, 4, and project horizontal lines. Step off a ½ unit either side of the center line, 5, then 1 unit for 6, 7 and 8. Project horizontal lines on the left hand side of the grid as shown.

B Step off a ½ unit from the new center line to the right and draw a vertical line. The reference points on this diagram show the extent of the two circles, which form the basis of the letter S. From 1 and 2 project lines at an angle of 45° towards 4. Repeat from 2 and 3 towards 5. Where the lines intersect is the central point between 1 and 2, and 2 and 3.

C Now project 4 to the left and mark the intersection with the first vertical line, 6. Repeat from 5, but extend to the second vertical line, 7. These points are the centers of the four circles used to construct the letter S.

D Using 6 as the center point open up the compass to the arrows shown and draw two circles. Repeat the procedure using 7 as a center point.

E Using 6 as a center point open up to the arrows shown and scribe two arcs to the left. Repeat the procedure using 8 as a center point. Project two parallel lines 9 to 10 and 11 to 12. Draw a line from 13 to the base of the grid and from the center to the cap line.

F Finished letterform.

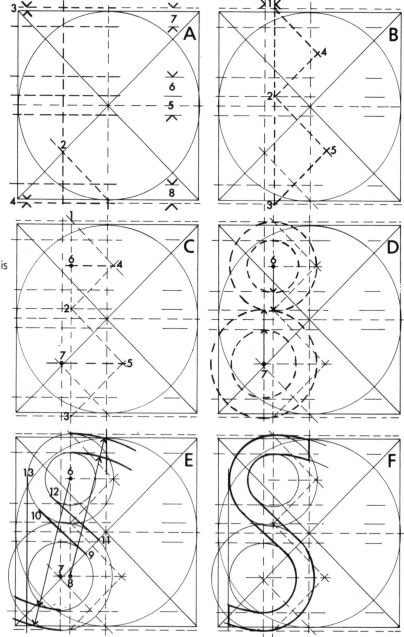

Using a 45° set square (triangle) to project a given thickness from a horizontal to a vertical or vice versa

For example, assume you have measured a unit of thickness on the main stroke of the letter D and having projected vertical lines you now wish to mark the thickness of the cross strokes. This can be done without a further stepping off of units as follows. The unit measured is "x." To project the same unit vertically, draw a line at an angle of 45° from 1; where this line intersects the vertical at 2, project a horizontal line. This will give you the same unit "y" but in the vertical plane. This method can be applied to many of the letterforms including the letters E and F for example.

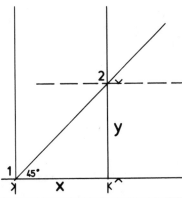

Using a 45° set square to divide a line equally

If you need to to find the center of an arc or circle when constructing a letterform (such as for example the letter B) one method is outlined below. From either end of the line X/Y project a line at an angle of 45° inwards; at the point of intersection project a line at right angles to the line to be divided; the intersection marks the center of the line X/Y.

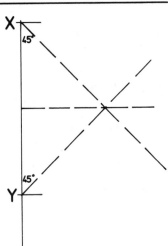

Using a compass to divide a line equally

Open the compass up to more than half the length of the line to be divided. Place the compass point on X (one end of the line) and scribe a semi circle. Repeat using Y as the center point. Where the arcs intersect, join with a straight line. The center is where the straight line cuts X/Y.

Sans serif: capital letters 2

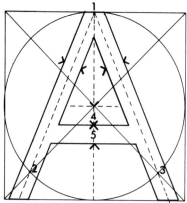

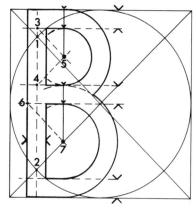

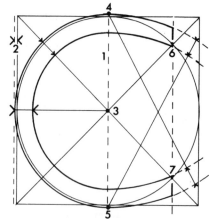

A

Draw a vertical line from the cap line to the base line through the center of the circle. From 1 draw a diagonal line through 2 to the base line. Repeat from 1 to 3. Mark a ½ unit either side of the diagonal lines and project parallel lines to form the main strokes of the letter A. From the center of the circle mark down 2 units and project horizontal lines for the cross bar of the letter A.

B

Draw a vertical line through 1 and 2. Step off a ½ unit either side and draw vertical lines to form the main stroke. Step off 1 unit from the center of the circle, cap line and base line and project horizontal lines to the left. From 3 project a line at an angle of 45° towards 5. Project a line at an angle of 45° from 4 to 5 to form the center point for the upper arcs. Project a line at an angle of 45° from 6 to 7 to form the center for the lower arcs. Position the compass point on 5 and scribe arcs from the radius marks; repeat the procedure from 7.

C

Draw a vertical line through the center. Step off ⅙ of a unit at 2 and draw a vertical line. Step off 1 unit. Scribe semi-circles, using 3 as a center point, from 4 to 5. Using 4 as a center point, scribe an arc from 5 to the right. Repeat using 5 as a center point to scribe an arc from 4 to the right. Draw a vertical line through 6 and 7 to produce sheared terminals.

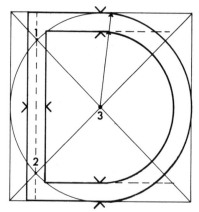

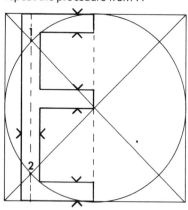

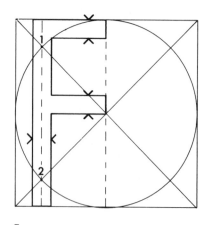

D

Draw a vertical line through 1 and 2. Step off a ½ unit either side of the line drawn. Draw vertical lines to form the main stroke of the letter D. Step off 1 unit at the cap and base lines and project horizontal lines. Using 3 as a center point, scribe two semi-circles using the radii marked.

E

Draw a vertical line through 1 and 2. Step off a ½ unit either side of the line drawn. Draw vertical lines to form the main stroke. Draw a vertical line through the center of the circle. Step off 1 unit up from the center line. Repeat the procedure at the cap and base lines. Project horizontal lines to the main stroke.

F

Follow the instructions for the letter E, but omit the base cross stroke.

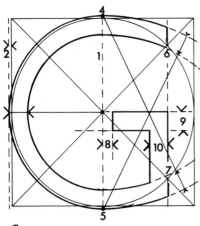

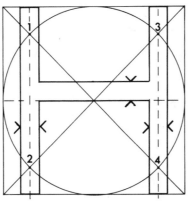

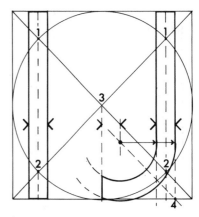

G

Follow the instructions for the letter C, but with the following additions. Step off a ½ unit from the center vertical line to the right. Draw a short vertical line, 8. From the center step down 1 unit to form the cross bar of G. Project a horizontal line towards the center. From the vertical line 6/7, step off 1 unit to the left, 10, to form the short vertical stroke of G.

H

Draw a vertical line through 1 and 2. Step off a ½ unit either side. Repeat the procedure for 3 and 4. Draw vertical lines to form the main strokes of the letter H. Step off 1 unit above the center line. Project horizontal parallel lines to form the cross bar of the letter H.

I

Draw a vertical line through 1 and 2. Step off a ½ unit either side. Draw 2 parallel vertical lines.

J

Draw a vertical line through 1 and 2. Step off a ½ unit either side. Draw two parallel vertical lines. Project a line at an angle of 45° upwards from 4. From 3 draw a vertical line to the base and step off 1 unit to the right of the line. Draw a short vertical line through this point and where this intersects with the 45° diagonal line, scribe two arcs to the radii shown.

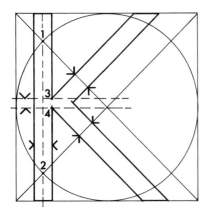

K

Draw a vertical line through 1 and 2. Step off a ½ unit either side and draw vertical parallel lines. Project a horizontal line from the center of the circle to the left hand side of the grid. Step off a ½ unit upwards and project a line to the right. From 3 project a 45° line upwards and step off 1 unit width. Project a parallel line. Repeat the procedure from 4 but in a downwards direction.

L

Draw a vertical line through 1 and 2. Step off a ½ unit either side and draw vertical parallel lines. From the base line step up 1 unit and draw a horizontal line from the main stem to the center of the circle to end the base stroke.

M

Drop a vertical line from the center of the circle to the base line, to give 3. Step inwards 1 unit from both corners at the top of the grid to give 1 and 4. With diagonal lines, join up 2 to 1, 1 to 3, 3 to 4 and 4 to 5. Step off a ½ unit either side of each of the lines as shown and project parallel lines using an adjustable set square.

Sans serif: capital letters 3

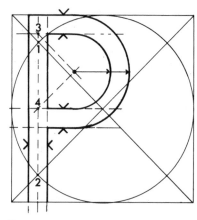

N

Draw vertical lines through 1 and 2, and 3 and 4. Step off a ½ unit either side of both lines and project vertical parallel lines. Join 5 to 6 with a diagonal stroke. Step off a ½ unit either side of the line and using an adjustable set square (triangle), project parallel lines.

O

Step off ⅙ of a unit at the left hand side of the grid. Project a line from the center of the circle to the left hand edge. Step off 1 unit from the extreme left hand side of the grid towards the center. Using the center of the circle as a center point scribe two circles as shown.

P

Draw a vertical line through 1 and 2. Step off a ½ unit either side. Draw two vertical parallel lines. Step off 1 unit from the cap line to 3 and 1 unit from the center of the circle downwards. Project horizontal lines. From 3 project a line at an angle of 45° down and from 4 project a line at an angle of 45° upwards. Where the lines cross use as the center point and scribe arcs as shown.

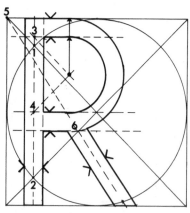

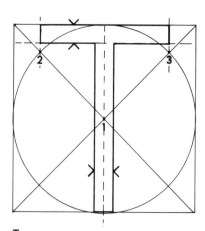

Q

Follow the instructions for the letter O, and add a tail by stepping off a ½ unit either side of the lower right hand diagonal stroke. Project parallel lines to the circle.

R

Follow the instructions for the letter P, and add a tail by projecting a diagonal line from 5 through 6. Step off a ½ unit either side of the line and draw parallel lines using an adjustable set square.

T

Draw a vertical line through 1 from the cap line to the base line. Step off a ½ unit either side of the line and project two parallel lines to form the main stroke of T. Project vertical lines to the cap line from 2 and 3. Step off 1 unit down from the cap line and project two horizontal lines to form the cross bar of the letter T.

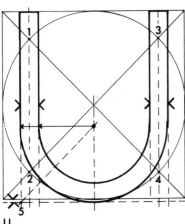

U

Draw vertical lines through 1 and 2, 3 and 4, from the cap to base lines. Step off a ½ unit either side of the lines and project parallel and vertical lines. Step off ⅙ of a unit beneath the base line and draw a horizontal line. From the center drop a vertical line towards the base and project a line at an angle of 45° from 5 to generate the center point. Scribe two semi circles to the radii as shown.

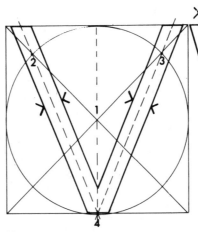

V

From the center drop a vertical line to the base. From 2 and 3 project diagonal lines to 4. Step off a ½ unit either side of the diagonal lines drawn and project diagonal lines to form the letter V.

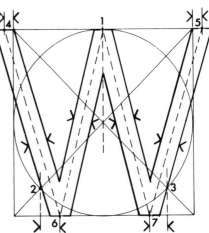

W

Project a vertical line from the center to 1. Drop two vertical lines from 2 and 3 to the base. Step off 1 unit to the right of the line to form 6 and left of the line to form 7. From the top left of the grid step off a ½ unit; repeat at the top right. Join 4 to 6, 6 to 1, 1 to 7, and 7 to 5. Step off a ½ unit either side of the lines drawn. Using an adjustable set square project two parallel lines for each stroke to complete the letterform.

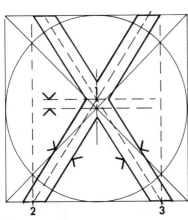

X

Draw a short vertical line up through the center and step off a ½ unit up to form 1. Project vertical lines from the intersections of the circle and diagonals, to form 2 and 3. Draw a diagonal line from 2 through 1 to the cap line and repeat for 3. Step off a ½ unit either side of the lines and project parallel diagonal lines using an adjustable set square.

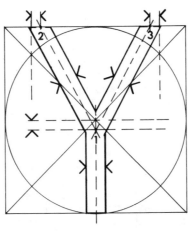

Y

Project a line from the center to the base. Step off a ½ unit down from the center to form 1. Draw vertical lines from the intersections of the circle and diagonal lines to the cap line. Step off a ½ unit inwards from both lines to form 2 and 3. Join 2 to 1, and 3 to 1. Step off a ½ unit either side of the vertical center line. Project parallel vertical lines and diagonal lines to complete the letterform.

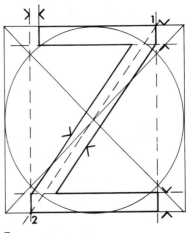

Z

Draw vertical lines from the intersections of the circle and diagonal lines to give 1 and 2. Join with a diagonal line. From the top left side of the line 2/3 step off a ½ unit inwards. Step off 1 unit down from the cap line and 1 unit up from the base line and draw horizontal lines. Step off a ½ unit either side of the diagonal line 1/2 and using an adjustable set square, project two diagonal parallel lines.

Sans serif: lower case letters 1

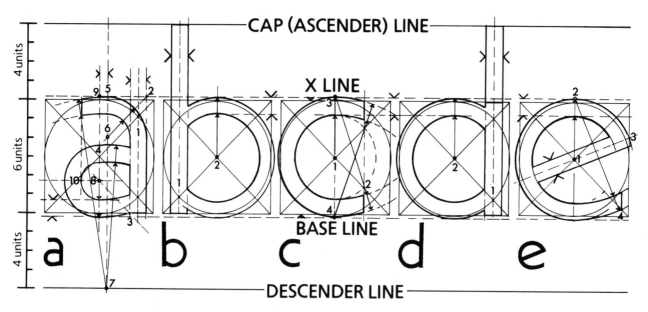

Grid for lower case Sans serif alphabet

Before you begin to construct the Sans serif lower case alphabet it will be necessary for you to draw a grid which contains 14 units, as illustrated above (see also page 174). You will observe that the new stroke width is ⅝ of the capital letter width.

a

Project a vertical line from the base, 1, and step off a ½ unit either side of the line. Draw vertical lines. Project lines at angles of 45° from 2 and 3 toward the center. Draw a vertical line through the center of the grid, 4. Step off a ½ unit to the right, 5. Project 5 to the descender line, 7. Step off 1 unit width up from the dotted compensation line at the base and project the horizontal line, 5. Using 6 as the center point scribe arcs to the vertical on the right. Taking 8 as the center point scribe semicircles to form the base of the letter a. Using 7 as the center point scribe arcs from the semicircles drawn to the vertical of the letter a; continue using 7 at the center point, open the compass up to the dotted compensation line, 5, and the upper arm of the letter a and scribe arcs to the left. Cut the arm to length by projecting a line from 10 vertically.

a (alternative)

An alternative letter a may be produced by following the instructions for the letter d, but omitting the ascender at the x line.

b

From 1 draw a vertical line from the base to cap line. Step off a ½ unit either side. Project parallel lines. At the top right, measure down 1 unit from the dotted compensation line and project a horizontal line to the left. Using 2 as the center point, scribe arcs.

c

From 1 project a vertical line from the base to x line. Measure down 1 unit from the top right of the grid at the dotted compensation line and project horizontally to the left. Using 1 as the center point scribe a semicircle for the outer curve and a circle for the inner curve. Where the circle intersects with the diagonal at 2, draw a vertical line which will terminate the arms. Using 3 as the center point scribe arcs to the right at the base. Repeat using 4 as the center point. Project arcs at the x line.

d

From 1 project a vertical line from the cap to base line. Step off a ½ unit either side and project parallel lines. At the top left of the grid, measure down 1 unit from the dotted compensation line and project a horizontal line to the right. Using 2 as the center point, scribe arcs.

e

Draw a vertical line through 1 from the base to x line. Step off 1 unit at the top left of the grid and project a horizontal line to the right. Using 1 as the center point, scribe arcs from the base to beyond 3. From 3 project a line through 1, step off a ½ unit either side and using an adjustable set square (triangle) project parallel lines. From 2 scribe arcs from the base toward 4. From 4 draw a short vertical line to cut the lower arcs of the letter e.

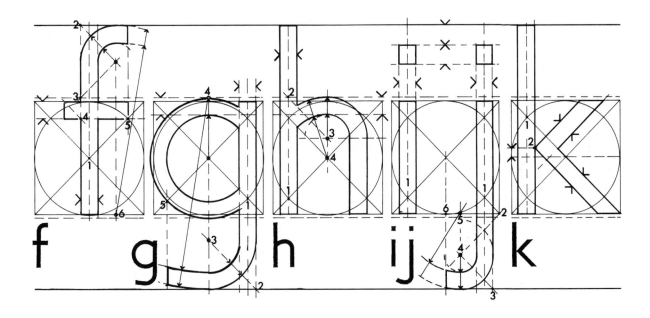

f

Draw a vertical line through 1 from the base to cap line, step off a ½ unit either side and draw parallel lines. From 2 draw a line at an angle of 45° down to the right. Repeat from 3 but in an upward direction. Using the intersection 7 as the center point draw a vertical line to the base then scribe two arcs as indicated. From 6 scribe 2 arcs as indicated. Draw a line at an angle of 45° up from 4 and to the left of the main stroke. Where this cuts the x line draw a vertical line. Draw a vertical line at 5 and continue to the cap line for the terminal of the arm.

g

Project a vertical line through the center from the x line to the descender line. Step off a ½ unit either side of this line and project two further parallel lines. Step off 1 unit on the top left of the grid and project a horizontal line to the right. Draw a line at an angle of 45° up from 2 to the left. From the center of the grid scribe two arcs to meet the vertical strokes at the top and bottom. From 3 scribe arcs to the descender line. From 4 scribe arcs as shown. From 5 draw a vertical line to cut the lower arm of the letter g.

h

From 1 draw a vertical line from the base to cap line, step off a ½ unit either side and project parallel lines. Step off 1 unit down from the dotted compensation line at the top right of the grid. Draw a line at an angle of 45° from 2 to intersect with a vertical line up from 4 to point 3. Project a horizontal line to the right. Using 3 as the center point scribe arcs to the right. Where the arcs intersect with horizontal line 3 to the right, draw two vertical lines. Using 4 as the center point scribe arcs to the left from the vertical line to meet the main stroke.

i

Draw a vertical line from 1 to the cap line. Step off a ½ unit either side and project parallel lines. To mark the position of the dot, measure 1 unit down from the cap line and 1 unit for the height of the dot.

j

Draw a vertical line from the descender line through 1 to the cap line. Step off a ½ unit either side and project vertical parallel lines. From 2 project a line at an angle of 45° to the left and down, and from 3 upward. Intersection 4 is the center point for the arcs. Project a vertical line from 4 up to the base line. Project a line from 6 to produce the cut off point of the lower arm of the letter j. Position the dot for the letter i.

k

Draw a vertical line from the base line through 1 to the cap line. Step off a ½ unit either side and project parallel lines. Draw a horizontal line from the center of the grid to the left edge. Step up a ½ unit from this and project a horizontal line to the right. From 2 draw a line at an angle of 45° up to the right and step off 1 unit. Repeat the procedure from 2, downward to the right. From each line project parallel lines.

l

Follow the instructions for the vertical stroke of the letter k.

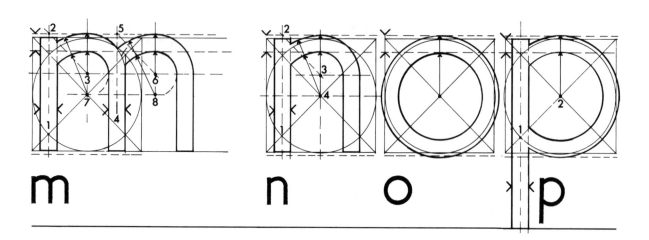

m

n

o

p

m

Extend the dotted compensation line, x line, center line and base line to the right. Draw a vertical line from the base line through 1 to the x line, step off a ½ unit either side and project parallel lines. Step off 1 unit down from the compensaton line in the top left of the grid. Project the line to the right. From the center of the grid project up a vertical line. Draw a line from 2 towards the last line drawn and where they intersect, 3, project a horizontal line to the right. With the compass point on 3, scribe an arc to the right to touch the horizontal line through 3 and from the arcs draw vertical lines to the base. Using a unit gauge, mark the center between the uprights, 4, and project up to the dotted compensation line to 5. From 5 project a line at an angle of 45° to 6 and draw a vertical line from 6 to the dotted compensation line and down to the center line. Using 6 as the center point, scribe arcs to the right to touch the horizontal line 3/6 and drop two vertical lines to form the stroke. Project the center of the grid to the right. Using 7 as the center point scribe arcs to the vertical line 1/2. Repeat for the vertical line 4/5, using 8 as the center point.

n

Follow the instructions for the letter h but shorten the main vertical stroke.

o

Draw a vertical line from the center up to the dotted compensation line. Step off 1 unit from this dotted line down from the top left corner of the grid and project to the right. Using the center of the grid as the center point scribe two circles.

p

Follow the instructions for the letter b but lengthen the main stroke to the descender line. Cut at the x line.

q

Follow the instructions for the letter d but lengthen the main stroke to the descender line. Cut at the x line.

Useful tip

When scribing arcs, always start at the cap or base lines and work inwards. This avoids the problem of the arc not meeting the cross stroke.

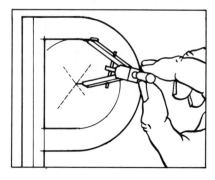

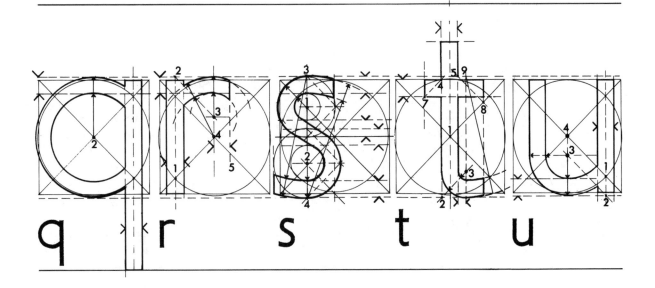

r

Project a vertical line from the base through 1 to 2. Step off a ½ unit either side and draw parallel lines. Draw a vertical line from 4 up to the dotted compensation line. Project a line at an angle of 45° from 2 towards 3. Step off 1 unit down from the dotted line and project a line to the right of the grid. Using 3 as the center point scribe two arcs. Using 4 as the center point scribe arcs to the main stroke. Step off 1 unit to the right of the center line of the grid and project a line upwards for the cut off point of the arm.

s

The general method of construction is virtually identical to the capital letter. However, note that both upper and lower circle center points, 1 and 2, are directly above each other on line 3/4. Stepping off units also change. The upper circle is stepped off down from the dotted compensation line and up from the center line. The lower circle, being larger, is stepped off a ½ unit above and below the center line. The arcs for the arms of the lower case letter also change, with 3 becoming the center point for the lower circle and 4 for the upper.

t

Draw a vertical line from the base line through 1 to the cap line. Step off a ½ unit either side and project vertical lines. Step off 1 unit at the top left of the grid and draw a horizontal line to the right. Step off a ½ unit at the base, right of the main stroke. Draw a vertical line. Project a line at an angle of 45° from 2. Scribe arcs from 3. Draw a line at an angle of 45° from 5 to 8; draw a vertical line at the intersection. Draw a line at an angle of 45° from 4 to 7 and a vertical line from 7. At the x line measure up 2 units for the terminal. Use 9 as the center point for the arcs at the base.

u

Draw a vertical line from the base through 1 to x height. Either side of the line step off a ½ unit and project vertical lines. From 2 project a line at an angle of 45° towards 3. From the center of the grid draw a vertical line to the dotted compensation line and draw a horizontal line through 3. Step off 1 unit at the base of the grid and project a horizontal line to the right. Using 3 as the center point scribe arcs from the dotted compensation line up to the line through 3 and project parallel lines from the arcs to x line. Using 4 as the center point, scribe arcs on the right to meet the vertical stroke of the letter u.

Accuracy hints

1 Make sure that your work is taped securely to the drawing board surface.
2 If using a tee square check that there is no movement between the blade and butt.
3 When projecting horizontal lines check that the butt is against the drawing board.

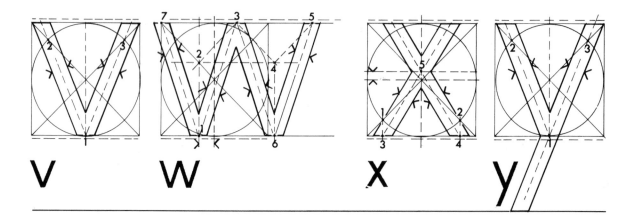

V W X y

v

From the center line draw a line to the base, 1. Project lines from 1 to 2 and 1 to 3. Either side of the diagonal lines step off a ½ unit and project parallel diagonal lines from the base to x line using an adjustable set square (triangle).

w

From the center of the grid draw a line to the base. Step off 1 unit to the left and project a vertical line to 2. From 2 project a line at an angle of 45° to the x line, 3. Draw a line at an angle of 45° from 3 to 4 and then from 4 to 5. Alter the adjustable set square to align with 6 and 5, turn the set square through 90° and draw a line from 6 to 3. Turn again and project a line from 3 to 1 and finally from 1 to 7. Either side of the lines, step off a ½ unit and project parallel lines to form the letter w.

x

Draw a vertical line from the x line through the center of the grid to the base. Draw vertical lines from 1 to the base and 2 to the base. Step off a ½ unit above the center and project a horizontal line. Draw a line from 3 through 5 to x line. Repeat from 4 through 5 to x line. Either side of the lines step off a ½ unit and project lines with an adustable set square to the x line.

y

Follow the instructions for the letter v, but lengthen stroke 3/1 to the descender line.

z

Project lines from the x line through 1 to the base, repeat through 2 to the base. From 3 project a line to 4, step off a ½ unit either side and draw parallel lines using an adjustable set square. Step off 1 unit down from the x line and up from the base line. Project horizontal lines. From 4 draw a line at an angle of 45° towards the center of the grid. Where this cuts the x line, draw a vertical line.

&

For the ampersand ("and" sign), first draw in above the cap line (ascender line) ⅙ of a unit, as a dotted compensation line. Draw a vertical line through the center of the grid from the base to 1. Project a line at an angle of 45° down from 1 to the right and up from 2 to intersect. Draw a horizontal line to the left to give 3, the center of the upper circle. Step off 1 unit down from the upper compensation line and from the lower compensation line below the base. Project parallel lines towards the center. Using 3 as the center point, scribe circles. Using the center of the grid scribe the lower circles. Project a line at an angle of 45° from 3 to 5. Join 5 to 4 and follow the line through to the base. Using an adjustable set square set to the angle formed by line 5/4, project a further line to the base to give the stroke thickness. Extend the base line to the right and draw a line from 6 to 7; project a further line for the thickness of the stroke. Using 8 as the center point, scribe arcs from the base to the right. Draw a horizontal line from 4.

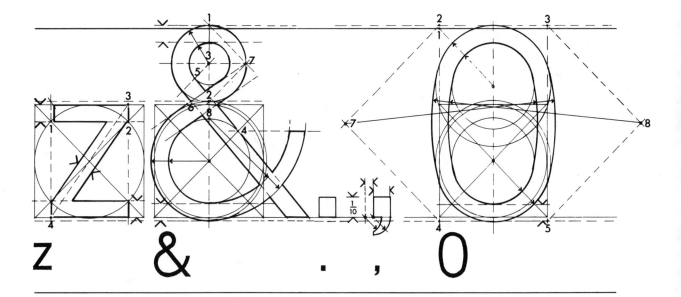

Comma and full stop (period)

Step off ¹⁄₁₀ of the cap height from the base line. Step off 1 unit (lower case) wide, then a further ½ unit. Use the base left hand corner as the center point and scribe an arc; use a ½ unit mark to the left as the center point and scribe an arc.

1 Lining numerals
2 Hanging numerals

0

Draw vertical lines from the left, center and right of the grid from the base to cap compensation lines. Step up 1 unit from the base dotted compensation line. To find the center of the upper circle project a diagonal line, 1 to the center. Scribe the lower outer circle using the center point of the grid, and with the compass still set scribe the upper outer circle. Repeat the procedure for the inner circles. To find the centers for the outer arcs, project lines at an angle of 45° from 2 to 7, 4 to 7, 3 to 8 and 5 to 8, and project the arcs as indicated.

Numerals

There are two types of numerals – lining numerals and hanging or old style numerals.

Lining numerals

Lining numerals sit on the base line and invariably extend upwards to the capital line, or in some styles fractionally below.

Hanging numerals

Hanging numerals are placed in one of three positions on the grid. the numbers 1, 2 and 0 sit within the x height area. The numbers 3, 4, 5, 7 and 9 are treated like a lower case g, with part of the numeral within the x height and part extending as a descender into the descender area. The numbers 6 and 8 sit on the base line and project through the x line and into the ascender area.

Optional lining or hanging numerals

Some serifed letter styles or typefaces have optional lining or hanging numerals. This allows the designer or lettering artist to choose the preferred style. Lining numerals look best with capital letters and hanging numerals are more sympathetic when used with upper and lower case. Sans serif alphabets use lining numerals in the main although a few styles have both.

¹ 1234567890

1234567890

² 1234567890

1234567890

Sans serif: numerals

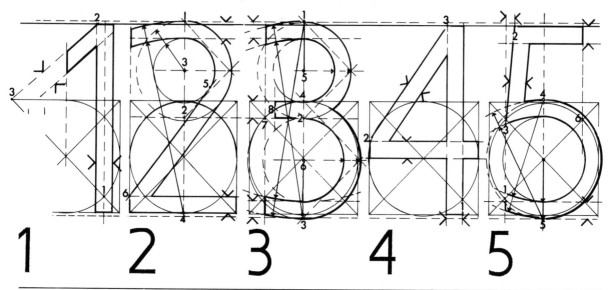

1

From the base draw a vertical line through 1 to the cap line. Step off a ½ unit either side and project vertical parallel lines. From 2 draw a diagonal line to 3 and, stepping off 1 unit, with an adjustable set square project a further diagonal line parallel to the first. Draw a vertical line from the center of the grid as the terminal position of the diagonal stroke.

2

Draw a vertical line from the base through the center of the grid to the compensation line above the cap line, 1; from 1 project a line at an angle of 45° down to the right. Step off 1 unit down from the dotted cap compensation line and 1 unit up from the base line; project horizontal lines. From 2 draw a line at an angle of 45° up to the right. Where the intersection occurs, project a horizontal line to cut the center line. Using 3 as the center point scribe arcs. Using 4 as the center point scribe arcs for the upper arms. From 6 draw a diagonal line to form a tangent with 5; project a further diagonal line using an adjustable set square. Cut the upper arm at the left side of the grid.

3

Step off 1 unit down from the dotted compensation line above the cap line, x line and up from the dotted compensation line below the base line; project all three lines horizontally. From 1 draw a line at an angle of 45° down to the right; repeat the procedure from 4. Draw a line at an angle of 45° up from 3 and then 2; where the diagonal lines intersect, project horizontal lines to cut the center. Scribe upper circles using 5 as the center point. Scribe lower circles using 6 as the center point. Using 3 as the center point scribe arcs for the upper arm and using 1 as center point scribe arcs for the lower arm. From 7 project a vertical line to cut the upper and lower arms. Where the circles intersect at 8, draw a short vertical line for the middle arm and project short horizontal lines to the right.

4

From 1 draw a vertical line from the base to the cap line. Step off 1 unit to the left of 1 and draw a vertical line. Project a horizontal line through the center of the grid and step up 1 unit; project a horizontal line. Join 2 to 3 with a diagonal line and step off 1 unit inwards projecting a parallel diagonal line.

Task
Styles
Look through your typeface collection in your scrap book and establish which styles have both hanging and lining numerals. If you don't have examples of lining and hanging numerals, search through library typeface books and dry transfer catalogues and take photocopies to paste into your typeface collection.

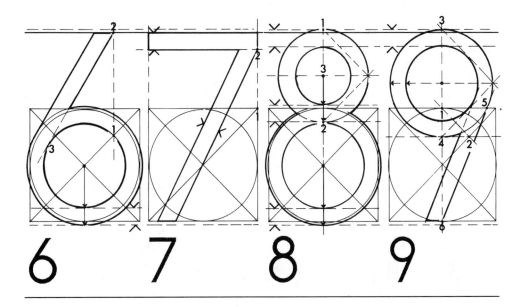

5
Draw a vertical line from the base through 1 to the cap line. Step off a ½ unit to the right. Step off 1 unit down from the cap line and 1 unit up from the base compensation line. Using the center point of the grid scribe circles. Project a vertical line through the center of the grid from the base compensation line to the cap dotted compensation line. From 2 draw a diagonal line to 3; step off 1 unit and project a further diagonal with an adjustable set square. Using 4 as the center point scribe arcs at the base. Using 5 as the center point scribe arcs at x line. Project a vertical line from 6 to give the terminal point of the cross stroke.

6
Step off 1 unit up from the base compensation line. Scribe circles. Project a vertical line from 1 to the cap line 2. From 2 draw a diagonal line to form a tangent with the inner circle, 3. Using an adjustable set square, project a further diagonal line to give the stroke thickness.

7
Extend the right side of the grid vertically to cap line 1 and repeat with the left side. Project a horizontal line. Step down 1 unit from the cap line. Draw a diagonal line from 2 through the center of the grid to the base line. Step off 1 unit and project a line to give the stroke thickness.

8
Draw a vertical line from the cap to the base through the center of the grid. Step off 1 unit down from the cap compensation line; 1 unit down from x height dotted line; and 1 unit up from the base dotted line. Project horizontal lines. From 1 draw a line at an angle of 45° down and to the right; from 2 draw a line at an angle of 45° up to intersect. From the intersection project a horizontal line to cut the vertical line. Using the center of the grid scribe the lower circles. Using 3 as the center point scribe the upper circles.

9
Draw a vertical line through the center of the grid from the base to cap line. Step off 1 unit down from the cap compensation line. Draw a line at an angle of 45° down from the center line, 1, to cut the diagonal line, 2, and project to the left to cut the center line, 4. Project a line at an angle of 45° down from 3 to the right, and up from 4 to intersect. At the intersection draw a horizontal line to the left to cut the center line. Scribe circles. Project a diagonal line from 5 to 6 using an adjustable set square and, moving the square to form a tangent with the inner circle, project a parallel diagonal line.

Sans serif: repetitious forms

You may have noticed when constructing your letterforms that certain shapes within the capital and lower case alphabets are repeated. Letterforms can be grouped by shape or ease of drawing. Some letters have the same construction details and can therefore be superimposed to eliminate extra work. Furthermore, an understanding of the way in which letterforms are repeated will assist you in generating new alphabet styles.

After carefully analyzing an alphabet style it is possible to group together those letters which may be generated on the same grid.

 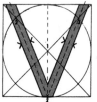 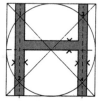 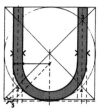 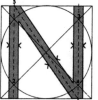

Capital letter groups
A, H, I, N, U and V are similar forms in width but not in shape. When overlapped, the forms can still be seen. Once the letter A has been drawn, the letter V can be taken from it by inverting the letter and omitting the cross bar. The letter H has been drawn on the same grid, not because it has a similar shape but simply to use the available area on the grid. The letters U and N are identical in width to the letter H and therefore have been superimposed to save work. The I can be taken from any vertical sided letterform.

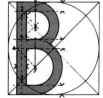 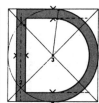

The cross stroke in the letter B is in the same position as the letter E. By deleting the lower cross stroke the letter F is generated. By deleting the two upper arms, but retaining the lower cross stroke, the letter L is created. A curve has been added to the vertical and upper and lower cross strokes to form the letter D.

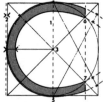 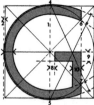 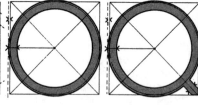

The letters C, G, O and Q can be generated from the same drawing. The letter D does not fall into this group because it has flat cross strokes at the capital and base line.

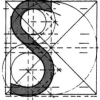 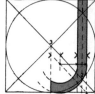 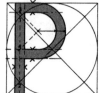 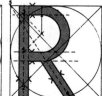

The letters S and J (*left*) are grouped together because their lower arches are identical. If you add a leg or tail to the letter P it becomes a letter R (*right*).

The remaining letterforms, K, M, T, W, X, Y and Z, require drawing separately. The letter M cannot be inverted to form a letter W because their shapes are very different.

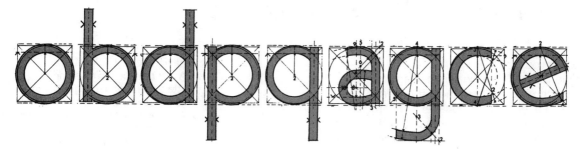

Lower case letter groups

The lower case alphabet also has much repetition. All the round letters can be generated on one grid by adapting, ie inverting, mirror imaging or adding or subtracting strokes.

Once the letter b is drawn it can be mirror imaged to form a letter d. If both the letters b and d are inverted they form the letters p and q respectively. By omitting the ascender from the letter d at the x line, the letter a is generated. By making a few additions to the letter a the letter g can be produced. The letters c and e can also be worked on the same grid.

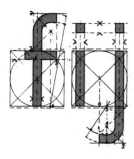

The letter f when mirror imaged and inverted will form the the basis of the letter j.

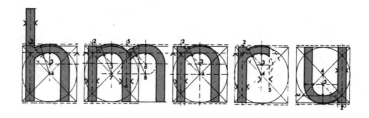

The letters h, m, n, r and u may be drawn on the same grid because they are of similar width or have similar construction details.

All of the remaining letterforms, k, s, w, x and z require drawing separately.

Task
Mirror images
Draw the letter b on tracing paper over a grid. Mirror image and invert it to see which letters can be generated.

Numerals
There are similarities between the numerals 2, 3, 5, 6 and 8. It might not be apparent at first glance but some of the curves are generated from the same points. The remainder of the numerals require drawing separately. The number 9 for instance is not six inverted because the bowls differ in size. The numbers 1, 4 and 7 may be grouped. It is simpler to draw the zero separately because of its many curves and construction details.

Task
Comparison of forms
Trace the capital letter C from your alphabet sheet. Overlay the letter C onto the other round capital letters and note the similarities. Work through each of the groups above and make notes of your findings in your scrap book.

Inking in your alphabet

When you have constructed your sans serif alphabet you may then wish to ink it in. The techniques used when inking in on tracing paper are slightly different from those used when inking in on stiff paper. If your alphabet is constructed on tracing paper it is inadvisable to use a brush with india ink to fill in the strokes as the tracing paper buckles or cockles when wet.

Tools and materials
You will need the following:
1 A technical pen, with compass attachment, or a ruling pen and compass ruling pen attachment.
2 A waterproof fiber pen for filling in the strokes.
3 A scalpel holder (or X-Acto knife) and blades for correcting.

Curved lines
Using either your compass and technical pen or ink compass, scribe all the circles and arcs throughout the alphabet. This will save time and negate cleaning of the ink compass (if used) after each letter. Once all the circles and arcs have been drawn in ink, repeat the exercise but this time reduce or increase the circles/arcs to thicken the lines slightly. Remember to always thicken on the inner side of the line working inwards to the stroke, not outwards, as this will distort the letterforms.

Straight lines
Once this is completed, draw over the straight lines in ink, again thickening the lines to the inside of the stroke.

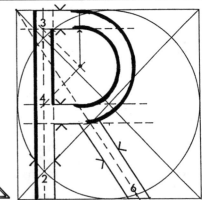

Filling in
When all the letterforms have been outlined, take a medium point fiber tip pen and fill in the insides of the letters.

Useful tip
When inking in letterforms and using set squares and rulers as straight edges, stick masking tape to the underside of the rule/set square a little way in from the edge. This prevents the ink from seeping underneath the edge.

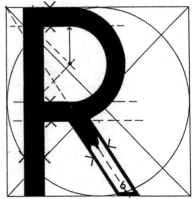

Cleaning away mishaps

However much care you take in inking in letterforms, mishaps do occur; ink blots, overrunning a line, and smudging your work all can appear disastrous. You can clean away ink from tracing paper using a scalpel blade.

Gently scrape away the ink using a 10a (or X-Acto no. 11) blade flat to the surface. The movement should be in more than one direction working into the offending area. In this way not only is the ink removed but also a layer of tracing paper without leaving a sharp ridge. Once the error has been removed, burnish the paper by rubbing the area with a finger nail. This flattens the fibers so that when the surface is reworked the ink doesn't feather or bleed.

Build up a store of master alphabet sheets

When you have finished inking in your alphabet you may find it useful to store this safely in order that you may use it in any future projects you undertake. Once you have become proficient at freehand drawing and letter and word spacing, the alphabet you have produced makes a good reference for over tracing.

When a sign or poster is required quickly, the alphabet sheet is used as the master and the letterforms are traced directly from the sheet. Master alphabet sheets are more durable if lettered on stiff paper. It is useful to have several sizes of each alphabet to give a choice of letter height when producing signs or posters. The master alphabets can be drawn separately to different heights, or alternatively, a photocopying machine which has the facility to enlarge or reduce the original can be used.

Task

Drawing a letter P

Draw up a letter P on tracing paper in 2H pencil, outline with your technical pen and fill in the center with a fiber tipped pen. Continue with other letters of the alphabet until you feel that you are proficient.

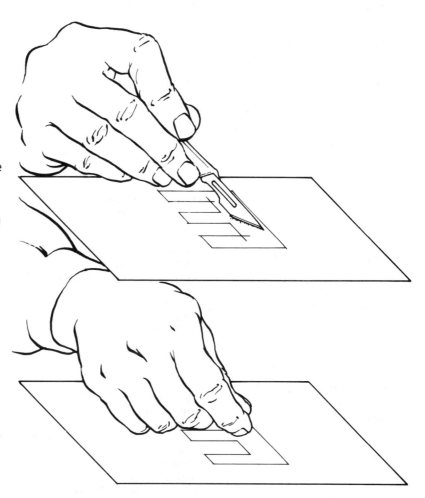

©DIAGRAM

195

Roman alphabet 1

The classic forms of the Roman capital alphabet are the basis of many designs and have been used for over the past 2000 years. Originally produced as carved forms their beauty is now part of our cultural heritage. Because the letters are highly sophisticated forms that do not lend themselves to direct mathematical construction, they are best drawn freehand using a grid as a guide to their shapes.

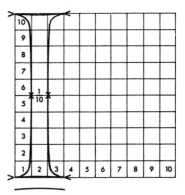

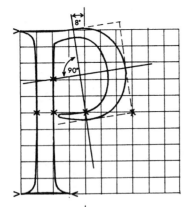

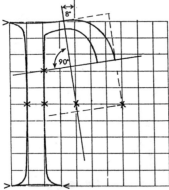

An example of a Roman vertical and round stroke letterform
The letter P is illustrated above. To create the letter, reference points have been gained by examining the form on its grid. Where necessary, lines are projected to assist in the construction. The dotted area shows half of the rectangle in which the curved strokes are constructed, with the upper quarter being drawn first and the lower portion being generated by inverting the upper quarter.

Tools and materials
To construct this alphabet you will require the following tools and materials:
1 A drawing board.
2 A tee square (or parallel motion).
3 An adjustable set square (triangle).
4 A ruler.
5 HB and 2H pencils.
6 An eraser.
7 Masking tape.
8 Tracing paper.
9 A sheet of stiff paper.

Basic proportions for Roman capital letters
Before you start the classical Roman alphabet, study the proportions of the examples shown. This alphabet has been placed on a gridded square measuring 10 units high by 10 units wide. The stem of the main stroke is approximately 1/10 of the cap height. However, the main stroke splays outwards from this width, which is centralized on the height.
The horizontal stroke is approximately half the main stroke width at its thickest point. The maximum point of stress on all round letterforms is at 90° to the angle of inclination, which is 8° from the vertical. As with all round strokes the weight is slightly heavier for optical adjustment. The letterforms should be freely drawn on the grid first in HB pencil and firmed up with a sharp 2H or 4H pencil, rubbing out areas as they are corrected.

The Roman capital I
In the above illustration the capital letter I is placed on the grid. Note the reference points with arrows. The letterform is 3 units wide if we include the bracketed serifs. The stroke width of the character measures 1/10 of the height (1 unit). The line at the head and foot of the letter is curved (not flat) so you can still see the capital and base lines; this is a trait of the style and all the characters ending with a similar serif are treated in this way. Study the main stroke and you will see that the lines are not parallel, but from the 1/10 unit splay out upwards to the capital line and downwards to the base line. This again is a characteristic of the style. There are no parallel or straight lines in the alphabet as they all taper and splay. The letter I forms the criterion for all the vertical stroke letters, diagonal and secondary (cross) strokes, regardless of thickness.

The Roman capital letter T
The letter T is formed from the letter I with a cross stroke of 1/2 unit width added at the capital line. This cross stroke has a bracketed serif at each end and is not a straight line but a gentle curve. The cap line is just visible in the center of the stroke.

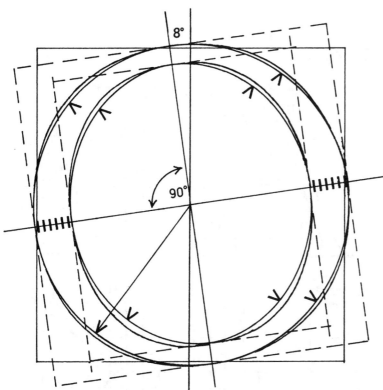

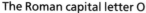

The Roman capital letter O

The above illustration shows the letter O placed on the grid. The shape of the O forms the criteria for all round letters. It has stress, ie the letter shape is not vertical but leans to the left. The angle of stress is 8° from the vertical. The shading, ie the widest part of the curve is at 90° to the stress and marginally wider than the 1/10 width. The thin stroke is about a 1/2 unit in thickness. The classical Roman alphabet can be described as having diagonal stress with oblique shading for its round characters.

To show the shape, the letter O has been superimposed onto geometric shapes – an outer circle and an inner ellipse. You will see that the letter O conforms to neither the inner nor the outer shape. The letter O (like the letter I) has no geometric form in that it is a freely drawn shape.

Examples of errors sometimes made when drawing the Roman capital letter O

The illustration (*top right*) shows a letter O which is too wide. The original quarter section was not drawn accurately in width and when the image was overworked (ie maneuvered to give inverted and mirrored images) to generate a full letter O, the error was compounded. In the illustration (*second right*) the first quarter of the letter O has been drawn inaccurately, producing a pointed effect at the axis. The curve should have been fuller in shape and at right angles to the axis at the point of intersection.

In the illustration (*third right*) the true form of the letter O has been highlighted to show the degree of error in the above two drawings.

Practice makes perfect

From the examples you can see how important it is to draw the first quarter of the letter O correctly. You may find that you need to make several attempts before the final shape is correct, but it is well worth the effort because other characters

are generated from this shape. Remember that all round letters, except for the capital and lower case letter S, have a stress of 8° from the vertical. Round letters also break the grid lines and should be drawn to a compensation line to allow for optical adjustment.

Roman alphabet 2

The remaining letters of the Roman capital alphabet are shown opposite. There was considerable interest during the Renaissance in the Roman capital alphabet. Artists reconstructed letterforms using rulers, straightedges and compasses and there was much discussion on the proper ratios of letterforms.

Letterforms based on the work of Renaissance artists

Fra Luca de Pacioli used the compass as much as possible in constructing his alphabet, which was published in 1509.

Albrecht Dürer's constructed alphabet was published in 1525 in Nuremberg. Dürer's models show slightly more reliance on freehand drawing and less reliance on the compass.

Geoffroy Tory's alphabet was published in 1529. He considered that capital letters should be fashioned after the three most perfect figures of geometry – the circle, the square and the triangle.

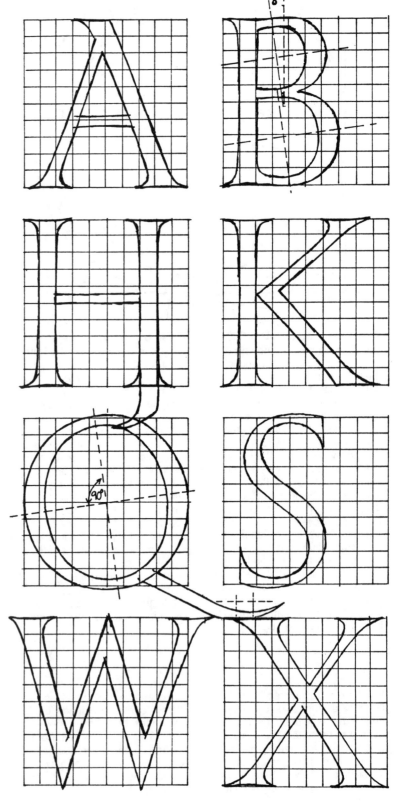

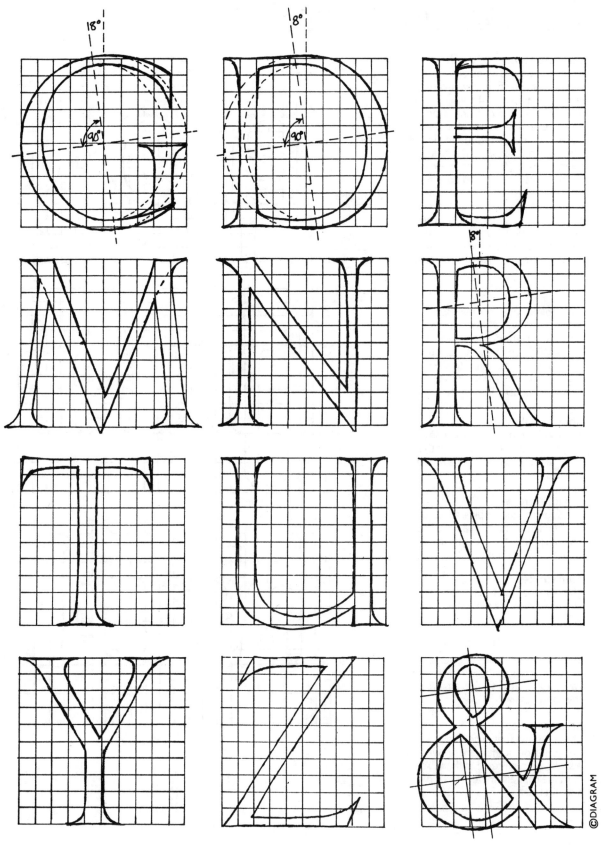

Roman alphabet 3

Basic proportions of classical Roman lower case letters

The grid on which the lower case letters are drawn is 14 units in height. It is only extended by 4 units from the base line downwards to accommodate the descending letters (the descender area). In this style there are 10 units from the base line to the capital line (ascending line). However, these units are subdivided to give two separate areas, the x height and the ascender area. The x height measures 6 units from the base line up to the x line and the ascender area takes up the remaining 4 units.

Stress

The angle of stress for the lower case letters remains at 8° from the vertical. All rounded letterforms have this stress. When you begin to construct letterforms it is advisable to start with the letter O as this shape, or variants of it, are repeated frequently.

Round strokes

The width of the main stroke on a round form is marginally more than 1/10 of a unit but not as wide as the capitals.

Straight strokes

The straight main strokes are drawn to approximately 1/10 of a unit. They do not splay out as much as their capital counterparts.

Thin strokes

The thin strokes of both round and straight letters are slightly less than half of 1/10 of a unit.

Cross strokes

The cross strokes on the letters f and t are slightly below the x line. The lower case letter z cross strokes dip only in the center of each stroke.

Serifs and feet

The serifs and feet, whether horizontal or inclined, are drawn with a slight concave curve to them. As with the capitals, there are no true straight lines.

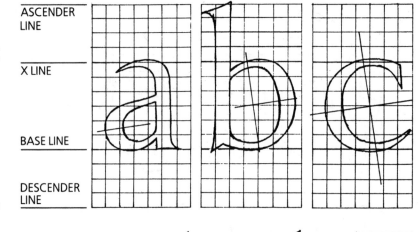

ASCENDER LINE

X LINE

BASE LINE

DESCENDER LINE

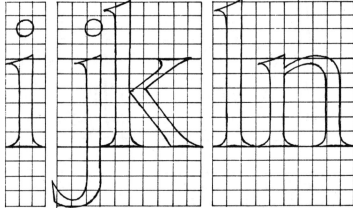

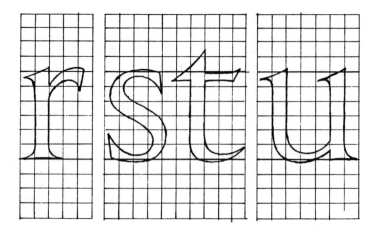

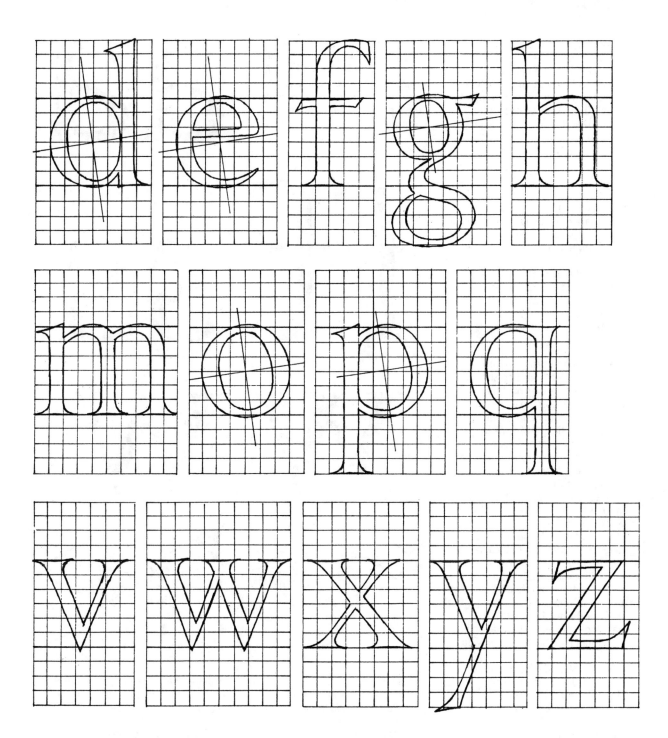

Repetition

It is much more difficult to mirror image and invert shapes in the Roman style than in the Sans serif style. The p and q, for instance, are slightly different. When examining the letter m you can see that the counters are somewhat narrower than those of the letters h or n.

Roman alphabet 4

Alternatives
Two styles of the letter w have been produced. The original version consists of two overlapping leter v's while the modern form has a pointed middle apex. It is perhaps worth noting that this alternative style may be used in the capital alphabet. Here are two alternative terminals and serifs for the letters a, s and f. Whichever style is chosen it is important to use the same endings consistently in order to produce a harmonious effect.

Inking in on paper and board
If you have drawn your letters directly on to stiff paper or board you may ink them in with a brush.

Tools and materials
You will need the following:
1 An artist's sable no. 3 pointed brush.
2 India ink (non waterproof).
3 A home-made bridge.

Starting with vertical strokes
Load the pointed sable brush with ink, removing excess on the edge of your bottle by turning while wiping. Position your bridge for painting in a left hand vertical stroke. Ink in the vertical stroke resting your painting hand on the bridge while supporting the bridge with your free hand. Look directly over the line being lettered to monitor the progress of the brush. Start at the base of the letter and work upwards ending the stroke a little way from the cap line (*see diagram 1*). Move on to the next left hand vertical stroke and repeat the procedure. All the left hand vertical strokes in the word should be lettered before moving onto the other parts of the letterforms. This method of painting reduces the time taken in positioning the bridge for individual strokes.

The work should now be turned upside down so that the right hand sides of the letterforms can be inked in (*see diagram 2*).

Diagonal strokes
Once the word has all of its vertical strokes painted in, the bridge can be moved into a position suitable for diagonal strokes. Ink in these strokes following the same procedure as for vertical strokes.

1

2

Cross strokes
All cross strokes should be inked in next. Paint one side then turn the work over and paint in the other side (*see diagram 3*).

Round strokes
Paint the outer edges of round strokes first (*see diagram 4*). The bridge can be repositioned as each portion of the curve is completed.

You may have to reposition yourself a number of times around your work surface to complete the letterforms. Once the outer curve of a letter is finished, the inside curve can be painted. If the work is not too large, the work piece itself can be turned. It is important not to rest your hand directly on the work, as grease from your hand will transfer to the work surface and ink will not take to it. If

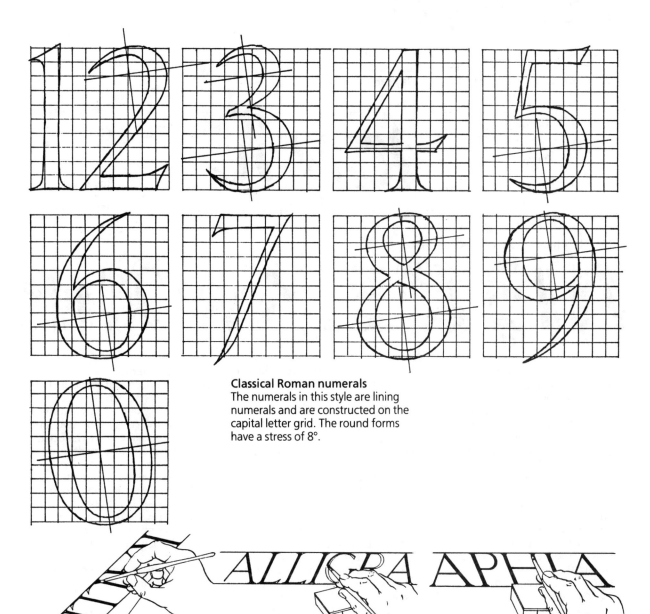

Classical Roman numerals
The numerals in this style are lining numerals and are constructed on the capital letter grid. The round forms have a stress of 8°.

3

the work is to be turned, it is difficult to use a bridge. Protect the work surface with a piece of card under your hand.

Serifs
The serifs should be painted in last. Work in from the point of the serif to the main stem (*see diagram 5*).

4

Retouching
If any areas require retouching, opaque white paint for white backgrounds or a mixed designer color for colored papers may be used. When retouching, it is important not to allow the india ink to become too wet as it may bleed into the retouching paint.

5

Task
Inking in with a brush
Choose some letters to draw up on stiff paper and follow the instructions for inking in with a brush.

Brush script 1

Brush script is a very versatile method of producing quick professional quality lettering. It is ideal for those urgent notices, posters and display cards.

		Capital line
1 unit		x line
2 units	*kyR*	
		Base line
1 unit		Descender line

Basic brush directions of practice strokes

Setting up a work surface
You will need to set up a drawing board. An adjustable one is useful as the angle of the work surface can be changed to suit. If you don't have one, a board leaned against a table top and resting on your lap is fine. The angle should be approximately 30° to the horizontal.
It is important to be comfortably seated when practicing brush script. The position of the head and eyes in relation to the work is also important. The line to be lettered should fall slightly below eye level. The working surface should be kept clear of inks, paints, water jar and other equipment.

Task
Drawing grid lines
Tape a sheet of stiff paper to your board and draw a series of grid lines on the sheet with the cap to base line measuring ¾" (30 mm).

Method of lettering in brushscript
Grid lines are drawn with an HB pencil for the capital line, x line, base line and descender line. The lines are positioned just below eye level when you are in a seated position.
Load the brush with ink or paint by first dipping the hair in the pigment, and then wipe the brush on the side of the bottle or pallet while turning the brush. If there is too much liquid remaining on the brush, the ink or paint will run, while if there is too little the brush may run out of ink or paint before the stroke is finished. Lay the tip of the brush on the paper at an approximate angle of 30° to the writing line. The degree of pressure applied governs the weight of the stroke produced. Italic letters have an inclination of about 20° to 25° from the vertical. The starting point for most strokes in the capital alphabet is at the capital line.

Size of letters
The thickness of the stroke is determined partly by the size of the brush used and partly by the pressure applied. A no. 3 long haired sable brush has been used to produce the illustration of the letter S (*right*).

Basic movements
The strokes illustrated above are the basic movements, which require mastering, for both capital and lower case letters. On close inspection you can see that nearly all the characters in the alphabet can be made up from these strokes.
The style is built up from positive deliberate movements and is best achieved when the strokes are completed in one movement. If you hesitate slightly in the middle of a stroke the positive action is lost. The movement emanates from the shoulder and wrist depending on the size of the letterforms.

Proportions of letterforms in brush script (*left*)

The proportions of the letterforms, ie x height to ascenders and descenders is usually 2:1. This ratio can, however, be modified to suit the requirements of the work in hand.

Tools and materials

To produce this versatile freehand style you will need the following tools and materials:

1. An adjustable drawing board or sloped drawing board and tee square.
2. A set square (triangle).
3. A ruler.
4. A good quality long haired no. 3 sable brush.
5. Non waterproof ink or gouache.
6. A pallet.
7. A jar of water.
8. Stiff paper.
9. An HB pencil.
10. Masking tape.

Even pressure

Uneven pressure

Straight strokes

Holding the brush at an angle of 30° from the capital line, move it down towards the base line. Speed is of the essence and this movement should be done quickly to give character to the letterforms. If the stroke is lettered too slowly the form will not be so clean and the result will be uneven.

Task

Practicing brush strokes
Take your no. 3 brush and ink or paint (mixed to the consistency of light cream) and practice the strokes.

Brush action

The action of the brush is important and a good sable brush has spring, which assists in the construction of the forms when pressure is applied and released to give the thick and thin strokes. Use the little finger to lift the hand, while bending the thumb and index fingers to lift the brush away from the writing surface.

Task

Examining strokes
Examine the direction of the practice strokes and the weight of each stroke. Take special note of the curved forms, the point at which pressure is the greatest when the stroke is at its thickest and the point at which the pressure is the least when the stroke is at its thinnest.

Pressure

The pressure on the brush hair governs the stroke width and therefore must be kept constant. The result of uneven pressure is an erratic letter with irregular sides.
On curved strokes, the pressure is light at the start of the stroke and steadily increases until a weight of stroke is achieved which is compatible with the straight letterforms. The pressure is then gradually eased off to thin the stroke again. This laying on and easing off of pressure can be seen clearly in the practice stroke which forms the left side of the C, G, O and Q. It is essential to master this before attempting the Sans serif alphabet.
Compare the examples of the brush strokes (*center left*) in which the pressure is even, with those (*center right*) in which the pressure is uneven.

Brush script 2

Once the basic strokes have been mastered the alphabets shown below can be approached with confidence. Follow the order and direction of the strokes indicated, taking note that some of the strokes end on an upward movement. The thickness and thinness will depend upon your brush and the pressure you apply. The style will be the result of your handwriting characteristics.

Variety
The selection of examples (*right*) show how the simple forms of a brush script in the hands of a practicing lettering artist take on different features. Not only are they individually different, but national characteristics affect them because of differing educational and cultural influences.

ABCDEFGHIJKLMNOP

QRSTUVWXYZ 12345

67890£?!&OQabcdef

ghijklmnopqrstuvwxyz

abcd *aabcd* *abcde*
ABC *ABCD* **ABCD**

Examples (*left*) of a Sans serif style alphabet, upper and lower case, produced using a long haired sable brush.

Capital alphabet (*right*) produced using a square ended brush.

Task
Try different brushes
Draw out the alphabet between two lines with your usual brush. Then redraw the letters using either a larger or smaller sized brush.

Task
Try different size letterforms
With your usual brush try drawing your script style in either a larger or smaller size.

Task
Try to build up speed
Draw out a row of letters of the alphabet evenly and carefully, taking as much time as you need. Repeat the row of letters several times, building up speed as you practice.

ABCDEFGH

ABCDEFGH

IJKLMNOP

IJKLMNOP

QRSTUVW

QRSTUVW

XYZ!?

XYZ!?

©DIAGRAM

207

Chapter 4

ABCDEFGHIJKLM

ABCDEFGHIJKLM

ABCDEFGHIJKLMN

ABCDEFGHIJKLM

ABCDEFGHIJKLMN

APPLICATION

This chapter is concerned with the application of letterforms and how to use the alphabets that you have constructed.

There are numerous ways in which letterforms are used to communicate. They are employed to convey information, as on handbills, posters and signs. Letterforms often play a decorative role on murals, house signs, sail boards, boats, skateboards or T shirts where the forms are an embellishment. Fairground letterforms are a wonderful example of letters being used to project a fun, larger than life atmosphere.

There are many ways of applying letterforms. They can be cut out of several different materials – card, paper, acrylic sheets, laminates, wood, metals or cloth and can even be baked as biscuits. Almost any material which can be formed by molding, or is capable of being cut out or incised into can be adopted. The forms can be conventionally painted by brush or spray painted using a mask or stencil. In the following pages we will look at the application of letterforms in creating stencils, painted signs and artwork for reproduction. When you have mastered these techniques you may wish to venture further into using the many materials available.

The essential part of any lettering method is the origination – the tracing from which the letterforms will be generated. The process of tracing and tracing down is explained in full, as many of the methods employed in producing letterforms require this process.

NOPQRSTUVWXYZ

NOPQRSTUVWXYZ

OPQRSTUVWXYZ

NOPQRSTUVWXYZ

OPQRSTUVWXYZ

©DIAGRAM

Developing letterforms

Having mastered the basic proportions and construction techniques of letterform design, you can then develop the characteristics of letters in a variety of ways. Remember that whatever the inventive and interesting adaptations you devise, the prime purpose of any word is to be read. Avoid styles which are over elaborate and therefore hard to produce. It is better to achieve an excellent simple solution than a poorly produced elaborate one. Lettering artists have been developing their styles for over 5000 years and will continue to twist and distort the basic proportions, testing our powers of identification.

Ideally, any decorative style you introduce should reflect the character you wish to portray in the word. Inappropriate styles, such as flowery letterforms on a highway sign or nineteenth century forms for a computer company symbol, hinder rather than strengthen the message they are conveying.

Within the forms
The basic outline features of a style are retained but the surfaces are decorated or changed in some way to add interest.

Perimeter additions
The basic outline features of a style are retained but edges beyond the surfaces are decorated or changed in some way to add interest.

Special shadows
The basic features of a style are retained but their silhouette characteristics are repeated, usually in a lower position to imply that they are casting a dropped shadow of their forms. This method is very easy to produce as initial pencil tracings of the forms can be reused in a new position.

Three dimensional
The basic features are retained but the letters are extended in some way so as to indicate that they are constructed from solid material or incised into a surface.

Outline forms

The basic features of the letterforms are retained but the centers of the shapes are not filled in so that the letters appear in outline. This style is often very delicate and refined but is also very difficult to paint or draw with accuracy.

Distorted forms

Lettering artists often distort basic letterforms to produce a personalized and unique form. In this situation no rules apply as the letters are often the work of inspired invention.

Serifed forms

The ends of strokes of the letters can have a wide variety of embellishments. In traditional calligraphic styles these were quick twists of the pen after completing the stroke. In later styles the ends became a dominant feature of the forms.

Swash forms

These are extensions to letterform strokes. They are mainly used with styles that have serifs, although, brush script styles often have this type of adornment. There are a few Sans serif styles which adapt to swash extensions. In their true form, swashes are curved strokes ending in a curl, point or small ear.

Task
Embellishing alphabets
Draw or photograph the many ways in which the word "Sale" may be embellished. Put the drawings or photographs in your scrap book for reference.

Task
Collect examples
Collect samples of embellished letterforms from packaging, newspapers and magazines. Take photographs of signs and vehicles. There is a wealth of reference in every main thoroughfare which you can record for future use.

Task
Embellishing sans serif and Roman letters
Take a word and letter it in both Sans serif and Roman. Work over your words on tracing paper and experiment with the various embellishing techniques.

© DIAGRAM

211

Stencils

Stencil applied letters are a quick method of producing a sign or decorative image. The materials involved are easily obtainable and require little outlay.

Stencil alphabets
The alphabets which have been described in this book can be adjusted to allow for stenciling. However, specifically designed stencil letters may be obtained, as these examples show (*below*).

ABCDEFGHI
abcdefghij

äbcef
ÄBCDE

ABCDEFGHIJKLMNOPQ

Tools and materials
In addition to your general equipment you will need the following:
1 Cutting tools, either artists' knives or scalpels.
2 Sponges and flat-headed stencil brush, for dabbing ink into the surface.
3 Spray diffuser, for spraying inks through the stencil.
4 A tin of spray paint suitable for the surface to be worked on. Alternatively a suitable brush paint can be used.
5 For the more ambitious an airbrush is a useful tool. Although airbrushes, cannisters and compressors are expensive, they provide the opportunity to produce a range of different finishes to your work.
6 Some oiled paper/board or card.
7 Artists' self-adhesive clear film (such as that used to cover books).

A basic stencil
A basic stencil is an image cut out of a piece of card or similar material. The chosen medium is passed through the open stencil on to the surface to be decorated or lettered. The material for stencil making must therefore be non-porous so that the medium only passes through the cut out areas.

Adjustment to letters
Because the area to be applied is an open shape, letterforms which have inner counters require some adjustment to prevent the counter from separating and moving while the medium is being applied. Ties are therefore needed to link the inner counters to the surrounding areas and give the stencil stability.

Making a basic stencil (*right*)
1 Trace down the required image onto the oiled paper or board. If you are using ordinary card trace the image down and then cover both sides of the card with a sheet of self adhesive clear film. This will prolong the life of the stencil if more than one application is required.
2 Cut out the letterforms, remembering that all inner counters require a tie with the surrounding counter of the letterform.
3 Place the stencil onto the desired surface and, using a brush, paint or dab the image area until the required coverge is attained.

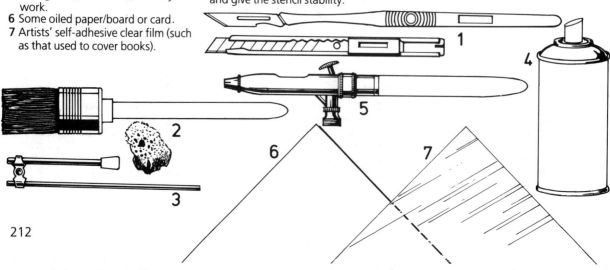

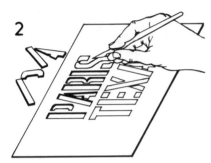

Using masking film to produce a stencil (*right*)

A stencil may be produced using masking film. This method gives a professional finish with clean edges to the letterforms. This is achieved because the stencil is adhered to the surface as opposed to merely resting on top. It is perhaps worth noting, however, that masking film can be applied only to smooth surfaces.

Advantages

The major advantage of producing stencils using masking film is that it permits greater choice of letterform style. There are few restrictions on the styles used because the inner counters adhere to the surface, eliminating the necessity for ties. It is ideal for producing images on surfaces such as laminates, glass, spray painted metal and painted or varnished wood.

Making a stencil using masking film

1 Trace down the image onto the required surface and cover with masking film.
2 Cut around the letterform with a scalpel.
3 Remove the letterforms which require painting (the image area) by first lifting the corner of a letter and then peeling away the form. Take great care in removing the letter to prevent the inner counters from becoming detached.
 The area surrounding the letterforms may require further masking if the letters are to be spray painted. If necessary use newspaper taped to the surface with masking tape.
4 The stencil may now be painted or sprayed. If using a spray paint, check that the board is in the vertical position and wear a face mask.
5 Remove the stencil while the paint is still tacky. If oil or acrylic is allowed to dry completely a skin is formed between the letter image and the edge of the stencil which can result in the letterform lifting away with the stencil.
 It is advisable to peel away small sections at a time. A scalpel may be used to separate a portion of stencil from the main area.

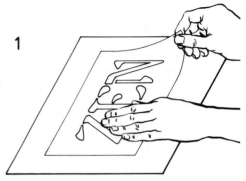

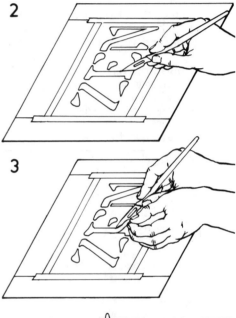

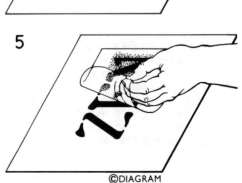

©DIAGRAM

213

Artwork for reproduction

Lettering intended for reproduction by a printing process is produced in a similar fashion to forms lettered on paper or board. All lettering which is generated as artwork for subsequent printing is generally produced black on white. Before artwork can be printed it must first be photographed onto film. Some colours on artwork, for example red, will show up as black on the film whereas light yellows and blues will not register on the film at all. The lettering artist should be aware of this as it directly affects the preliminary stages of producing artwork.

 If the artwork is required for a poster or handbill, then the work can be lettered in strips on line cut paper and assembled later. This is called a paste up.

Paste up

Stages in producing a paste up
1 **Master artwork sheet**
 Mark in light blue ink or pencil the extremities of the project (sheet size to be printed).
2 **Tick marks**
 Place a tick mark (in black ink) at each corner of the frame; these are used as a guide for the printer when guillotining the finished printed work. Tick marks are also used to register each overlay into its exact position and should therefore also appear on the acetate overlays.

Tools and materials
In addition to your usual equipment you will require the following:
1 Tracing paper for initial ideas and designs.
2 Line art board or paper.
3 India ink.
4 Light blue pencil or very light 2H or 4H pencil.
5 Rubber cement or an art adhesive spray.
6 Petroleum lighter fuel.

Artwork

Preliminary work
All of the preliminary work prior to lettering in black ink on a white surface should be produced in light blue pencil or a very light 2H or 4H pencil, otherwise these lines may be picked up on the film.

Useful tip
Clean equipment and hands are an important requirement. In order to reduce grease on hands and fingers, dust them in French chalk.

Stages in producing artwork
1 **Generating ideas**
 Work out your idea on tracing paper in pencil or fine fiber pen. Progress your ideas and experiment with different letterforms and layout. This initial design stage is a very important part of the production process.

2 **Size of artwork**
 Once you are satisfied with your design, decide on the size to draw the artwork. It should be drawn at least to the same size as the finished work is to appear, although it is usually drawn half as big again as the final version. The reduction of the artwork onto film reduces any minor deviations in stroke width which may be present in the original.

3 **The master drawing**
 You should now produce a more precise drawing of the designed lettering on tracing paper. This should be drawn to the enlarged artwork size. At this stage the letter and word spacing together with the positioning of the elements should be decided upon. The initial drawing should be produced with a sharp 2H or 4H pencil. If the lettering is of a complex nature it may be necessary to overwork the drawing on a further sheet of tracing paper. Quite often two or more drawings are made until the design is worked up to a satisfactory standard. This drawing is the master from which the artwork will ultimately be generated and therefore should be clean and accurate.

4 **Preparing the master for tracing down**
 The line art board or paper on which the artwork is to be lettered must now be cut to size and taped securely to the drawing board. Turn the master drawing over and work over the reverse of the tracing in HB pencil. Work the graphite into the tracing paper using a piece of paper towel or tissue. Remove any surplus or loose graphite before tracing down. It is advisable not to apply the HB pencil with the tracing resting on the line art board as the pencilled image of the lettering may transfer onto the line board.

5 **Tracing down**
 The tracing sheet should now be turned face up, placed on the art board or paper in the required position and taped securely top and bottom. Taking a hard pencil, 4H or 6H, trace the image over to offset the HB pencil onto the line art board. This should be done very carefully and accurately in order that a clean image is achieved on the board surface.

6 **Checking the image**
 Remove the tape from the bottom of the tracing paper only and lift to check that all of the image has been transferred.

3 Letter the text
Letter the text for the project on line art paper following the step by step procedure described. Once all the text is lettered, it can be cut into strips ready for pasting-up. Check that all pencil lines and graphite are removed before attempting to paste-up.

4 Inner border
Draw an inner border in light blue ink or pencil, leaving margins on all four edges of between ⅜" to ½" (9mm to 12mm). This gives room for the machine to grip the sheets of paper during printing.

5 Position the text
Position the work onto the artboard to check that the words fit into the width and depth of the frame.

6 Glue text into position
Apply rubber cement or an art adhesive spray to the reverse of the strips and position as paste-up. The main color of the design is positioned on the base artwork (on the paper or board) and acetate overlays are used for additional colors.

7 Check elements are square
Check that elements are pasted up square to the frame by using your parallel motion, tee square and set square or ruler and set square (triangle).

8 Remove excess glue
Remove all excess glue. Petroleum lighter fuel will remove the spray adhesive but be careful not to smudge the ink during cleaning.

9 Overlay with tracing paper
Once the work is completed, tape a protective overlay of tracing paper to the board as a cover.

7 Painting in
The style drawn will determine the drawing or painting in equipment to be used. If the letterforms have many straight lines then a technical pen can be used to draw these; a compass attachment may be used to draw arcs and circles. If the letterforms are drawn freehand then a good quality no. 1 or no. 2 pointed sable brush together with india ink and a bridge should be used.

8 Correcting errors
If mistakes have been made during lettering it is not difficult to rectify these using a designer's opaque white paint. Make sure that all pencil lines are erased before attempting to retouch work. Use a plastic eraser over the whole of the design to remove pencil marks and tracing down graphite. It is essential that the ink be perfectly dry before you attempt this process. Impatience has claimed many pieces of artwork. Test a small corner before using the eraser on your work. Check that your brush is clean before applying opaque white paint to errors. If the paint does not cover with one coat, allow the first coat to dry before further application. Overworking the paint while it is still wet results in a softening of the india ink and produces an undesirable gray effect. Retouch the black areas using india ink to give a dense overall consistent cover.

9 Final artwork
When all the letterforms and images are satisfactory, allow the work to dry completely, then cover it with a tracing paper overlay to keep it clean.

This step-by-step procedure is for the production of a piece of artwork for a single color printing job. Where more than one color is required, additional artwork for the different colors should be produced on overlay sheets of acetate which are then taped to the base artwork.
There are a number of drawing film type acetates on the market which accept india ink. Even though the acetate is for a second or third color when printed, the work must still be carried out in black ink or cut from a red blocking film. The film is overlayed onto the acetate and the desired image is cut with a scalpel and the non-image is removed.

Useful tip
If constructing circles and arcs with a technical pen attachment and compass, place a small square of line board over the center for the compass point on the artwork to prevent having to retouch compass points out of the artwork.

Size and layout

When producing a poster or signboard you will apply the skills acquired in studying and practicing letterforms. Your sign may be either a permanent statement or an ephemeral one, but irrespective of its intended use it is important to plan each stage and take care in carrying out your work. You may find it useful to experiment with different letterforms and layouts before finalizing your design. If you need to enlarge the letterforms or if, for example, your design incorporates a logo or other established design, then the step-by-step instructions given below will assist you.

Enlargements
The enlargements can be produced by a photographic process or a photocopier which has an enlarging facility. The latter method is the most economical as black and white photographs can be expensive. There are a number of ways in which brand names and logos can be manually enlarged or reduced.

Enlarging by squaring off
1 Starting at the left hand side of the lettering or logo to be enlarged, draw a line (AB) at the base of the logo in red or blue ink to avoid confusion when plotting the letter.
2 Project vertical lines (AC and BD) at either end of the logo to contain the image.
3 From the bottom left hand corner, project a diagonal line (AE).
4 Divide line AE into equal units and project the last division to the right hand bottom corner of the logo.
5 Project vertical parallel lines from AE to divide the base line (AB).
6 Step off the base line units against the left hand vertical line (AC). Project horizontals until the logo is contained within the grid.
7 Number the units along the base line and up the left hand vertical.
8 Decide on the size of the enlargement you require for the logo.

Task
Enlarging and reducing
Take a logo or brand name and enlarge or reduce it by squaring off.

9 On a sheet of tracing paper, mark in red or blue pen the width you require the logo to be.
10 Subdivide the width into the same number of units as the original.
11 Draw up a grid and number along the base line and left hand vertical.
12 Start plotting the image from the original.

More definition
Definition can be increased by further subdividing the squares already drawn in the original (see the square drawn at the base of the letter K in the illustrations below). This method of enlarging is based on manual digitizing of the original image, therefore the smaller the units used, the more accurate the final drawing.

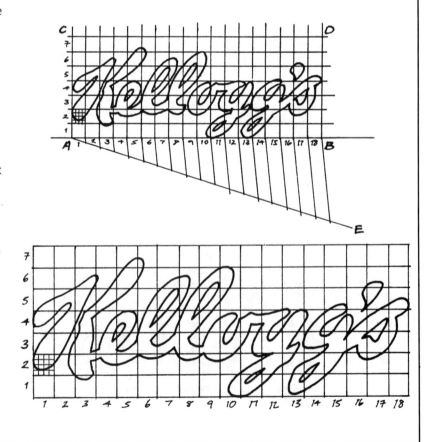

Communication and layout

The layout of all work is important. The information must be conveyed in a simple and easily understood manner. The main aim when producing posters and other notices is to communicate quickly and effectively, capturing the interest of the reader long enough to convey the message.

The choice of layout is very often determined by subject matter. There are, however, five different ways of achieving interest in the arrangement of words. In each of the examples (*right*) a different method of positioning text has been used to achieve the desired effect.

Key words

To arouse the reader's interest, key or "buzz" words are employed. On a sale poster, the word "sale" would be prominent, emphasized by different size, weight, style or color. In its simplest form emphasis can be achieved by merely underlining the key word.

Centered

The line or lines of text in a format which is centered are positioned centrally on an axis to create a symmetrical effect.

Asymmetrical

An asymmetrical layout is one in which the line or lines have no particular relationship with the ground area. They are artistically or aesthetically positioned as opposed to being positioned by set rules.

Justified or squared-up

A justified or squared-up layout is one in which the lines of text are of equal length. Text is aligned vertically at both the left and right hand sides by adjusting the spacing between the letters and words.

Ranged left (or flush left)

A ranged left or flush left layout is one in which all the text has a vertical alignment on the left. The right hand side of the lines of text are unaligned or ragged.

Ranged right (or flush right)

In a layout which is ranged or flush right the lines of copy are vertically aligned on the right hand side, leaving the left hand side appearing ragged or unaligned.

©DIAGRAM

217

SECTION 4
DESIGNING WITH LETTERS

This section serves as a guide to the enormous variety of alphabet and word designs created by designers over the past 5000 years. Because the more recent solutions appear predominantly in the ephemeral medium of print, the most interesting examples are often the work of unknown or forgotten artists. Nevertheless modern designers very much benefit from exposure to new ideas, or more importantly old ideas re-discovered. Designing is not a private or solitary activity, it is the resolving of visual problems for specific needs and, more likely, commercial demands. The creative designer is always at the service of his client. Twentieth century designers have paid greater attention to devising geometric forms than to traditional calligraphic ones. This is primarily because the newly designed letters are intended for duplication by artists who will simply repeat the methods of construction to arrive at the new forms. Calligraphic styles require intuitive writing skills that stem from much practice and knowledge. These skills are rarely taught satisfactorily today and in the current commercial world of design are bypassed in favor of more expedient methods such as dry transfer lettering.

There are a vast number of alphabet designs and many more interesting ways of organizing these into words. The success of a design can only be judged by the resulting word patterns, by the character of the projected word, its appropriateness, and its legibility. It is important to remember that, although words are made of letters, a newly designed word is more than the sum of its letters. The word has its own character and the best designers modify the arrangement both with care for spacing and with adjustments to individual letters.

The tasks and examples of exploratory designs in this section are those produced by design students. It is often found that the uninitiated mind is the most creative when offered the challenge of thinking along new lines. Each person has some unique qualities to bring to design tasks, and no two designers offer similar solutions. The best designs are often those which are the product of fun, spontaneity and a willingness to look carefully and afresh at the shapes of letters and words.

Chapter 1

Origins

The original letters of our alphabet were written in lines of text that could be read along alternate lines in either directions. This *boustrophedon* style (the Ancient Greek for "ploughed field") in the example (*below*), from a Lemnos column of c630 BC, enabled the scribe to write the first line from left to right, the second from right to left and so on through the text. This technique meant that vertically symmetrical letters like A M O were read the same in either direction, but vertically asymmetrical letters like E P Z appeared as mirror images of themselves in alternate lines.

Profusions

Five thousand years since the earliest letters were developed, the designer can incorporate an infinite variety of letter forms. (*Below*) An Italian 1915 designer, Ardenyo Soffici, plays with a futurist poem's letters using a technique known as collage (the sticking together of pieces of earlier printed materials).

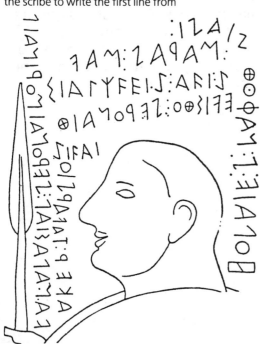

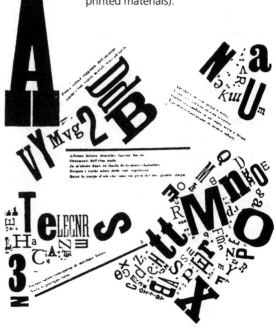

LETTERS

Lettering is the visual form of speech. It uses symbols to represent sounds which in turn represent, when combined into groups to form words, the meanings and ideas we wish to convey. The symbols of the Western "Latin" alphabet have evolved over the past 5000 years. Although everyone agrees that these are the norm for the shape of each letter, their shapes can be subjected to an infinite variety of adaptations. The letters project their character, but must remain legible. They are the clothes that words wear. The skill of the lettering artist is an important feature of 20th century communication industries. Even with the growth over the past 80-90 years of cinema, radio and television, the printed and displayed word is still a strong contender for our attention. It is the most convenient method used in our streets, transportation systems, newspapers, magazines and books. Commercial pressures to seek attention for products have created a generation of inventive and imaginative designers who are pushing the letter shapes into ever wilder contortions. Traditional calligraphic forms are becoming extinct as computer technology enables designers to achieve distortions without having to master drawing skills.

Perversions

Letters convey meaning in their assembled groups of words. Here *(right)* Paul (an antique dealer) has designed his shopfront using classical Roman capital letters. He knows that in Roman times the letter U did not exist so he has inserted a V. The ultimate in perversion is to have put his telephone number GUL 3081 into Roman numerals!

PAVLS

GVL.
MMMLXXXI

Illegibility

This 1900 German designer has had fun inventing wildly distorted versions of letters *(right)*. The first word is ARCHITEKTUR, but subsequent words are extremely difficult to interpret. Remember that all designs however interesting must be legible.

Recognizing letters

After mastering the identification of letters in our early days at school we quickly become able to see the meaning of letters in many guises. Designers use this familiarity to play games with our perceptions and explore the letterforms as a means of conveying some special feature of the word.

Letter parts
Each letter's elements build up a construction which enables us to identify it and read the word in which it appears (*above*). The 1917 Dutch designer Theo Van Doesburg has devised elements to the letters within the words DE STYL that make it extremely hard for us to read the words. Legibility must always influence your strongest enthusiasm for new forms.

Parts of letters
Each letter is a group of marks distinguishable from the others by some unique feature. Several letters need only small adjustments to make similar ones: E is F with an added lower horizontal, R is P with an added diagonal. The examples (*below*) help one appreciate the uniqueness of letters. There are four alphabets drawn upside down in which only one half of a letter, either a vertical or horizontal section, is revealed. This proves that letters are so individual that no part can be misinterpreted; others could be misconstrued if only parts are revealed.

Letter shapes
The characters' shapes in MEXICO 68 (*above*) have been used to send vibrations across the surface like ripples caused by a stone thrown in a pond. Very few of the lines in this design form letters of the alphabet, but their overall impression suggests to us the Olympics word and date.

a

bhij
klmn
pr

ceoq

ft

s

t

vwy

z

x

The shape of space

Letters appear in groups, and the shapes they make between one another are often clues to their identification. Some produce similar shapes, others unique ones. The example (*above*) is of the shapes created between the lower case alphabet and a preceding vertical character.

Task
The shape of space

Place tracing paper over a large word or group of letters and, using a soft pencil or felt tip pen, fill in the spaces between the letters.

Variety

Although each letter has its own unique form, each can be portrayed in an infinite variety of styles (*above top*). The style of a letter is its current personality.

Task
Variety

Using a scrapbook containing over 26 pages, allocate a page or pages to a letter of the alphabet. Then stick examples of individual letters cut from as wide a source of printed material as you can find. You will quickly realize that this task has no end as there is an infinite number of letter variants.

Task
Shape recognition

Draw out the alphabet in capitals or lower case, or choose a simple word to draw. Use a thick felt tip pen, and draw the letters between two parallel pencil lines *upside down*. Then as a further experiment draw them back to front, and, even more challengingly, upside down and back to front.

The shape of space

When we look at the shapes of letters it is often the surrounding shapes we also take into our impression that helps us identify the forms. Letters are traditionally seen as dark marks on a light background, but designers enjoy the playfulness of transposing the emphasis to a negative form, or omitting parts of the characters altogether.

Solid or hollow
Letters can be solid dark areas, light areas on dark background, or described in outline (*above*) with their forms containing the same tonal value as the background.

Solid space
Because of our prejudgement of shapes (we expect the shapes to convey a message) designers can present the spaces between the words as the positive values (*left*), and leave us to read the message in the negative (omitted) values.

Ghosts
The three dimensional features of this example (*left*) leave us with the problem of reading into the spaces letters of the alphabet. Our familiarity with such letterform designs means that designers can mischievously hint at the letters.

Substitutions
The wonderful French designer Cassandre produced an alphabet (selection *above*) in 1929 that omitted parts of the letters. As each design solution was a carefully considered product, we have no difficulties in reading the letters as if their total elements were included.

Reflection
The strange pattern (*above*) forms the letters of the name XAVIER written twice, once normally and then as if in a mirror. How we read letters very much depends on what we expect them to say.

Negative and positive
This Alexander Rodchenko Soviet catalog cover of 1925 places the figures on light and dark backgrounds. The central figures URSS are both in outline and light on dark. A defect of this style of interchanging backgrounds is that the readers must change their reading methods within one statement.

Patterns
In the Islamic faith sentences from the Koran are so familiar that the designer of a quotation can play fantastic tricks with the shapes. The decorative labyrinth (*above right*) is not symmetrical as each of the eight segments contains different words in a greatly stylized version of Arabic script.

Visual clues
The designer of this 1968 advertisement and logo, Rosmari Tissi of Zurich, has played a trick on our perception of the letters by placing an absent letter P over the darker letters of T I and S. We read the P as pieces omitted from the other letters.

225

The growth of letters

Our current alphabet is the result of developments in the ancient civilizations of the Mediterranean. Prior to the single letters writing had often been an arrangement of simplified pictures (pictograms) used to express ideas and subjects. These first writing systems were slow to develop; they were difficult to implement as the scribe had to draw complex arrangements of lines for each "word."

Pictures as words

The visual form of an idea has to be simplified so that it can more easily be repeated in manuscripts and monuments. The name of the Egyptian Queen CLEOPATRA when written in our script contains nine letters. When written in hieroglyphics, the writing of ancient Egypt (*right*), the name contains 18 simplified pictures.

Symbols and signs

In addition to the commonly used letters, abbreviations of groups of letters or specific meanings have special letterforms (see *right*):

1 In German this is the mark for the two letters S and H when combined in a word.

2 In classically derived words (often in zoology or botany) this is the mark combining a and e.

3 This is Norwegian for double o.

4 This is the international symbol for the word AND, known as an ampersand.

5, 6 The common signs for the pound sterling and the dollar.

Noisy letters

The different European nations all use the same group of letters of the alphabet, but, to make the pronunciation intended clearer, the letters often carry additional marks to soften, harden, shorten or lengthen the sound (see *above*).

Roots

The chart (*below*) is based upon the work of the great lettering historian David Diringer. Each of the horizontal rows is from a different Mediterranean culture. Reading vertically Diringer suggests these indicate the development of the individual letterforms.

1 Phoenician
2 Classical Greek
3 Etruscan
4 Roman (Latin)
5 Modern Capitals

४	O	7	१	٩	٩	W	t	x					1
N	O	Π		P	Σ	T	Υ				X		2
५	O	7	୧	٩	५	1	Υ						3
N	O	Γ	Q	R	५	T	V				X		4
N	O	P	Q	R	S	T	U	V	W	X	Y	Z	5

Аа	Бб	Вв	Гг	Дд
Ее	Жж	Зз	Ии	
Кк	Лл	Мм	Нн	
Оо	Пп	Рр	Сс	Тт
Уу	Фф	Хх	Цц	Чч
Шш	Щщ	Ъъ	Ыы	
Ьь	Ээ	Юю	Яя	

Αα	Ββ	Γγ	Δδ
Εε	Ζζ	Ηη	θ8
Ιι	Κκ	Λλ	Μμ
Νν	Ξξ	Οο	Ππ
Ρρ	Σσ ς	Ττ	Υυ
Φφ	Χχ	Ψψ	Ωω

Other roots

Our present alphabet is one of a group of letterforms currently in use in Europe. Both the Greek alphabet (*left*) and the Russian, Cyrillic (*far left*) have a number of common letters, but they also include letter shapes unique to their languages.

Task

Signs and symbols

Copy out unfamiliar symbols from books and magazines. These are particularly common in books on mathematics, physics and geometry.

©DIAGRAM

227

Elements of letters 1

Letters are an arrangement of linear parts, either straight or curved. Most have two basic forms, the larger forms (capital letters) and the smaller forms (lower case letters). Of the 26 letters of the alphabet 10 have the same form in both styles. These are C O P S U V W X Y Z. With these 10 common forms and the other 16 letters each with two forms the alphabet consists of 42 characters.

In addition two of the letters in the lower case have alternative forms; these are the a and the g. These characters, although complying to the accepted arrangement of shapes, can be subject to a wide variety of distortions. Their proportions, their elements, and the method of producing them can each influence their overall shapes.

Individuality
Groups of letters with common features when placed together can be difficult to read. The design (*above*) of seven letters in the lower case produces the English word minimum, which is hard to read as all its components have similar features.

Variations in the shapes
Two letters in the small versions of the alphabet (the lower case) have two different forms. The a and g can be drawn in different ways. All the other letters have a basic form which is consistent however much it is distorted by stylistic changes.

Variations in style
Because of the consistency of letter structure the designer can play tricks and design an alphabet in which the forms are pushed and distorted to points almost beyond recognition. The examples (*right*) show how different these solutions can be.

Variations in proportion
Letters may have normal ratios of height to width, or they may be greatly narrowed (condensed) or widened (extended).

1 ILHTEF

2 RPBJUD

3 KVXYZWMNA

4 OQCGS

Common components
The letters of the capital alphabet can be grouped into four types.
1 Those constructed from vertical and horizontal straight lines.
2 Letters made from combinations of straight and curved lines.
3 Those constructed from either vertical and diagonal lines combined or groups of diagonal lines.
4 Letters constructed from curves.

a 1 abcdefghij
ABCDEF

b 1 abcdefgh
ABCDEF

c 1 abcdefgh
ABCDEFG

Heads, hands and feet
The ends of the letterforms can have a variety of design solutions.
a Traditional forms have tails (called serifs) which are the result of earlier forms produced by carving and calligraphy.
b The 19th century solutions often had very heavy mannered ends known collectively as Egyptian or Old Style serifs.
c Recent forms are without decorative ends and are known as Sans Serif.

©DIAGRAM

229

Elements of letters 2

The lower case letters have developed from a handwritten form. They are mostly made of curves and protruding verticals. The examples on these two pages are experiments by students creating letterforms from a small group of common elements.

Letter groups

The lower case letters can be arranged in three groups.
1 The central part falls between two common lines.
2 The letters have a vertical which extends (known as an ascender).
3 The letters have an element which protrudes (known as a descender) below the common area.

1

aceimnorsuvwxz

2

bdfhklt

3

gjpqy

Task
Building blocks

Draw a grid of squares, four wide by seven deep. On a tracing paper overlay copy out each letter of the lower case alphabet, plotting the shapes within the grid. Make one square the width of all the elements and try to keep each letter's shape within the squares.

2

3

abcdefghijklm

4

abcdefghijklm

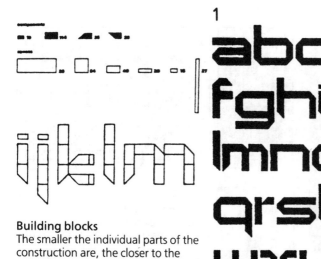

1

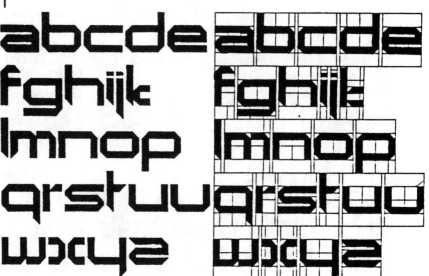

Building blocks
The smaller the individual parts of the construction are, the closer to the normal letter shapes they can be. The example (*right*) was made using only rectangles and triangles. The larger the elements the more ingenious and bizarre are the results (*below*).
Smaller elements **1, 3**
Larger elements **2, 4**

231

Matrix and modular

Contemporary forms of letters are often produced by the assembly of small elements within a grid or matrix. This regular net of lines is used to construct each letter so that it and the family group have a common structure. Because each letter's form is an assembly of small parts the ultimate alphabet design stems from the formula applied to their construction.

Task
Assembled form
The three letters (*above*) and the alphabet (*top right*) are the result of filling in squares on a regular grid. Using graph paper, build up the letters of a simple word by filling in dots on a square grid. The example shown uses a three-dot vertical stroke width and a two-dot horizontal stroke width. Diagonal lines and curves have to be expressed as stepped units.

Unit proportions
The examples (*left*) show how, by changing the number of squares allocated to the character widths, height and stroke thickness, the designer changes the style of the letters.
a 3 × 5 units, with one unit width for all strokes.
b 5 × 10 units, with two units width for all strokes.
c 6 × 7 units, with one unit for horizontals and two for verticals.

Task
Grid distortions
Using graph paper containing triangles construct a word or alphabet by the same method as the task above.

Electronic units
The letters (*left*) are designed for digital dials for clocks and meters. Each letter is made from a selection of the common part of a grid of verticals and horizontals. This method enables the electronic instructions to change the letters simply by changing the areas to be filled in.

Industrial applications

The needlework pattern sheet (detail *right*) has converted the flowing calligraphic forms into an assembly of small units. When implemented the visual effect of the assembly of small points creates an illusion of a continuous smooth line.

Computer forms

The VDU of a computer, and the dot matrix printer of a word processor achieve their visual effects by the same method as the embroiderer. Each letter is an assembly of very small units called Pixcels. The letter n (*right*) when seen actual size appears to be a smooth cursive line. This enlargement reveals the matrix structure of assembled tiny points.

233

Regular distortion

If we consider that the letters can be constructed within regular grids, and assembled within a framework, we can then develop distortions of the letters by changing one or more of the ratios of the sides of the matrix. This method is very easy to draw and can also be applied to other alphabets which have calligraphic origins or traditional forms. The recent technology of word processors and computers has enabled typesetters simply to program their machines to produce distortions electronically.

Task

Regular distortion

Trace a simple word onto a regular grid (see *right*) (**A**) Redraw the grid changing one of the features, either condensed (**B**) or angular (**C**).

Constructed distortion

The example (*below*) is by a student who placed a fine grid over each of the letters of a standard alphabet and Arabic cardinal numbers, then, after vertically extending a similar grid, replotted the letters and figures so that their horizontal features remain constant but their vertical features become elongated.

1 2 3 4 5 6 7 8 9 0

ABCDEFGHIJKLMNOPQRSTUVWXYZ

ABCDEFGHIJKLMNOPQRSTUVWXYZ

Ratio distortions

The most common method of changing the letter shapes is by extending the vertical or horizontal ratios and retaining all the other elements. This produces condensed (narrow) letters or expanded (widened) letters.

Angular distortions

Retaining the horizontal elements and constructing the vertical features at an angle to the horizontal produces sloping letters. This sloping to the right is commonly called Italic. A less common distortion is to retain the verticals and slope the horizontals.

Weight distortions

The ratio of the thickness within the letters to their overall proportions can be varied to create letters with thicker limbs (bold alphabets) or with thinner limbs (light alphabets).

Emphasis distortions

Traditional calligraphic forms had thick and thin elements in the letter shapes which were the consequence of holding the broad-nibbed pen at a constant angle. Later designers used this feature to distort regular forms by systematically thickening either the vertical or the horizontal elements.

abcdefghijklmnopqrstuvwxyz

abcdefghijklmnopqrstuvwxyz

©DIAGRAM

Irregular distortion

Letters are so commonly used in our everyday world that their forms have become recognizable even when subjected to the wildest distortions. A word printed on a balloon will change its shape when the surface is enlarged by inflating the balloon. Reflections of words in convex or concave mirrors take on unusual shapes like those seen in a fairground Hall of Mirrors. You can produce your own unique distortions by simply replotting a regular alphabet or word in an unusually distorted grid.

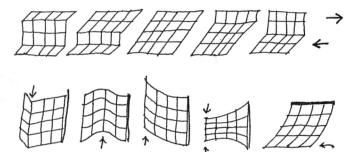

Inflatable distortions
The letters T A P (*left*) have been transformed by replotting on a surface which appears to be seen in a reflective sphere.

Task
Distortions
Select a style of grid from the examples above. Using a ruler and set square (triangle) or curves, construct a grid 2in (50mm) high. Draw some distorted letterforms.

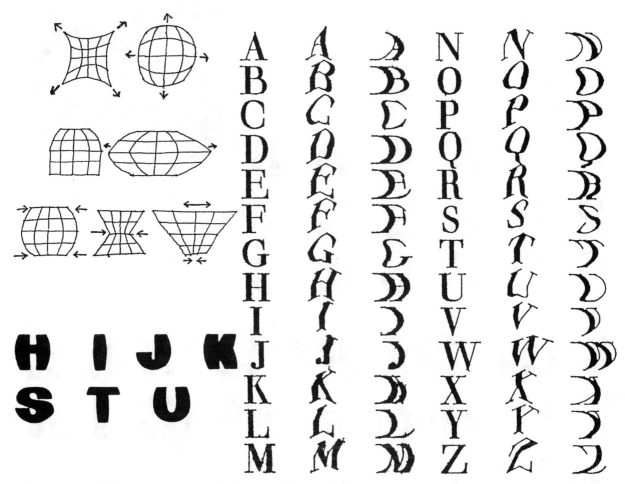

Geomorphic distortions
The three alphabets (*left*) were produced by students who replotted existing alphabets onto grids inspired by cartographic projections. When completed and the grid removed, the new alphabet often resembles forms produced by inflation or liquid distortions. The example (*below left*) twists a popular letterform to such an extent that its original character is hard to recognize.

Distortion by weight

Letters in their simplest form are thin line structures, but because of their calligraphic origins these lines are often expressed as thicks and thins. These variations in the linear forms have encouraged designers to explore the effects of distorting the letters by greatly varying the weights of parts of the letters.

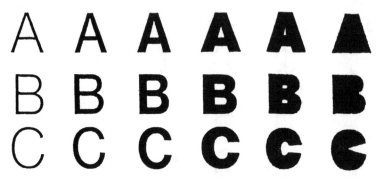

Stretch
The word foto (*above*) has had its vertical axis stretched resulting in a thickening of the horizontals.

Normal to abnormal
The three letters (*left*) are drawn in fine line structures which progressively become solid shapes.

ABCDEFGHIJKL XY abcdefghijklm

Traditional distortions
The alphabet (*above*) is one designed by 18th century Italian typesetters. This example is called Bodoni in which the verticals are maximized and the horizontals minimized.

Two way stretch
The alphabet (*right*) by the designer Edward Wright has its proportions stretched horizontally, but the verticals are minimized.

Solid letters
The French designer Jean Larcher has developed these 1970s letterforms to such an extent that they are barely recognizable. Each has perhaps the maximum weight distortion possible without losing its basic identifiable character.

Fill in

The letters A, B, C, V (*right*) are solid shapes. We only realize they are letters when we search for meaning. The panel of text (*far right*) mischievously challenges our reading abilities as the letters are rendered beyond recognition. The first word is JANNER (with a lower case a), the next word is SONNTAG (Sunday).

Task
Painting letters

Using a sheet of black paper, paint a row of letters in white without first pencilling in shapes. Imagine you are carving out the forms. Only add white to the spaces around the forms until they appear as letters.

MNOPQRSTUVW

nopqrstuvwxyz

fghijklmn

tuvwxyz

FGHIJKLM

STUVWXYZ

©DIAGRAM

Decorating letters

In the production of books, before printing, the first letter of a page or paragraph was often enlarged or decorated. This letter, an initial, was usually drawn by an artist with a brush, whereas the text was produced by a scribe with a pen. These large letters became vehicles for imaginative experiments and fun. Later designers devised individual letters or alphabets intended for specific applications, deriving their inspiration from elements of fantasy, natural materials or just enthusiastic penmanship.

Simple embellishment
Basic letters (*above*) with a simple spiral added.

Added decoration
Three alphabets originally with traditional forms (upper one is 16th century Gothic, middle one classical Roman capitals, bottom one Italic) but now all decorated.

240

Living forms

The two letters (*left*) are versions adapted in the nineteenth century from medieval scribes' decorative initials. The letter (*right*) is by a designer who has gone wild with enthusiasm for his penmanship skills. This letter explodes like a released watch spring. It sings with energy.

Home made letters

The alphabets (*right*) are made as if of materials. These solutions are fun but hard to utilize when devising a word. The shapes need to be modified when combined.

Task
Cheese words

Using the examples (*below*) design the remainder of the alphabet in a similar style.

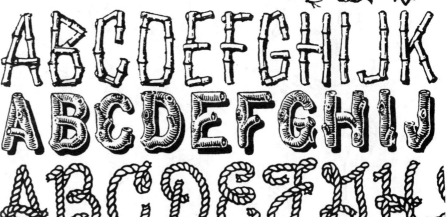

Task
Material forms

Choose any simple word and draw the letters as if made from some material like bricks, bones, or leaves.

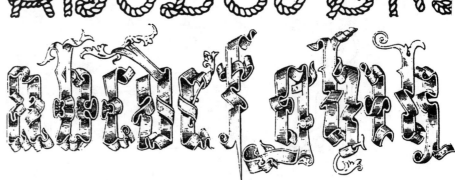

Embellishing letters

Letters made of animals or humans (anamorphic forms) freeze the figures in contortions of their limbs and bodies. No real attention is paid to the anatomy, perspective or physically possible positions. Successful alphabets are those which retain their character recognition, but whose inventive distortions are startling and often humorous. Designers also enjoy taking traditional letterforms and adding other elements to create busy shapes and styles.

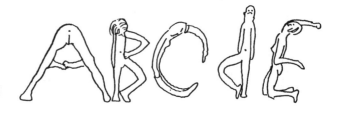

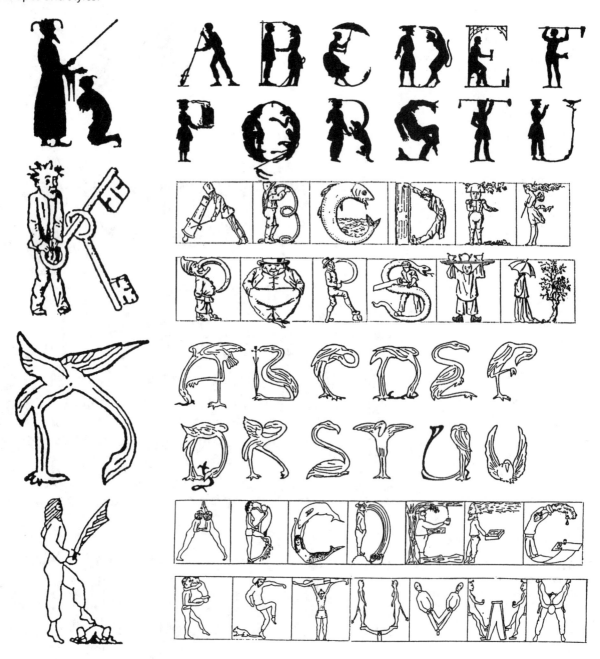

Task

Doodles

Sketches (*left*) are the first steps towards designing a crazy humanist alphabet. Try yourself to develop the other letters of the alphabet along these lines. Remember that invention is more fun than conformity.

Human letters

The alphabets (*below*) were probably intended as initial letters in 19th century magazines. The silhouette version has some unsuccessful letters, such as N U V W X Y and Z because the elements are not of a common thickness and the overall shape of the letter is obscure.

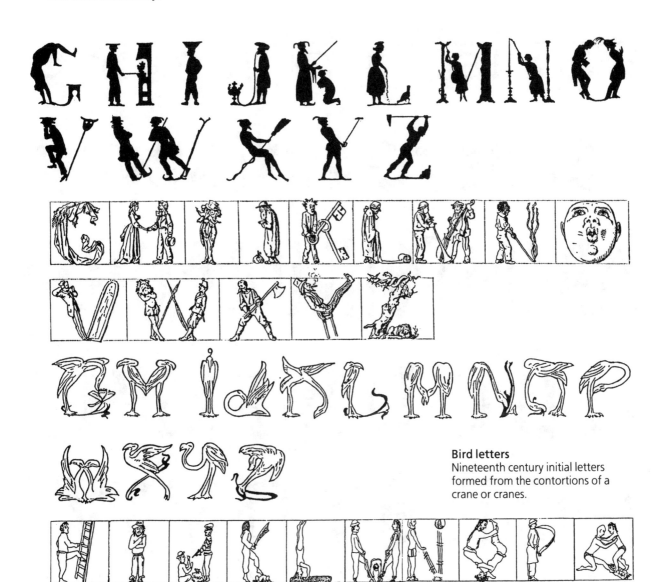

Bird letters

Nineteenth century initial letters formed from the contortions of a crane or cranes.

Contemporary letters

An alphabet designed by Brian (aged 16) as an exercise in imaginative composition.

Alphabets as other cultures

Because we are so familiar with the basic forms of letters, designers can play games with the shapes to imply that the alphabets belong to their cultures. These "joke" solutions are mostly useful in advertising where the type of culture to be implied is helped by putting the message into the appropriate writing style.

Task
Ethnic alphabet
Search through magazines to find examples of an ethnic style and from the few letters construct your own alphabet.

1 abcdeff ghijklmnop

2 ABCDEFGHIJKLMNOP

3 ABCDEFGHIJKLMNOP

4 ABCDEFGHI
PQRSTUVW
fghijklmnopqrst

244

Mimicry

The four alphabets (*below*) steal features from other language script styles to pretend to be derived from other cultures.

1 A script using the mannerisms of Sanskrit to purport to be an Indian alphabet.

2 A script exploiting the thicks and thins and the tails of the Hebrew alphabet.

3 Linear, angular forms of the ancient Greek pottery inscribers.

4 Broad and thin brush strokes characteristic of Chinese calligraphers.

5 Detail from an advertisement promoting a Japanese electrified heater where the designer not only emulates the brush style of oriental calligraphy but also places the characters in a vertical arrangement similar to Japanese literature.

qrstuvwxyz

QRSTUVWXYZ

QRSTUVWXYZ

JKLMNO

XYZ abcde

uvwxyz&!?

5

THE KOTATSU IS DESIGNED TO

HEAT THE PERSON, NOT THE ROOM

IT PROVIDES MAXIMUM EFFICIENCY

©DIAGRAM

245

Review

How can we judge a bad letter shape? Only experience can tell, and then only your personal reactions can be applied. Sophisticated forms are the cultural luxury that may be rejected by a designer in favor of naive and primitive forms more suitable to the design task. You can design your own letterforms and you can judge their relevance to the application.

Stretch
The Austrian designer, Alfred Roller, of a 1902 Vienna art exhibition poster (*left*) has picked out the letter S to link the word Secession with the bizarre letters below.

Historical styles
The rows of letters (*above*) are by 19th century designers except for the first row which is an adaptation of a medieval pen style called Black Letter (Gothic).

Task
Historical styles
Search magazines for examples of 19th century solutions. These are usually more elaborate than current styles. Cut out the discoveries and stick them in your scrapbook.

Form and function
The examples (*right*) show how far a designer can test our powers of recognition. We expect the letters to make words so we search for identification in the obscure inventions of designers. The third row is particulalry mischievous as at first glance it appears not to contain letters. These imaginative 1970s designs are by the French typographer Jean Larcher.

Current sources

Present-day dry transfer catalogs offer an enormous selection of bizarre styles. The manufacturers have commissioned designers to create alphabets for every conceivable need. These wonderful sources of alphabet designs can be used as the starting point of a new idea. See examples (*right*).

Task
Dry transfer
Order dry transfer letter catalogs. Do not copy the letters, study their design solutions as inspiration for your own.

Task
Mimicry
Design your own alphabet for a culture you like, maybe Viking, Aztec, American, Indian or Russian.

Task
Past sources
Where available, printers' catalogs can also provide you with ideas. Those of the 19th century often contain widely distorted alphabets intended for display and heading use. The larger alphabets were carved in wood and mounted alongside the lead characters of normal type.

Task
Rare sources
It is now extremely difficult to obtain what was once a very popular source of alphabet solutions: books on penmanship. These had examples by writing masters who, wishing to show their dexterity, would include wild swirling letters. Visit your local library and ask if they have any old calligraphy books.

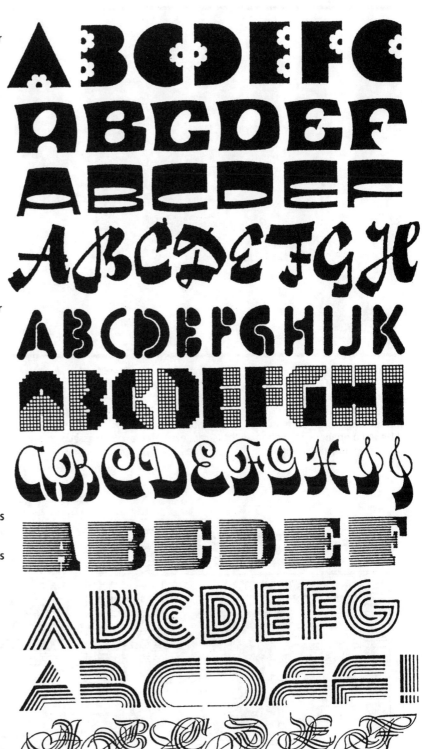

©DIAGRAM

247

Chapter 2

Ethnic differences

The examples of newspapers from around the world (*below*) contain different methods of formulating words. Each uses different alphabet systems and, in the case of oriental publications, individual characters for the words. Nevertheless it can easily be seen that the emphasis on the important words is achieved by size, weight and position. The levels of the message are evaluated and expressed similarly in each newspaper.

WORDS

The style by which you dress the words, your choice of letterforms and type style, produce a tone of voice. The word could shout, whisper, implore, command, instruct, suggest, or imply, all by the style chosen to produce the characters. In newspapers this range is used to organize the order in which we read the information. Key facts are placed in a prominent position and are usually larger and in bold. In the urban environment the words become a visual noise around us, calling to our attention services or instructions. Word styles are very often the result of cultural mannerisms learnt from drawing the letters. A Dutchman, Spaniard and a Pole would all draw the alphabet slightly differently having learnt to form the shapes at school and under the influence of distinct cultural heritages.

The meaniug of words

Words are groups of letters arranged to convey a meaning. The letters individually or collectively indicate sounds. Each group of letters produces an impression of horizontal spiky shapes which resemble marching rows of insects. It is the shape of the word which we read and not the individual letters. A mistake within a word is instantly recognizable to an experienced reader because the pattern does not match a mental picture they have of the word. An unconscious memory of the shapes is superimposed over each word to fit. Experienced raeders will have noticed that the title of this page has a word in which one of the letters is upside down and that this sentence contians two words with the letters in the wrong order.

S	A	T	O	R
A	R	E	P	O
T	E	N	E	T
O	P	E	R	A
R	O	T	A	S

Word structure
This group of 25 letters (*left*) from the Forum in Rome has been arranged so that the reader can read the same Latin words horizontally and vertically. They have the added magic of being able to be read forward, backward, downward or upward.

Picture words
Words can be substituted by picture words or abbreviations. In 1975 the designer Milton Glaser used a heart (*below left*) to represent the word "love" and the customary initials NY to represent New York. The message reads I LOVE NEW YORK.

Directional reading
We normally read words horizontally from left to right. The words TUO YAW (*right*) appear on a window which from the other side read WAY OUT.

Intervals
The rows of letters in this 9th century Carolingian manuscript (*above*) have little meaning even to a reader of Latin. This is because the scribe has written the text as a continuous line of letters without regard for gaps between words.

Word gaps
Because the groups of letters make words, the arrangement into words of a number of letters depends upon the spaces between the letters. The two words NOSMO KING (*below*) appear on the two sides of windows and in English read NO SMOKING. The gap was caused by a window support.

TUO

NOSMO

Background noise

Just as one voice talking in a crowded room is hard to hear, so words mixed among busy backgrounds cause us to strain to identify them. The designer of this book jacket (*above*), F M Nedo, has hidden the title WHO'S WHO IN GRAPHIC ART in a buzz of lines. Legibility must be the prime concern when we wish to convey information. Unreadable text means the message is missed.

Hidden origins

Groups of letters can become words when originally they represented more complex statements. The composer Verdi's name (*below right*) has the initials of the words Vittorio Emmanuele Re D'Italia. The Swedish company ESSELTE (*below*) was originally called Sveriges Litografiska Tyrckerier, whose initials, SLT, are pronounced in Europe as Esselte. The petroleum company Standard Oil is known world wide as ESSO.

Creatures

The pattern (*above*) was produced by writing the name *Christine M Clark* in pen and ink, and before the ink was dry folding the paper along the base of the word to produce a blotted mirror image of the word.

Verdi

YAW ESSELTE
KING

ESSO

©DIAGRAM

251

The shape of words

Designers can break the rules of word formations by rearranging the units while still retaining the message. The more familiar we are with the word the easier it is to distort and still retain its identity.

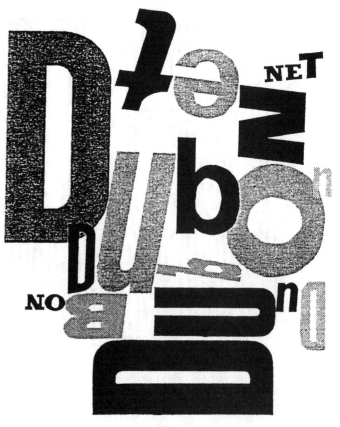

Letter patterns
The detail (*above left*) in a Dante poem has an introductory statement where the designer Anna Simons has worked Dante's words PER CORRER into a structure of letters by having various sizes of letter. Popular words easily identified, such as the French aperitif Dubonnet, afford the designer in the example (*above right*) the chance to jumble the letters but retain the message.

Overall shapes
Each word has its own unique shape and the grouping can produce other shapes if the designer selects combinations of capitals and lower case. The word Prague has three basic forms, each offering obstacles or possibilities for exploitation.

No shape
The word FORD in capitals is a solid rectangle shape. The designer of this 1956 poster (*right*), Herbert Leupin of Basle, has placed the modular letters vertically but not aligned under one another.

Inventive thinking

The Parisian designer Michel Leiris has had the brilliant idea of writing the word AMOUR so that each subsequent letter is within the preceding one. This is truly breaking new ground.

Breaking the mold

Each letter's basic form requires the designer to retain its elements. Words that are easily identified can have letters distorted beyond individual recognition. The letter F (*below*) is unrecognizable but at the beginning of the word FINAND it fits easily.

Constructionism

Designers frequently modify all the letters to comply with their overall design style. In the example (*below*) the word STEINER has no curves, the S and R are constructed from straight elements. The word JUGEND (*below*), used on an 1896 magazine cover, has been transformed by the designer Reimerschmid into entwining curves.

| Karl Steiner | Bauschreinerei und Möbelfabrik Laden- und Schaufensterausbau Coiffeureinrichtungen | Zürich 11/50 Hagenholzstra Telefon 46 43 4 |

©DIAGRAM

253

Energizing words

Words are an assembly of letters which are usually all the same size, weight and character. Varying the size of individual letters within words and from one word to another can have a dramatic effect on their overall appearance. Designers call attention to features of words by varying these elements to heighten the dramatic effect of the words.

Is our ARMY in Kharki now dressed

First letters
In the children's A B C book of c1900 (*above*) the first letter of each sentence (the sequential letters of the alphabet) is enlarged. The word associated with the letter is presented in capitals so that the young reader may link the introductory letter to the individual word.

Initial letters
Before the invention of printing, books were produced by a scribe writing out every letter and word. These hand-drawn books very often had two different craftsmen working on the page at different times. A scribe would write the text (using a quill or reed pen) but would leave a space for the first letter of the first word. This space would then be filled in by another scribe (usually using a brush) who drew out an enlarged letter that was often highly decorated. Detail (*above left*) is from a 16th century hand-written Latin religious Book of Hours. The example (*center left*) is from a Spanish 17th century printed book in which the printer has inserted large carved initial letters to imitate the earlier calligraphic style.

Varying the size of letters
Modern designers can behave misleadingly, knowing that the reader expects the shapes to make letters and the letters to make words. They often jumble up the basic principles of lettering and calligraphy to produce memorable and exciting designs. This technique only works when you wish to excite and interest the reader. It is less suitable when you are trying to inform the reader or assist understanding. The name of the pop group (*left*) has its letter sizes mixed and lower case letters are inserted among the capitals.

No-rules style

Having disregarded the principle of having all the letters the same size, style and weight in a word, the designer can even replace letters such as the r in this example (*right*) with a bent line.

Size and emphasis

The 19th century poster (*right*) uses differing sizes for each line of text. By putting the more important parts in a larger typeface the basic message of the continuous text is broken up and key words attract the attention of the reader. As the lines are often made from capital letters (which unify the word shapes) the designer has selected a variety of styles to further increase the interest and produce patterns of emphasis.

Energizing words

Normally, all the letters in a word are the same size. However, designers often diminish the size of the letters towards the end of the word to give it a sense of dynamism. The example (*above*) is from the label of a box of fireworks, where the receding letters and the scratchy forms give energy to the design.

RODNEY BOD

1869. May 10th. 1869.
GREAT EVENT
Rail Road from the Atlantic to the Pacific
GRAND OPENING
— OF THE —
PASSENGER TRAINS LEAVE
OMAHA
ON THE ARRIVAL OF TRAINS FROM THE EAST.
THROUGH TO SAN FRANCISCO
In less than Four Days, avoiding the Dangers of the Sea!
Travelers for Pleasure, Health or Business
Will find a Trip over The Rocky Mountains Healthy and Pleasant.
LUXURIOUS CARS & EATING HOUSES
ON THE UNION PACIFIC RAIL ROAD.
PULLMAN'S PALACE SLEEPING CARS
RUN WITH ALL THROUGH PASSENGER TRAINS.
GOLD, SILVER AND OTHER MINERS!
Now is the time to seek your Fortunes in Nebraska, Wyoming, Arizona, Washington, Dakotah Colorado, Utah, Oregon, Montana, New Mexico, Idaho, Nevada or California.
CONNECTIONS MADE AT
CHEYENNE for DENVER, CENTRAL CITY & SANTA FE
AT OGDEN AND CORINNE FOR HELENA BOISE CITY, VIRGINIA CITY, SALT LAKE CITY AND ARIZONA.
THROUGH TICKETS FOR SALE AT ALL PRINCIPAL RAILROAD OFFICES!
Be Sure they Read via Platte Valley or Omaha
Company's Office 72 La Salle St., opposite City Hall and Court House Square, Chicago.
CHARLES E. NICHOLS, Ticket Agent.
G. P. GILMAN, JOHN P. HART, J. BUDD, W. SNYDER,

Words in boxes

Words usually appear as a rectangular block of text in which the lines are horizontal and read from left to right. The cumulative effect of this block of text is like a texture. When a word appears in isolation the spatial tension is heightened. Designers often work out their ideas in miniature so that they can judge the overall effect of the way they have arranged the words.

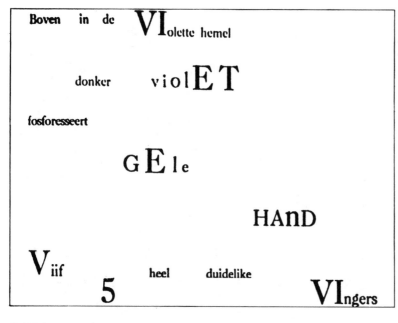

Pattern-making
The sketches (*above*) are for a greetings card design containing a poem. The designer has scribbled simple design roughs to depict possible arrangements of the words.

Task
Judging patterns
Pin one of your designs to the wall of your room. Position yourself as far away as you can and sketch the basic arrangements of the elements. The same effects can be achieved by obtaining a greatly reduced photocopy of one of your designs.

Spatial tensions
The Dutch designer Van Ostaijen used the open space of the rectangle (*above*) to suspend the individual words in a tension of space. This style of word play was a particular favorite of the artists working in the Dadaist style during the 1920s.

Angular tensions
Horizontal is not necessarily the best, as the poster (*right*) shows. The designer has enlarged the main text and tilted it so that it appears to be going beyond the available space.

Task
Directional reading
Make a collection of examples of words reading in various directions. Although these are not all in everyday use, you may find that the vertical designs are often used on signs in inner cities, particularly on cafes and bars.

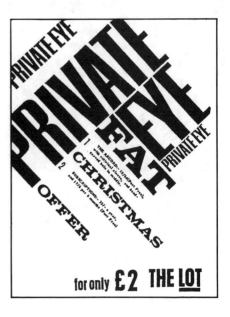

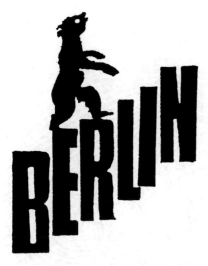

Stepped designs

The Berlin city bear climbing the word is from a German matchbox cover (*above*). Package designs often contain examples where the designer has played with the arrangements to obtain interesting combinations of shapes.

Wavy designs

Only three of the 10 lines of words on this 19th century label are horizontal. Most of them twist and curve to form interlocking patterns which resemble ribbons (*above right*).

Task

Wavy

Carefully trace a word containing over 10 letters along a horizontal line. Then draw a curved line, either a wavy one or one which forms part of a circle. Trace the word again using this curved line. Take care to adjust the letter spacing to maintain the unified appearance of the letters forming a single word.

Directional reading

The six boxes (*right*) contain the same word arranged in a variety of ways:
1 Forward, reading horizontally
2 Backward, reading horizontally
3 Forward, reading diagonally downward
4 Backward, reading diagonally upward
5 Vertical, reading downward
6 Vertical, reading upward

MOSCOW 1

WOCSOM 2

MOSCOW 3

WOCSOM 4

MOSCOW 5

WOCSOM 6

© DIAGRAM

257

Words as texture

Just as each individual brick in a wall loses its identity when viewed from a distance, each word, when seen against a background of all the surrounding words becomes part of the visual texture of a statement. Traditionally, in print, words are dark marks on a light background and their textural appearance is a result of the style of lettering and the scale of the words.

Textural words
The 16th century Bible title page (*above*) contains both printed Latin text and handwritten German notes (by Luther in 1542/3). This example, which is greatly reduced, shows the almost knitted quality of the handwritten parts.

Spatial textures
The decorative embellishments in the Dutch announcement (*above right*) link the words and help to give a tonal quality to the individual lines.

Imaginative textures
The American designer John Berg produced this extremely inventive design (*top*) in which the letters of the word "Chicago" blend with the patterns and whirls of a thumb print. Ideas like this can appear to be obvious when they are presented, but are, in fact, the unique inventions of a fresh mind.

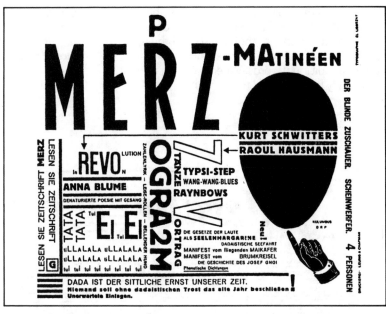

Structured texture
The German designer Hans-Joachim Burgert has linked each line of text (*above left*) with each row of letters to produce a structure which is difficult to read (even for a German!). It can only be interpreted using the knowledge which the reader already has. This technique is not intended to convey information. The designer has simply used the letters as a starting-point when building a pattern.

Monumental pattern
Classical buildings in Greece and Rome often incorporated textural statements. These Greek patterns of letters (*left*) could be read because the reader was often familiar with the word structures and so could separate out the words without needing spaces between them to aid their understanding.

Variable textures
The typographical designers of the 1920s often mixed sizes, weights and positions to produce textures in their pattern-making. Observe how the designer in the example (*above*) has used two sizes of letter for the word REVOlution.

Task
Pattern-making
Write out in capital letters a short quotation or poem. Eliminate the line spaces so that each line butts up to the line above it. Make each letter occupy the same width as its neighbors. This is made easier if you work on tracing paper over a sheet of graph paper or a square grid. The resulting lattice work may be unintelligible at first sight but it helps you to see the pattern of the letterforms.

Accidental patterns
The Italian telegram message (*left*) was intended to be read. Its decorative quality is the result of the line-feed mechanism in the tranmission machine operating in such a way that each letter stands directly below the one above it.

Review

By grouping the individual letters into established combinations, words are formed. These of course vary depending on the language so that the 42 characters available can make an almost infinite range of individual words. When we learn to read we quickly lose the need to memorize the combinations of letters, and develop the ability to identify words by their overall shape. This enables designers to test our interpretations by producing words copied from hundreds of different lettering styles.

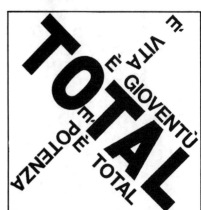

Texture
Large quantities of words in typographical presentations are normally grouped into blocks. These groupings create the illusion of changing textural surfaces. The Dutch magazine design (*above*) contains a window of white space into which a larger word has been inserted. Designers who use this technique often consider their work to be similar to that of an architect designing a facade. The text complies with an inner structure, a grid, on which the designer positions all the elements so that they interrelate.

Noisy words
This early Soviet poster (*above right*) uses size to indicate the intended volume and importance of the political message. It is often very helpful when working out a design to simply imagine that weight and size are equal to the impact of the words. Big words are easier to read and so appear to be more important.

Task
Texture
Select a design containing a great deal of text and make a reduced-down photocopy of it. The smaller your photocopy, the less legible the words become. The overall texture of the design becomes the clearest feature.

MŪSJK JM LëbeN dēR VÖLKeR
AM 21. JULJ 20 Uhr
dJRJGJeRT JM ŌPeRNhAUS
FJTeLbeRG
WARShAUS
beRÜhMTeR dJRJGeNT
WeRKe
POLNJ5her MeJSTeR

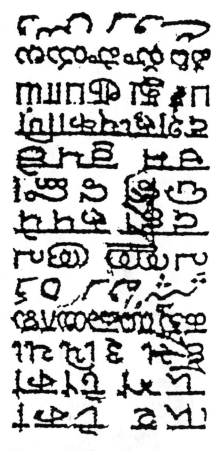

Criss-cross
The Italian Studio Boggeri has used the possibilities of creating spatial tensions by placing Total gasoline slogans of 1940 in a square (*left*). The text is all in capitals and only two sizes are used, but the interest is achieved by having to read interlocking lines at right angles to one another.

Task
Spatial tension
You can create a sense of tension in your design using a cut-out rectangular hole. By moving this frame around your design you will find that you have many dynamic solutions. Whatever solution you create it is important to make the message always readable.

Anything goes!
The 1927 phonetic type design (*above*) is by Dutchman Kurt Schwitters. Because the readers can be assumed to follow the message, the words have been distorted by the insertion of characters from both the capital and the lower case alphabets. In the case of the word "July" the letters have been twisted to satisfy the designer's overall ambition of involving the reader in the deciphering of the message.

Information
The lines of text (*above*) are an enlarged detail from an Indian 10-rupee note. Each line says the same thing but is in one of the many different languages of India. Designers enjoy playing with the textural qualities of words but they also have a responsibility to maintain the message-carrying quality of the letter combinations.

Chapter 3

When designing with words you should think about the overall effects of the words within the frame of your composition, and think of the words as possibly having individual features, as if they were depictions of objects or ideas. As we judge the total design by the spaces around the words as well as by the words' shapes, you should plan your design by making small sketches so that you can evaluate all of the elements at the same time.

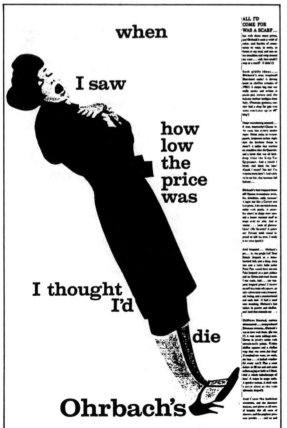

Two-dimensional space
The American designer Robert Gage uses the words placed around the figure (*left*) to produce pauses and groupings in the sentence which hold the attention of the reader on this 1957 New York department store advertisement.

Three-dimensional space
The designer Josep Renau has substituted airplanes for the letter "V" in this 1937 Spanish Republican Civil War poster (*below*). The two arms of the "V" reach into space.

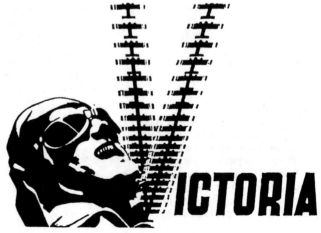

PICTURES

With some words you may be able to develop the three-dimensional qualities as if they receded or protruded or were solid forms. Occasionally you may even be able to make the words form a picture or pattern which may be only a slight distortion of their shapes.

Words express ideas and these ideas can be illustrated by imaginative adaptations of letterforms or by trying to depict the idea in the way the word is displayed. The letter styles have characters which can be used to enhance the meaning of the words, so you should choose a style which you think suits the word's character.

Words and letters were originally developed from pictures, and designers often try to establish a pictorial quality for words. This is often achieved by the arrangement of the initial letters to form an interrelated pattern. These solutions, called monograms or letter-logos, are ideally suited for use when establishing an identity. They become a badge or emblem, replacing the words describing a company or a person.

Emblems
The designer F H Ehmcke has used his initials to form the teeth of a key (*left*), for his own 1928 Munich exhibition. Many designers enjoy exploring the shapes of groups of letters, but this is a particularly clever combination.

Pictorial words
The name of the newspaper *Der Tag* (*left*) has been drawn as cascading water in this 1900 German advertisement. The designer Ludwig Sütterlin must have realized that the branching arms of the capital T are like a fountain's spray.

Ideas
The players in the Spanish ball game Jai Alai (similar to pelota) use a racket made from basket-work which is shaped like a scoop. The designer Bud Jarrin has used the capital J (*above*) to suggest this implement. He also wittily converts the dot of the lower case i to be the ball (pelota).

©DIAGRAM

Composition

Horizontal lines of text can be arranged in relationship to one another and to the edges so that their sequential importance is enhanced. Working within a rectangular frame you can consider the effect of positioning each line knowing that you can rely on the reader having some understanding of your message.

1

JOHANN SEBASTIAN BACH

2

JOHANN SEBASTIAN B A C H

3

JOHANN SEBASTIAN BACH

4

JOHANN SEBASTIAN BACH

Position
Rows of letters can be grouped horizontally in four ways (*above*):
1 Centered
Each line is centrally positioned directly underneath the one above it.
2 Justified
Each line has the letters or the word spacing stretched or compressed so that all the lines take up the same width.

3 Ranged (flush) left, ragged right
The first letter of each line is directly under the first letter of the line above it.
4 Ranged (flush) right, ragged left
The last letter of each line is directly under the last letter of the line above.

1

CLICK CLACK CLUCK

2

CLICK CLACK CLUCK

3

CLICK CLACK CLUCK

One size
The movie poster (*above*) uses only one size, weight, character and color. The designer achieves his effects by the skillful positioning. The tension comes from the other elements of the composition such as the city lights.

Two sizes
The 1955 Swiss electoral committee poster (*right*) by Armin Hofmann uses two sizes, large for the word "ja" (*yes*) and a smaller one for the remaining text. The composition's power is achieved by the dominant element of black and the feeling that the reader peers into a narrow space in order to read the text.

All ways
The 19th century poster (*left*) uses as many different styles, sizes, capitals and lower case as the designer can get into the area. The rectangle is filled with the larger words increased in size until they fill up the available space.

Six ways
The words click, clack and cluck appear in three rows in the panels (*below*). The changes to the final words by the insertion of a different style letter is achieved by:

1 Position
Moving one of the normal letters to another position.

2 Size
Inserting a letter which is larger but in the same style.

3 Weight
Inserting a letter which is the same style but much heavier (bolder).

4 Color
Inserting a letter the same size, style and weight, but in a different color. (Shown as an outline.)

5 Character
Inserting a letter from a different typeface (lettering style).

6 Techniques
Changing the method by which the letters are made. The previous rows of letters were made using dry transfer lettering. The U was drawn with a pencil.

4 CLICK CLACK CLUCK

5 CLICK CLACK CLUCK

6 CLICK CLACK CLUCK

Stepping into space

Creating letters which appear to be within a spatial area can offer you very exciting possibilities. Simply to add a thickness to the forms, or to imagine the row of letters in the word to be bending, receding or moving in some interesting way into the space of your page, opens up the possibilities of creating arresting designs. This technique is only advisable for short statements and single words.

Overlap
(*Above left*) Individual letters can be overlapped, either to each of the adjacent letters or to duplicates of themselves.

Recession
(*Above*) Although our reason tells us that the smaller letters are on the same surface as the larger ones, the first impression gained is that the letters are all of the same size but are receding into the picture area. The artistic convention of creating the impression of depth by having larger objects in the foreground and smaller ones in the background is influencing our interpretation of this design.

Solid forms
The three examples (*above*) are outline versions of basic letters. The student has applied a side section of solid black tone to indicate whether the forms reveal a top edge, side edge or part-top and side.

Task
Solid forms
Trace a simple word from a magazine. Move your tracing down and to the left a little. Retrace the outlines of the letters without crossing any of the lines of the first tracing. You now have letterforms which have a three-dimensional appearance.

Absent forms
These alphabets (*above* and *right*) are not drawn. Their appearance is deduced from the sides of the supposedly solid shapes. This technique is particularly successful with single words which you wish to stand out from the surface of the page.

Solid forms

The letters can be drawn as if constructed from solid materials. The examples (*left*) are taken from dry transfer catalogs in which the designers have created the illusion of solid shapes by adding areas indicating shadow or volume.

Into space

In the South African World War II poster design (*right*) the artist has placed the lower text on the side of a box so that the letters are within the compositional space. The message entering the ballot box is drawn flat on the surface, but appears to be flying through space.

Curved space

The letters in the logotype (*right*) have been constructed to appear as if they were on a curved surface. Only the letters E and T (in the foreground) are correctly formed. The other letters are distorted so that they appear to be part of a curved group of solid letters.

© DIAGRAM

Making pictures

You can exploit the pattern quality of words by considering them as total shapes, or as ribbons of shapes. You can run the lines of a text into a pattern that forms a picture. You can bend the outline shapes of the words to fit the areas representing objects. You can use the white spaces between each letter and word as a design motif. You can substitute letters with pictures or symbols, and you can combine the individual letters to make patterned structures.

Ribbons
The American company emblem (*above*) uses the traditional heraldic device of placing the rows of letters along a band. This was a very popular technique in the 19th century, but now appears to us as fussy and too elaborate.

Task
Picture sources
Keep a scrapbook of examples cut from newspapers of designers playing games with letters and words. It is surprising how many examples you can find in daily newspaper advertisements.

Picture ribbons
The Chinese poster (*above*) of 1911 runs the lines of copy around to form the outline of a bull with prayers for the animal's protection. Traditionally, Chinese text could be read horizontally left to right or vertically top to bottom. The grass in this picture is the latter and the text above the bull the former.

Textural patterns
The German baroque poet J R Karst has designed his 1667 piece "Fern" in the shape of that plant. The letters inside represent the leaf's texture (*left*) and the key word has a double meaning. This technique of forming pictures with lines of copy can be irritating if the shapes created obscure the text message. The Italian Futurist poet Pino Masnata (*right*) has squeezed his 1918 words of passion into shapes representing a plate, knife, fork and food.

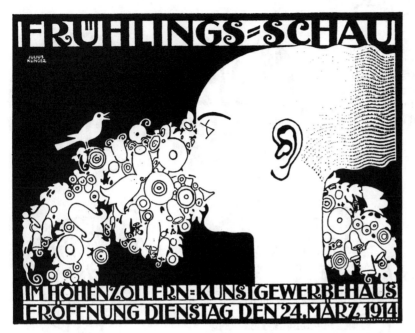

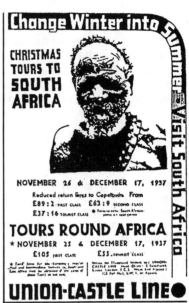

Reading spaces
The white spaces within the letters and between the words have been used by the Austrian designer Julius Klinger to hold together the elements of this Berlin spring art exhibition poster (*above*). We read the bands of words as if they were a dark fence of lines seen against a bright background.

Picture elements
The need of companies to establish a distinguishable and memorable identity with the word describing them has led designers to produce word shapes that often have image substitutions for letters, distorted letters, or pictorial elements added. The five modern examples (*below*) are a selection of typical company emblems.

Transformations
The travel poster (*above*) has a line of copy which begins as white on a dark background. Not only does it turn a corner and descend an edge of the design, but it also becomes black on white.

Task
Seeing words as shapes
Copy a simple word from a magazine by placing the original upside down under your tracing paper. You will more likely see the shapes when you are not reading the word. A similar task would be to trace a word from a language you cannot read.

©DIAGRAM

Forming circles

Because we read the word or words in a statement as a continuous ribbon of marks, designers can bend the row of characters into any shape they choose, as long as they retain their legibility. All the designs on these two pages are examples of lettering having been arranged to fit within a circle.

A1

A2

Lettering arrangements

The message within the circle can be arranged in four different ways.
A The words are horizontal and arranged so that they fit within the area.
B The words are arranged around bands within the circle, either all running in the same direction or in either direction.
C The words are one continuous band spiralling into or out of the center.
D The words are distorted to appear as if on the surface of a sphere.

A1 The name DUVAL JANVIER in which both words share the common central letter V.

A2 REKLAMA MECHANO (type composition by Henryk Berlewi, Warsaw c1925) in which the letters at the sides are reduced to fit within the circle of this advertising agency's trademark.

A3 Russian rouble coin for centenary of Napoleon's defeat in which the letters are centered in rows.

A4 A German 1962 type design by Hans-Joachim Burgert.

B1 British 19th century cold cream circular jar lid.

B2 Postal franking stamp, France 1957, continuing both horizontal and circular techniques.

B3 Brand name on a New York powder jar seal, lettering by Tommy Thompson c1937.

B4 A cheese box label, France c1930.

A3

A4

B2

B1

B3

B5 The calligrapher Irene Sutton's journal of a 1934 English holiday.

C Early 18th century German writing master I C Hittensperger's demonstration of spiral skills celebrates God's wisdom.

D The original company logo for IBM c1945.

Task
Proverb
Write a short proverb inside a circle.

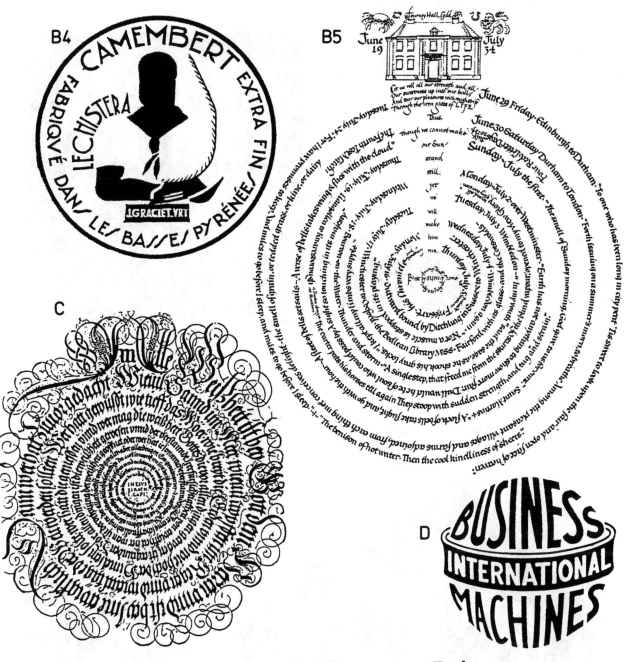

Task
Circular prose
The aim is to find the correct sized circle for a continuous ring of text around the circumference. Draw a series of circles from the same center point but with radii at ½in (12.5mm) intervals. Begin a short line of prose, perhaps your full name or a proverb, writing it around the circumference of one of the circles. Should your solution not extend all the way round, repeat the text in a circle closer to the center point. If your text exceeds the available ring space, repeat on a circle farther from the center.

Task
Word shapes
Copy a series of words in a language you do not know; you could find a short poem in a library book in an unfamiliar foreign language. Because you cannot "read" the text you are more able to direct your attention toward the shapes of the letters and words.

©DIAGRAM

271

Expressing ideas

Words convey ideas, and the choice of letterforms can help. Both the selection of a style and the method by which it is drawn can in some way indicate the character of the subject. Because letter styles are the clothes words wear, you can dress your message in any style you think appropriate.

Slogans
The word SOLIDARNOSC (Solidarity) has since 1981 become a representation of Polish political dissent. The written style of this slogan (*above*) is made to look like a marching column of protesting workers with the Polish flag.

Task
Mood
Choose a word that describes a mood and then select a letterform to express it. Perhaps the word is Depressed, Jolly, Angry or Dizzy. Try your idea on dark paper, or use colored inks, or collage (cut out from newsprint).

Capturing mood
Designers of movie posters and book jackets often need to convey the mood of a subject by both images and words. The design (*above*) has the main title's letters quivering with fear.

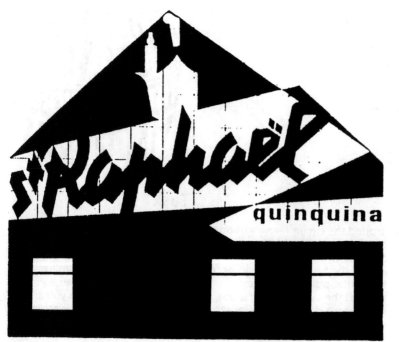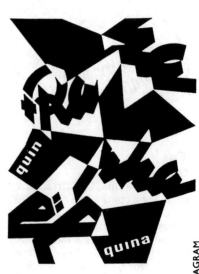

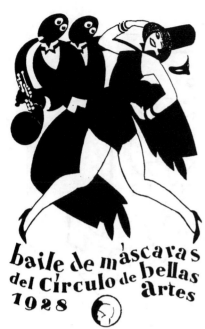

baile de máscaras
del Círculo de bellas
Artes
1928

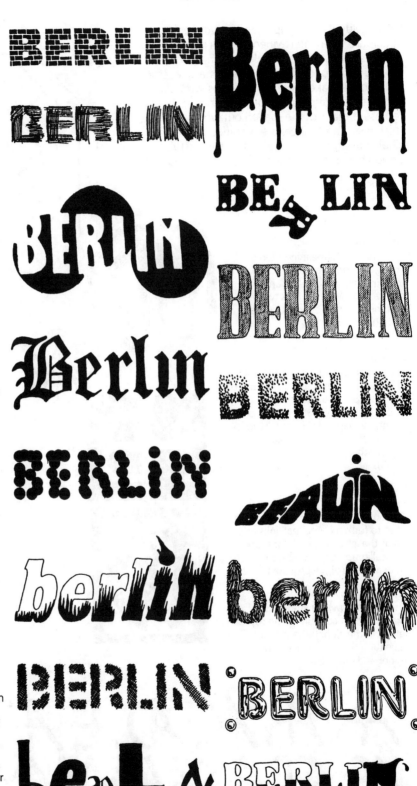

Expressive lines

The Spanish poster (*above*) has lines of text "dancing" under the feet of the figures. By arranging the letters in a wobbly row a festive feeling is conveyed with the information.

Expressive letters

The examples (*right*) by students explore the ability of letterforms to depict character. Although all the examples are of the same word, BERLIN, the way in which they are drawn suggests many different interpretations of the word.

Establishing style

The persistent use of a very distinguishable letter style and colors over many years has enabled recent designers to convey the message even though the lettering is unreadable. The original 1939 calligraphic style of the French designer Charles Loupot (*far left*) has been transformed in a 1950s poster (*left*) where the word is mutilated but the message is still clear to those familiar with the aperitif company's graphic styling.

Making patterns

For individual letters representing words, the initials are often intertwined to form a single design element. These emblems, variously called monograms, logos, trade marks or marques (for automobile makes), are then used as symbolic but often enduring and more powerful representations of the spelled out words. Sizes, thicknesses and shapes are modified to form a single integrated unit, and, when successful, the design becomes more than the sum of its parts.

Distortion
The initials MG (meaning Morris Garages) (*right*) have been distorted to fit into an octagonal shape. The normally symmetrical M is twisted and the normally curved G is made of straight lines.

Combination
Letters can be superimposed either sharing common elements like the HB (1957 logo by Paul Rand for US publisher Harcourt Brace & Co) or simply overlapped like the WI (*right*), actually the signet of the Austrian goldsmith Wenzel Jamnitzer (1508-1588).

Framing
The outer limits of the letters can be used to form a frame that links and holds the letter in a trellis of shapes. The calligraphic lower case tb (*right*) sit in a strong almost square frame.

Shared parts
The row (*below*) is a student's experiment at combining the capital letters in the alphabet and then repeating the sequence combining upper and lower cases.

Entwined
A very popular 19th century style of monogram was to combine and intertwine the letters. This can develop into a visual puzzle where you have to establish how many letters are in the group. The monogram (*above*) contains E H G W M cut in stone by A J J Ayres for a pre-1937 garden path.

Task
Shared parts
Select any letter of the alphabet and explore ways in which it can be linked to all the other letters. Use a thick felt tip pen so that you are making strong bold shapes and not thin lines.

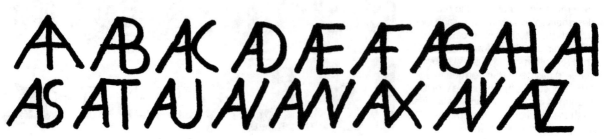

Monograms

There is an ancient tradition among craftsmen to sign their work not with a signature but with a device containing their initials or letters and shapes related to their profession. They were used by stone masons, carpenters, painters, gold and silversmiths, potters and calligraphers to identify their work. The design (*above*) is the monogram of the Early Christian scribe Furius Dionysius Filocalus, later calligrapher to Pope St Damasus I (366-383). Filocalus has very ably combined letters of differing sizes and used common elements to join them.

Seals

The pen-drawn monogram (*above*) was used by the great European Emperor Charlemagne (768-814) from the Latin for his name — KAROLUS. Kings, governments, churches and authorities have all used such stylized letters to represent their power. The badge or mark comes to represent the idea that the object on which it appears has the seal of approval or belongs to that authority, as in the "Bob on the Square Ranch" cattle brand, Texas 1875 (*right*).

Task
Monograms
Begin to keep a source book of company emblems, symbols made from combining letters. They often appear in trade journals and newspaper advertisements.

AJ AK AL AM AN AO AP AQ AR
Aa Ab Ac Ad Ae Af Ag Ah

Review

This chapter has been about the way that letters, when combined into words, create their own personalities. Lower case words are like insects, each with individual groups of protuberances above and below the central areas (ascenders and descenders). The rows of words in a sentence march across the page to form horizontal strands of shapes, each similar but in unique ways different.

Words are the visual noise in our environment. Wherever we go they are used either to inform, invite, warn or seduce us. In their printed form they call our attention to the subject they are describing by their selection of types and sizes. Letters are of course flat but they can be used as solid objects or to indicate receding space; or, most importantly, they can be used to convey ideas about the subject depicted.

Composition
The edges of the area containing the message act as a frame to which the elements relate. In addition, each of the separate elements relates to one another. The design (*above*) uses normally very small features to create an arresting impression. By greatly enlarging the punctuation to dwarf the letters, the designer has created a sense of crowdedness within the small area.

Task
Composition
Draw four 6in × 6in (150mm × 150mm) squares. Within each place a word. The first should shout, the second whisper, the third be as large as possible without being illegible, and the fourth should be surrounded in a sea of other words and become lost.

Space
Letters are of course flat shapes usually appearing on flat surfaces. Designers enjoy deceiving the eye by providing the illusion of solid or overlapping forms. The German trade show poster (*above*) by the designer Heinrich Joost links the letters D and G to suggest they are overlapping one another.

Task
Space
Draw a simple word so that its letters appear to be overlapping.

Pictures
Very often designers producing a company logo or emblem use the letters to create an image connected with the subject. The word cotton (*above*) has been developed by Walter Landor Associates for Cotton Inc (US 1973) so that the central pair of ts has become the stem of a cotton plant.

Task
Pictures
Select a simple word that suggests an image and develop the letterforms to portray the subject. For example try BALL, BUSH, HAND, SKULL, PEN, WINDOW or BOOK.

calder

sandy calder
ein mann wie ein baer
haar weiss-shirt rot helle hosen
alles rund nase mund und koerper
die warmherzige natur der humor
aus dem mundwinkel
fallen
kurze
eckige saetze
aus groben fingern
fliesst leichte bewegung
das material
stahldraht blech
und gleichgewicht
feine aeste mit
grossen herbstblaettern
gelbe
schwarze rote
weisse
balancierend im luftzug
helle wolken
beschreiben oben
froh und farbig sich windend
figuren ohne anfang und ende
oder
es wachsen
dunkle riesige
bodenstaendige gestalten
signale kohlenhaendler spinnen
lange nase schwarze witwe schwarzes biest
hund schuh kaktus die guillotine fuer acht

alexander calder hat in den fruehen dreissiger jahren
als erster amerikaner einen beitrag geliefert zur entwicklung
der bildenden kuenste : bewegung und gleichgewicht ohne maschine
sein lebenswerk gehoert geschichte und gegenwart

Patterns
The arrangement of much text within a rectangle creates patterns of horizontal lines which seen as areas of texture form patterns. The Dutch designer Willem Sandberg has taken the imaginative idea of setting his 1962 tribute to the American sculptor Alexander Calder into lines not vertically beneath one another, but set at an angle to form streams of prose.

Task
Patterns
Write out a short poem so that the lines run continuously but all the text occupies a diamond, circle or heart shape.

KING'S CROSS

Ideas
Words convey ideas, and designers make use of familiar ones. The London KING'S CROSS Railway Station has 10 letters in its name, but this designer has used an X and a crown to deliver the same message.

Task
Ideas
Devise a distorted arrangement of the letters in a word to convey its meaning. You could try JUMPED, CRAWL, SCRAMBLE, MIX-UP, or SQUASHED.

Foreign words (*above*)
Letters in an unfamiliar language more clearly appear as an arrangement of shapes. This design by the Russian Ivan Bilibin was for the title page of the 1903 magazine *Art Treasures of Russia*. It uses characters from the Cyrillic alphabet and fills in the spaces with small blocks to achieve an overall patterned effect.

Emblem
This monogram signature is by the French painter Toulouse-Lautrec, Paris 1892. The Impressionist painters were often influenced by the recently imported Japanese crafts; the prints, vases and lacquered work of which carried devices designed by the craftsmen.

Task
Emblems
Using your initials, try a variety of ways of combining them in a circle. Then try a square and a diamond. Remember you can vary the size of each letter, or have them share common parts.

Chapter 4

Task
Energetic lines
Copy a line of curving forms of a word very carefully, then repeat the word over and over again. Work faster and faster until the word loses its inhibitions and becomes an energetic free expression of marks.

Task
Free expression
Draw a simple word using brush and paint, by the normal method of resting your hand on the surface while working. Repeat the same task but without your hand touching the paper for guidance. You will see how the second version is freer than the first.

The marks on a surface are the result of the method by which they were produced. Before printing and photography, each mark was the evidence of the method by which it was made. Present day processes enable the designer to use words which may have been produced by a wide variety of techniques. These are subsequently presented by reproduction. Beginners studying lettering design are often confused by the techniques of origination as these are further disguised by not revealing the size of the original artwork. It

Uninitiated
The simple signs displayed by retail stores often have a wonderful naive style which you can copy in your work. The innocence of joining up the letters on this sign (*above*) is an idea often applied to much more advanced works. If the design requires it, hand drawn forms need not be rejected in favor of more sophisticated solutions.

Traditional sources
Calligraphy examples in design history books (detail *top*), typography of earlier periods, and mannerisms of old styles can all be exploited in exploring new techniques. Although you cannot easily acquire the skills of master calligraphers, you can adopt their forms for your own use.

Deliberate accidents
The word (*above*) was drawn in slowly drying ink and while still wet was blown at through a straw. The close focused blasts of air blew dribbling streams of ink away from the main lines of the letters to produce this irregular yet strangely natural and organic solution.

METHODS

may have been drawn, the traditional calligraphic method. It may comprise dry transfer letters assembled individually. It may be typeset or photoset and recently may be produced by laser printers from computer letterform resources. Before beginning any task consider a number of factors which influence the resulting work. First, what tools are available? Although this may seem obvious, it is worth considering chalks, felt tip pens, or compass construction techniques. Second, what experience do you have of the tools?

One serious obstacle in the execution of a task is the difficulties met in mastering the tools. Third, what use is the task being put to? Will it be on permanent display? Is it for reproduction by photographic techniques? Can you draw it larger for reduction? Is it being created mechanically by typesetting or stencil?

This form of design often uses handcut letterforms which can be an inspiration as their irregularity disguises your inability to draw accurately correct letterforms.

Task
Techniques
Examine the alphabets in this book and try to deduce the method by which they were produced.

Graphic reproduction
This 1928 Campari poster was produced by a method called silkscreen printing, where the shapes are cut from a mask and the ink is squeezed through a fine mesh of silk onto the surface.

Exploration
Detail (*above*) of a design for use on a book jacket. It was made by scratching the forms into a tray of sand, then photographing the resulting shadowed forms. This free style can be arresting as the current profusion of letterforms can leave us bored and tired of similar methods of presentation. Try to explore new methods of making the letters and always store others' discoveries in your notebook for later attempts at new techniques.

©DIAGRAM

279

Hand drawn

Hand drawn lines have energy. The speed of drawing the lines, the surface qualities, the shape of nib or brush, and the pressure applied during writing all combine to produce the quality of the characters. Calligraphic art is the expression of these forces, and successful calligraphy is that which appears free and without physical restraints. Speedily created lines have a smoother and more energetic curve than carefully plotted lines.

Transformation
The letters (*below*) were copied using a felt tip pen for an earlier pen mark alphabet. You can achieve interesting designs by converting one way of producing the letters into another.

Graffiti
The broad sweep of an arm (*above*), working on vertical surfaces, produces shapes which are quite unlike those made by a hand working on horizontal surfaces. Without the guiding control of the hand touching the surface the lines are often freer and more expressive.

Handwriting
The artist's use of handwriting to convey his message (*below*) is made more interesting because his style lacks the free confident expression of an adult, but contains some unsure and hesitant forms of a child practicing writing exercises.

Shape versus sense
Simplicity is not easy. The Viennese designer Alfred Roller may have had to draw out the word SECESSION (*left*) over and over again, exploring the combination of curves and linking lines until he arrived at a satisfactory solution. Then he may have had to experiment with the writing tool to achieve an even flowing line.

Tools

The alphabet (*top right*) is by designer Roger Kohn, who has injected humor and frivolity into his pen line alphabet. Although the letters do not have a common structure pattern, they belong together as a family because of their scratchy and witty shapes.

Surfaces

This alphabet (*right*) exploits the effect of thin paint on canvas. The surface texture is used to give the letters character and they all contain a strong dark part, reminiscent of beginning with a paint laden brush.

Task

Handwriting

Make a collection of written examples, and if possible enlarge words on a photocopier so that you can study the character of the curves.

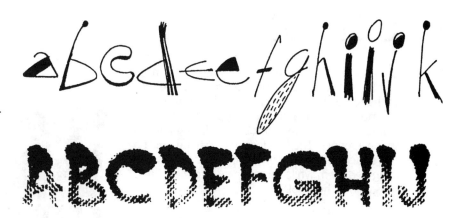

Typographic forms

Although the letters in the 1967 poster (*below left*) by the designers Z Sklemer and J Mracek have their origins in normal printing letterforms, the designers have adapted and modified the shapes by personalizing each letter. These solutions are normally created with a pencil, then painted carefully with a brush.

Brush styles

The designer Hans Rudi Erdt has devised (*below*) in 1914 from the writing styles of German schoolbooks a continuous cursive form, which he has then exaggerated to produce lines of copy that flow like copious thick paint lines.

Cut out

Just as a pen or a brush makes characteristic marks, so a knife or tearing will produce distinctive edges to the forms. It is most important that to produce the most effective and natural shape you should create the letterforms without first drafting out the shape in pencil. The freedom of the shapes will be more successful and spontaneous if you have imagined them while you are handling the knife, scissors or other tool.

Spaces are the message
The German artist who produced this design (*right*) cut the spaces from black card to reveal the shape of the letters. This method requires you to work out a provisional design, maybe with a broad-tipped pen. The final design is then made, referring to the provisional design from time to time.

1
ABCDEFGHIJK
NOPQRS

2
ABCDEFGHIJKLMN

3
ABCDEFGHIJKLM

4
ABCDEFGHIJK
LMNOPQ

282

Crude need not be bad

The poster (*left*) was made by Paris students in 1968. The letters are cut out of silk screen stencil sheets and are then printed. Each letter is individual, but the total effect of the words is one of natural and free shapes.

Four methods

1 These letters, derived from dry transfer sheets or typesetters' specimen books, are cut up to produce dramatic effects.
2 Each letter is torn from gray paper.
3 The letters are cut from linoleum and printed.
4 The stencil is cut out of card and shown placed over black paper.

Dry transfer

The process of rubbing-down individual letters from sheets of alphabets provides the designer with great flexibility. The manufacturers offer hundreds of different varieties of letterforms in many different sizes and weights. As a method of exploring your ideas and of producing clean artwork, the dry transfer technique saves you time and extends your abilities. You have complete control of your design, but are not limited to your ability to form the shapes of the letters.

1 MORT
MORT
MORT

2 montbanc

3 GOLIN

4 mozart

5 caRNiVaL

6 RASPUTIN

1 Letter spacing
The individually applied letters enable you to adjust the spacing either by opening out the letters or having them very close. You can also overlap the letters.

2 Alignment
Normal typography and lettering places all the letters on a common baseline – they are aligned. Dry transfer permits you to step up or down the horizontal positions of the letters.

3 Interlocking
Normally, each letter occupies its own space and the gaps between letters are usually constant. Dry transfer allows you to interlock the letters into one another's space.

4 Mixtures
You can use two sheets of letters of the same style and size but two different weights. This technique would be very difficult using any other method.

5 Varieties
Using a mixture of dry transfer sheets you can assemble words from a variety of sizes, styles and weights.

6 Transposition
By working on clear plastic film, and applying the letters to either side you can produce words with transposed letters.

7 Negative
The manufacturers produce dry transfer letters in a variety of colors as well as black and white. This enables you to apply the letters to dark or textured backgrounds. This solution has the letters applied to a pencil-rubbing of coarse texture.

7

8 Interference
By working with large letters, and putting these onto clear, smooth plastic film, you can subsequently scratch off the transfer material to create dynamic and expressive designs.

9 Curved
Because the letters are individually applied you can curve the direction of the baseline to suit your needs. This is particularly useful in simple mapping tasks.

10 Invention
You need not simply use the letters provided. You can adapt them to express your ideas. The word NEON was made by placing down the N and the E, then a letter C followed by a gap and then a back to front C. The word was ended with an N. The two Cs were then joined together using an inking pen and a brush.

11 Contrast
The letters in dry transfer alphabets are very carefully and accurately produced. You can exploit this feature and add hand work.

12 Distortion
Dry transfer can be applied to surfaces which are subsequently crumbled, torn or worn so that their textures become a feature of the letters.

13 Substitution
You need not only use the alphabet letters. Interesting ideas can be expressed by inserting other elements into the words.

Review

Ideas have legs! They jump out at you in the most unexpected ways. When faced with a design problem, your most successful solution may be the very first idea that occurs to you, or the last. Always have an open mind and try to bring fresh and new ideas to the problem. To help you achieve this, I have made a short list (it could be much longer!) of starting points, from which you can explore the features of your task. Never feel ashamed of using the solutions found by other designers – copying examples is the quickest way of gaining confidence in your own ideas. Remember that good solutions are often the simplest. DO NOT TRY TO BE CLEVER . . . only to become obscure. Legibility should be the primary concern of any statement. A brilliant design which is confusing and difficult to read will not succeed. Most of all, have fun. Creation is a wonderful activity, and, although sometimes difficult, it is very rewarding.

How to improve your design solution

Change its shape	**Change how you make it**	**Change its character**	**Change its position**
Flatten it	Typeset it	Do it in capitals	Do it upside down
Fatten it	Dry transfer it	Do it in lower case	Do it at the edge of the area
Thin it	Brush letter it	Do it in Italic	Do it at the top
Squeeze it	Use a quill	Do it in bold	Do it at the bottom
Stretch it	Use compasses and rule	Do it in light	Do it at the side
Bend it	Use pencil, chalk or crayon	Do it in solid letters	Write it upward
Curve it	Photoset it	Do it in outline letters	Write it sideways
Squash it	Cut it out	Do it in textured letters	Write it backward
Overlap it	Tear it out	Do it in color	Write it diagonally
Twist it	Scratch it out	Do it in 3D	
Slope it forward	Make it out of clay, tin,	Do it normal	**Go wild**
Slope it backward	metal, wood, sand, or	(not a bad idea . . .)	Smudge it
Put it in a square	anything else you can find		Scratch on it
Put it in a circle			Tear it up
Put it in a triangle	**Change a part**		Cut it up
	Mix capitals and lower case		Insert wrong letters
	Mix bold and light		Simplify it!
	Mix normal and Italic		Substitute pictures
	Mix decorative with plain		Substitute symbols
	Mix the way you make it		Try your own ways of distorting it
			Do lots of these methods at the same time

© DIAGRAM

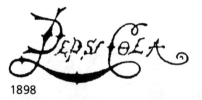

1898

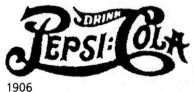

1906

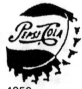

1950

1962

1973

Evolution
Current design solutions are the result of years of refining and developing ideas. The company symbol for "PEPSI" (*left*) has undergone serious revisions and simplifications since it was first developed in 1898.

Task
Creation
Try any or all of these suggested methods of transforming your lettering. Use words from this book, or from a magazine, as the original.

TOPIC FINDER INDEX